S0-BJN-168

ALLEGORIES
OF
MODERNISM

CONTEMPORARY

DRAWING

BERNICE ROSE

ALLEGORIES

CONTEMPORARY

OF

DRAWING

MODERNISM

THE MUSEUM OF MODERN ART, NEW YORK

DISTRIBUTED BY HARRY N. ABRAMS, INC., NEW YORK

Published on the occasion of the exhibition
Allegories of Modernism: Contemporary Drawing
February 16–May 5, 1992
Organized by Bernice Rose, Senior Curator
Department of Drawings
The Museum of Modern Art, New York

The exhibition is made possible by
a generous grant from Mr. and Mrs. Ronald S. Lauder.

Additional support has been provided by
The International Council of The Museum of Modern Art,
The Bohen Foundation, The Tobin Foundation,
and The Solow Foundation.

Copyright © 1992 by The Museum of Modern Art, New York
All rights reserved
Library of Congress Catalogue Card Number 91-67941
ISBN 0-87070-325-0 (MoMA)
ISBN 0-8109-6103-2 (ABRAMS)

Produced by the Department of Publications
The Museum of Modern Art, New York
Osa Brown, Director of Publications

Edited by Helen M. Franc and Harriet S. Bee
Designed by Emily Waters
Production by Vicki Drake
Printed by Litho Specialties, Inc., St. Paul, Minnesota
Bound by Midwest Editions, Inc., Minneapolis, Minnesota

Printed in the United States of America

Published by The Museum of Modern Art
11 West 53 Street
New York, New York 10019

Distributed in the United States and Canada
by Harry N. Abrams, Inc., New York
A Times Mirror Company

Distributed outside the United States and Canada
by Thames and Hudson, London

CONTENTS

PREFACE AND ACKNOWLEDGMENTS

This book is published in conjunction with the exhibition *Allegories of Modernism: Contemporary Drawing* at The Museum of Modern Art, and although it is not a catalogue of the exhibition it nevertheless discusses each of the artists whose work is shown and articulates the themes presented in the exhibition itself.

The following essay may be seen as an extension and re-evaluation of the premises of *Drawing Now*, an exhibition shown at the Museum in 1976 and accompanied by a publication of the same name. By that date drawing had become a major independent medium, but many of the basic grounds for that phenomenon and its implications were not yet entirely clear. It is now apparent that the shift from the narrow confines of a traditional medium into an expanded field, of which the change in drawing was both a symptom and a cause, was part of the transition from modernism to what is now characterized as postmodernism. The essay in *Drawing Now* presented a view of drawing from the 1960s to 1976. The present essay and exhibition review the position of drawing since 1976. And while they extend the premises of *Drawing Now* they also oppose them in focusing not just on the phenomenon of extension but on the "impurity" of drawing itself in the expanded field. This thesis follows the contemporary discourse between modes through the medium of drawing in which the emphasis on the purity of the various disciplines is seen to wax and wane, as diverse approaches revolve around one another within the larger scenario. The argument (and exhibition) begins with the work of Sol LeWitt, reviewing his transfer of the control of art to a self-regulative, seemingly rational system, his expansion of the fragment (the gridded structural underpinning) to "finished"

status, and thus his exposure to public view of the preliminary, formerly private province of drawing. Like Joseph Beuys's earlier transition from a private to a public mode through involvement with the "historical" and fragmentary in his drawings, this transfer from a private to a public mode, as well as drawing's elevation to a global principal, can now be viewed as a manifestation of the transition to the postmodern. In this view, the postmodern is characterized by breakup and fragmentation on its surface — its idiosyncratic details subject to re-arrangement according to new principles of material operation, as disparate modes are manipulated. One long-held myth of modernist art is that it is a virtually inviolable body of abstract principles in which form and content are one. But a tension has always existed between modernism's totalizing structure and its "perversely" subjective details, making it vulnerable to constant re-interpretation and opening it to allegory. The myth of modernism, which still obtains, making postmodernism continuous with modernism, holds that the principle of art — the aesthetic — is itself redemptive.

Appropriate to the new aesthetics of fragmentation, the exhibition itself takes place in three widely separated spaces in The Museum of Modern Art. In each area there are site-specific installations, which serve to create a reference and cross-axis that connects the diverse spaces conceptually. One space, however, also functions as a kind of *cabinet des dessins,* with many kinds of drawings — for example, study drawings and drawings after drawings — in it. Another site has been designated for large interdisciplinary works. Two large wall drawings, although oppositional in system, are intended by their public mode of address to provide the viewer with connections from space to space: one with abstract figures by LeWitt, the other figurative and representational by Jonathan Borofsky. The latter piece serves another purpose as well; its immense scale immediately connects by contrast to the smaller scale of the works in the adjacent galleries as well as to the larger works elsewhere.

But scale is hardly the sole factor determining the selection. Every exhibition represents a choice among many possibilities. Following *Drawing Now,* two other more limited exhibitions, *New Work on Paper 2* and *3,* investigated the nature of drawing as a range of practice by a variety of contemporary artists. Neither the previous exhibitions nor the present show presume to attach or establish firm definitions or limitations to the term "drawing." *Drawing Now* took a longer view than the two smaller exhibitions, which were in effect interim reports limited to a small group of artists and issues. *Allegories of Modernism: Contemporary Drawing* is a larger exhibition but still does not include every artist whose work is relevant to its premises. All of the artists included in the exhibition appear in the publication, although in cases where works have been made specifically for the exhibition other works are illustrated here.

The achievement of an exhibition requires the cooperation of many people. The exhibition and its accompanying publication have been generously assisted by grants from Mr. and Mrs. Ronald S. Lauder, The International Council of The Museum of

Modern Art, The Bohen Foundation, The Tobin Foundation, and The Solow Foundation. I wish especially to thank Mr. and Mrs. Lauder and each of the other donors for supporting a difficult project, and the Council and its individual donors for the generous support they have always shown for projects of the Department of Drawings.

The artists are the most important people to thank for the support of any exhibition, and I particularly would like to express my gratitude to all of them. In addition, special thanks are due those artists who have made works for the exhibition: Jonathan Borofsky, Günther Förg, Mike Kelley, Sol LeWitt, Allan McCollum, and Sigmar Polke.

I would like to thank all of the lenders who have parted with their works of art in order to make this exhibition possible. This project could not have been realized without their cooperation and without the help of the dealers — too numerous to mention individually — who represent the artists both in New York and abroad. They have been patient and tireless in locating works and in acting as liaisons between artists and collectors. I am especially indebted to David Nolan, Gisela Capitain, and Matthew Marks, who make drawings a special interest, and to Helen van der Meij and Susanna Singer, liaisons for Sigmar Polke and Sol LeWitt, respectively.

At the Museum I owe a very special debt to three people: Robert Evren, Curatorial Assistant in the Department of Drawings, for his skillful organization of all aspects of the exhibition and publication, his authorship of the artists' biographies and the bibliography, his help and encouragement throughout the writing of the essay, and his invaluable advice and independent judgment; Helen M. Franc, formerly Editor-in-Chief at the Museum, for her preliminary editing of the essay; and Harriet S. Bee, Managing Editor in the Department of Publications and the final editor of the essay, for her support and patience throughout a particularly intense process and unusually demanding schedule, and for her guidance of the book through all phases of publication.

I have been most fortunate to have had a great deal of help over the years from colleagues within the Museum. Kynaston McShine, Senior Curator in the Department of Painting and Sculpture, was particularly supportive during the *New Work on Paper* exhibitions, especially in informing me about the large work by Francesco Clemente titled *the loneliness of the frog, or bruno taut in istanbul, 1937, laughing* (1980), which was shown in *New Work on Paper 2*. Robert Storr, that department's new Curator, despite a tight schedule for his own first Museum exhibition, took the time to discuss the present exhibition with me; he was an early advocate of the work of Glenn Ligon (as were Helene Weiner of Metro Pictures and Jack Tilton, Ligon's first dealer). I also wish to thank the committee for the Projects series at the Museum for its enthusiasm in allotting the Projects gallery for Nancy Spero's work, and Kirk Varnedoe, Director of the Department of Painting and Sculpture, for ceding to this exhibition spaces usually reserved for the permanent collection. I am

also indebted to Riva Castleman, Deputy Director for Curatorial Affairs and Director of the Department of Prints and Illustrated Books, for her help and reinforcement during the preparation of this and other projects.

In the Department of Drawings special thanks are owed its Director John Elderfield for his support and advice; Magdalena Dabrowski, Curator, for essential support; Hadley Fine, Secretary, for her assistance on all aspects of the work; and Interns Sarah Reese, Petra Oelschlägel, Thalia Vrachopoulos, and especially Dorothea von Hantelmann, who extended her stay to work on the project.

Essential to an undertaking of this kind is the support and encouragement of the Museum's Director Richard E. Oldenburg to whom I owe a special debt of gratitude. I also wish to thank Antoinette King, Director of Conservation, for her careful attention to the condition of the works of art and that of her staff in the safe installation of unframed works. Jerome Neuner, Production Manager, Exhibition Program, has done his usual splendid job in planning the exhibition installation and, with Karen Meyerhoff, Assistant Production Manager, in coordinating the entire operation. Sarah Tappen, Associate Registrar, Exhibitions, has done an excellent job coordinating the logistics of loans and transport. I wish also to thank the International Program, especially its Director Waldo Rasmussen and Associate Director Elizabeth Streibert, for their organization of the exhibition's tour. Thanks are also due James S. Snyder, Deputy Director for Planning and Program Support, and Richard L. Palmer, Coordinator of Exhibitions, for their administrative guidance; and Sue B. Dorn, Deputy Director for Development and Public Affairs, Daniel Vecchitto, Director of Development, John L. Wielk, Manager for Exhibition and Project Funding, and Laura Auricchio, Grants Assistant, for their efforts on behalf of funding the exhibition. In the Department of Publications I want to express particular thanks to Osa Brown, Director; Nancy T. Kranz, Manager of Promotion and Special Services; Tim McDonough, Production Manager; Vicki Drake, Associate Production Manager, for supervision of the book's production; and Jessica Altholz, Assistant Editor, for skillful editorial assistance. My thanks also go to Michael Hentges, Director of Graphics, and to Emily Waters, Senior Graphic Designer, who designed the publication.

B. R.

ALLEGORIES OF MODERNISM

Drawing today is not a vehicle for self-expression within a fully realized structure of self-explanatory forms; nor is it a term that signifies a set of rules projecting a rationalist view of the world.

In the present era style and autography are no longer synonymous, yet drawing retains an authority over the notion of authenticity and affirms that the artist's hand still counts in the primary expression of ideas. Drawing holds a unique position within the spectrum of the arts, for while maintaining its own tradition it has also served the most subversive of purposes.

The formal purity of drawing is not an issue, nor is it of much concern to artists. The progression of modernism as the isolation of those means of production peculiar to each medium is now only one aspect of artistic practice. What is more important in understanding the current situation is that drawing has become one of the principal elements of a new language and that it operates in a variety of guises, conservative as well as revolutionary. Catalytic to the re-alignment of drawing has been its relationship to sculpture. Although drawing is still the primary conceptual medium for some artists, many others do not use it at all, and for still others it is an after-the-fact tool for the further exploration of previously completed work. Many artists continue to produce autonomous finished drawings, often as alternatives to painting. As drawing has moved toward its new status it has asserted both its linear autonomy and its conceptual control over other disciplines. Although increasingly an independent mode, it has also become inextricably mixed with other mediums, with painting and painterly devices, with color, and with paint itself. Distinctions

between painting and drawing — and printing — have become blurred, and the support no longer invariably serves as a dividing line between disciplines. A new language of the visual arts has thus emerged in the last two decades based on an expanded field of operations for each of its disciplines, on new relationships among them, and on the use of technological means.

At the critical center of art there is now a skepticism about the validity of the authorial role and the relevance of the signatory gesture. This struggle over self-expression as a still-valid concept strikes at the heart of drawing itself, long the primary medium of the authorial gesture. Technology has invaded the Garden:[1] in the face of the mass media and their techniques, and the intrusion of photography as an instrument for recording the artist's primary conception, the very means as well as the value of traditional artmaking have been assaulted. Self-expression and the belief that we can control our own destinies have been cast into doubt as just "two more cultural myths,"[2] in the face of the conformity and paralysis of individual will induced by the media as they seek to manufacture consent and re-form us into unquestioning consumers.

The tension between self-expression and originality, and the relationship of current artmaking to the past have been essential issues since the 1960s, with the stakes rising continually, as artists have addressed the fundamental premises of modernism: the need to constantly invent new pictorial languages and interrogate the very tenets of modernism itself. If modernism is conceived as a corpus, with its aesthetic doctrines as a kind of lexicon — an established vocabulary open to all — to what end may it be used? At the same time, technology has become increasingly relevant, not only as the means but also as the potential source of a moral dilemma. "Postmodernism" may be characterized as a continuing discourse between that modernist corpus and the present, accompanied by a questioning of the ethical nature of representation, of its social value, of who and what gets represented, and by whom. Thus there is no dominant stylistic direction or "movement," neither as a linear development nor a group consensus; rather, there are strategies that focus on these questions and make ingenious use of the means available.

Often, style comes down to the manipulation of elements within a multilevel system, in which the elements are read through one another. The mediation of printed matter and printing techniques, collage, copying, tracing, photographic projection, and the mass media are now taken for granted as contributing to a newly enriched technical visual language, much as traditional drawing's mixed means of watercolor, pencil, pen and ink, wash, and collage of cut-and-pasted papers, or the mix of drawing and painting, were long taken for granted as constituting a visual language. And if the technical language is changed, it is clear, too, from the 1960s on, that not only has iconography been restored to an important position in art but that the iconography itself is different.

The "iconography," or lexicon, of postmodernism is the abstraction and reworking — the "personification" — of modernist style itself, so that style is read

through style, with the body of modernism serving as the original text. Remembrance of the past is iconographically integral to the new language of art. Within this general area of agreement, there is an enormous range of play inherent in the new mode, and drawing, with its enormous potential for overwriting, has become a primary vehicle for this postmodern allegory.

But it is not merely a question of shifting the conventions of one medium to those of another. The term "interdisciplinary" applies here to more than the use of "mixed mediums" to create an object that is neither painting nor sculpture nor drawing; it refers to the introduction of elements previously outside those disciplines, and even external to art. Essential to the art of the late twentieth century and to a definition of postmodernism is a balancing act among written language, body language, and visual language (and their popular expression) to which drawing is pivotal. The authorial gesture of modernism is intimately tied to the body, to the expression of individuality as represented by the singular gesture and its aesthetic, and especially to the body in performance. Thus the notion of the body is doubled in current practice, as the body of modern art is read through the human body and as it has become central to the dialogue over modernist techniques and conceptions.

The tendency of twentieth-century artists has been to compress the pictorial space behind the picture plane — the space of illusionism. But paradoxically, as this pictorial space pressed forward, it expelled figures and objects from the well-ordered space of representation, outward, past the surface, and finally encompassed the viewer's space. A vacuum was created, and the numinous space itself became a subject of art, changing the terms of representation and of illusion, as light was absorbed back into the space of representation, re-creating it as an unlimited field. In the late 1960s and early 1970s, this space became the white space of the gallery — the space in which and for which art was created, the space that set the terms. The problems of representation grew into an ever-livelier artistic game, in which the threatened disappearance of the figure from the picture was often a kind of hide-and-seek, with the figure sometimes present and sometimes displaced to play the role of spectator. The displaced figure became both object and subject of the work as, in its process, it ultimately referred back to and mirrored the behavior of that figure. Thus, a phenomenological space, one of sensation, became integral to art.

The authorial gesture involves a paradox in that it is also viewed as the first concrete expression of concept, as mind taking precedence over hand. The conceptualization, or "mechanization," of the gestural mark has been a vital sign of late twentieth-century art, as the notion of originality that traditionally inheres in gesture-making has, ironically, itself become a convention. One aspect of this derives from the tension between hand and mind that Marcel Duchamp extracted from Cubism. Another lies in its relationship to language and also to body language, not only as a characterization of Abstract Expressionism as "participatory aesthetics,"[3] but in its extension in performance art. Yet another aspect of the mechanization lies in

its response to the ready-made image, a child of Duchamp as well as of the collage aesthetic projected by Max Ernst.

These are all graphic inventions vital to twentieth-century art that created a new sense of drawing, which is now composed of all of these languages. From Jackson Pollock to Joseph Beuys, drawing as a form of semiautomatic "occult" gesture has been fundamental to this process. It placed the body center-stage in a new representational mode. Drawing and painting became extensions of the body in performance; the body itself was a living sculpture; and photography became its document of authenticity, establishing the actuality of what had transpired.

The conceptual mode of drawing, which isolated line as an abstraction, treating it as meaningful on its own terms, dominated the 1960s and early 1970s. One of the most radical instances of the use of line as a conceptual device was in the work of Piero Manzoni, who, using a mechanical device, generated a line as long as the circumference of the world and enclosed it in a can. By 1968 several artists had made the conceptual line and the grid the basis of their art. These artists expanded both the scale and the arena of drawing through the generation of autonomous line, the use of nondescriptive line as a modular unit, and the compression of gesture. The expansion of scale and the isolation and concentration on line as a subject in itself had the effect of catapulting drawing, formerly relegated to a minor supporting role in art, into a major autonomous role.

Through the use of the grid, Sol LeWitt enlarged the scale of drawing and transferred it onto the wall to take over the space of the environment itself. It was, in its way, a culminating moment for formalism, which had defined "high" modernism as the isolation of those means peculiar to each discipline. A major determinant in a new conception of space, based ultimately on Cubism's reinvention of pictorial space, the grid was now projected in three dimensions. Minimalism was an art of three-dimensional objects arranged in a space projected from the "notational" concerns of drawing — of diagrams and plans — and of linguistic descriptions.[4] This emphasis on the notational became a major factor in Minimal and Conceptual art, so major that it detached itself into a separate mode. And in the 1970s as the mark itself and the process by which it was made came to be more and more the subject of drawing, the graphological and conceptual functions of drawing merged.

But at the same time something else was involved; LeWitt made language the basis upon which his drawing was projected. In his large site-specific drawings the written directions formed a text that was both dependent and independent; one had to be read through the other. LeWitt's was a "participatory aesthetic" — the instructions were handed over to be performed by others, connecting the Minimalist aesthetic to performances. The grid was the concrete form on which the word-game was played out. As the grid "disappeared," becoming something that was understood rather than apparent in the work, it formed an "erased" ground on which other ideas could be projected (as sinopia had historically formed the basis for murals). It had always been a ground over a ground, in any case; it left an opening

for allegorical reading and a new conception of space and its use. The exhibition itself became a work of art and an art form. LeWitt's recent colored-ink wall drawings (page 17) are murals projected from his earlier drawings, connecting his past with his present. These are no longer discrete grids drawn like the sinopia ghosts of frescoes. They are now frescoes, axonometric drawings representing three sides of solid geometric forms. These forms are not contained by the framing edges of the wall. As they spill over its edges, as if fighting off a state of entropy, they are cut off and become fragments. Thus these new wall drawings are virtual allegories of the relationship between themselves and his earlier work. At the same time they represent the appearance in his work of the coloristic painterly impulse that came to the fore in the 1980s. LeWitt continues to use the grid as a constant ground of origination, but he now takes advantage of a paradox inherent in overly logical systems: a tendency to illogic. He layers the "logical" grid over an "illogical" structure deduced from it. This "extended life of the grid" results not in "self-imitation" but in repeated acts of imitation.[5]

The expansion of the field in which drawing operates means that the autonomous, hierarchically structured object so important to modernism has been displaced. In an era of fragmentation, overwhelming plenty, and a welter of information and images offered by the media, art works in this expanded field, and in it allegory has come to play a major role. In 1980 critic Craig Owens placed allegory at the center of postmodernism. He wrote: "Appropriation, site-specificity, impermanence, accumulation, discursiveness, hybridization — these diverse strategies characterize much of the art of the present and distinguish it from its modernist predecessors. They also form a whole when seen in relation to allegory, suggesting that postmodernist art may in fact be identified by a single, coherent impulse."[6] Defining allegory and its place "*within* works of art, when it describes their structure,"[7] Owens cites Northrop Frye's definition of allegory as a structure in literature, in which "one text is *read through* another, however fragmentary, intermittent, or chaotic their relationship may be; the paradigm for the allegorical work is thus the palimpsest."[8] This is the text written over an original that has been erased, as when Robert Rauschenberg made a drawing by erasing a work by Willem de Kooning, leaving as his own work the marks of the eraser (a gesture comparable to Duchamp's painting a mustache on a reproduction of the Mona Lisa). Allegory may thus be seen as "essentially a form of script."[9] Although Rauschenberg's gesture was, in one sense, meant to clear the field, to push de Kooning into the past, in fact he was working over the past — redeeming it (one impulse of allegory being to act in the gap between the past and the present). As Owens noted, "Allegory first emerged in response to a . . . sense of estrangement from tradition . . . [and it has the] capacity to rescue from historical oblivion that which threatens to disappear. . . . Allegorical imagery is appropriated imagery; the allegorist does not invent images but confiscates them. . . . And in his hands the image becomes something other. . . . He does not restore an original meaning that may have been lost or obscured. . . .

Rather, he adds another meaning to the image. If he adds, however, he does so only to replace; the allegorical meaning supplants an antecedent one; it is a supplement."[10] In works of art this new meaning finally replaces the original one, overriding it, even obscuring it. Formally, it is equally important that it is "consistently attracted to the fragmentary, the imperfect, the incomplete,"[11] and that as it confuses genres, aesthetic mediums (for example, its mix of the verbal and the visual), it is itself "synthetic, crossing aesthetic boundaries. This confusion of genres, anticipated by Duchamp, reappears today in hybridization, in eclectic works which ostentatiously combine previously distinct art mediums."[12]

Thus the mechanical and its capacity to appropriate images from every sector of the world is at the center of the importance of allegory to current art practice. In this regard, Pollock represents a critical point of reference. His expansion of gestural line raised the stakes on automatic drawing, making it ritualistic and depersonalized, its mark mechanistic despite the apparent spontaneity of his process. The mechanical then intervened decisively in the art of Jasper Johns and Robert Rauschenberg (and others of the Pop generation) in the form of ready-made imagery — first in stencils and the conceptual reorganization of the Abstract Expressionist gesture and then in the form of the appropriation into drawing and painting of printed matter and print techniques.[13] Rauschenberg's *34 Illustrations for Dante's Inferno* (1959–60) were a brilliant marriage between found representation and the conventions of gestural abstraction. The ready-made images were cut from magazine illustrations and transferred to the drawing sheet by frottage — rubbing with a pencil. They appeared out of the pencil's scrawling marks as a form of ghostly projection, ironically juxtaposed with the mechanistic marks of which they were the product.

Printing (and photography by implication) was thus brought in as an essential component, and the mechanical became a look — an aesthetic in itself. One aspect of this photographic intervention was projection, the contrast between light and shadow that made the outline to be traced. It was the crux of the mechanical look and was responsible as well for facilitating the use of identical serial imagery and for equalizing the relationship between the mark and its support in conformity with its graphic models. In early Pop images outline drawing was appropriated into painting as a form of ready-made, a mechanical stereotype that rejected the cliché of drawing as graphological autobiography. Pop art was the first style to be based on graphic language and mechanical intervention. Pop paintings were initially third-hand graphic translations, pseudomechanical "reproductions" of drawings (and photographs) made large. Pop art used the graphic as a convention to bring together painting, photography, printing, and drawing in one mode, equalizing not only the support and the mark but also the hierarchies of subjects, mediums, and ultimately of styles, combining them in a new language. Going beyond collage's juxtaposition of fragments, the transparency of projection combined with silkscreen made it possible to bring images into still more surprising conjunctions, as it created layers of multilinear stories, among them the story of the revival of "dead" modern styles.

*Tilted Forms with Color Ink Washes
Superimposed.* April 1987

Installation view, Whitney Museum of American Art,
New York

Sol LeWitt was born in 1928 in Hartford, Connecticut.
He received a B.F.A. from Syracuse University in
1949. After completing military service he moved to
New York in 1953 where he worked as a graphic
designer for seven years. From 1960 to 1965 LeWitt
worked in the bookstore and as a night receptionist
at The Museum of Modern Art, where he met the art
critic Lucy Lippard (a library assistant), and artists
Robert Mangold, Dan Flavin, and Robert Ryman (then
guards). His first one-man exhibition of painted wood
constructions was held at the Daniels Gallery, New
York, in 1965. The following year he made the
first of the serial sculptures that became icons of
Minimalism. His work was subsequently featured in a
number of the exhibitions that defined the movement:
Multiplicity, The Institute of Contemporary Art, Boston
(1966), *Primary Structures*, The Jewish Museum, New
York (1966), and *The Art of the Real*, The Museum of
Modern Art, New York (1968). LeWitt was also a cen-
tral figure in the development of Conceptual art, pub-
lishing two influential statements on it in 1967 and
1969 in *Artforum*, and exhibiting work in such key
exhibitions as *When Attitudes Become Form*,
Kunsthalle, Bern (1969), and *Information*, The
Museum of Modern Art (1970). In 1968 at the Paula
Cooper Gallery, New York, LeWitt made the first of
more than 580 wall drawings. During the late 1970s
he also worked extensively in photography, catalogu-
ing "found" grids and serial compositions in the built
environment. In 1976, with Lucy Lippard, Pat Steir,
Carl Andre, and Edit deAk, he founded Printed Matter,
the first organization dedicated to the publication,
sale, and exhibition of inexpensive artists' books.
Among LeWitt's most important one-man exhibitions
during the past fifteen years are a retrospective at
The Museum of Modern Art (1978), a retrospective
of wall drawings from 1968–84 at the Stedelijk
Museum, Amsterdam, and the Wadsworth Atheneum,
Hartford (1984), a show at the Musée d'Art Moderne,
Paris (1987), and a retrospective of wall drawings
from 1984–88 at the Kunsthalle, Bern, and the
Wadsworth Atheneum (1989). He has also exhibited
in the Venice Biennale (1976, 1978, and 1988), and
in the *Biennial*, Whitney Museum of American Art
(1979 and 1987). LeWitt lives and works in
Connecticut and Italy.

With no need for the reasonable connections of language proper, outline drawing
based on projected images made it possible to create allegories, layers and layers of
images requiring no explanation but their presence: the text was implicit in the tech-
nique. The purely visual had taken control of narrative and made a pictorial lan-
guage of allegory.

Allegory is abstraction personified, a universal idea portrayed by particulars.
And perhaps modernism has had a "potential" allegorical subtext all along — the
allegory of imitation, as a "structural possibility inherent in every work."[14] This was
intimated as early as 1939 by Clement Greenberg, when he speculated that in its
reflection on its own processes modernism was imitating itself.[15] But if we accept
one of the distinctions between modernism and postmodernism as that in which alle-
gory ceases to be an "aesthetic error," and comes to be a structural premise of con-
temporary art, then Pop art, Minimalism, Conceptual art, Happenings, Fluxus, Arte
Povera — all those movements of the 1960s and those that dominated the 1970s —
must be re-examined as possibly participating in what Owens has called an allegor-
ical attitude — if not in allegory itself.

In the mid-1970s the outside world was brought home very strongly to America
in the form of withdrawal from the Vietnam War. A crisis in confidence in the United
States coincided with the reopening of the New York gallery system to European art,
which acknowledged the presence of a strong and growing international art scene —
initially of Italian and then, especially, German art. The interaction had existed for
some time but had been dominated by the American voice. Now it was rebalanced,
and Europeans once more influenced Americans. Artists traveled back and forth,
showing with greater frequency; Europeans worked in New York, and some
Americans lived for a time in Europe. Politics and social conditions became overt
subjects of art, as well as providing the impetus for new formal solutions.

Joseph Beuys and Cy Twombly rank as two of the more important influences on
the European scene and in its transcontinental extensions. Beuys was very much a
part of the performance movement, with its bias against the self-sufficient object,
and saw the active role of art as social, while Twombly affirms the validity of paint-
ing as a vehicle for poetic transcendence. Although distinctly different, nevertheless
they share a common understanding of drawing as a language of its own and as a
language of origination. For Twombly, as for Beuys, the act of drawing, as well as
the drawing itself, is allusive, composed of fragments that must be reconstructed by
the viewer in order to construe its meaning. Each however takes his mark and its
reading in a different direction, both interpretations being central to current practice.

Twombly, born in the United States, has lived in Italy for many years. For him
the work of art is a testament to sensual power that is inherent in the mark itself. In
his hands drawing has become the essence of the work, the physical gesture as an act
of love, of homage to a history and civilization which has left only its ruins, its
heroes, and their poems and stories. Twombly's work constitutes a "sensual body"
through which many texts are read; each work consists of the fragment of a physical

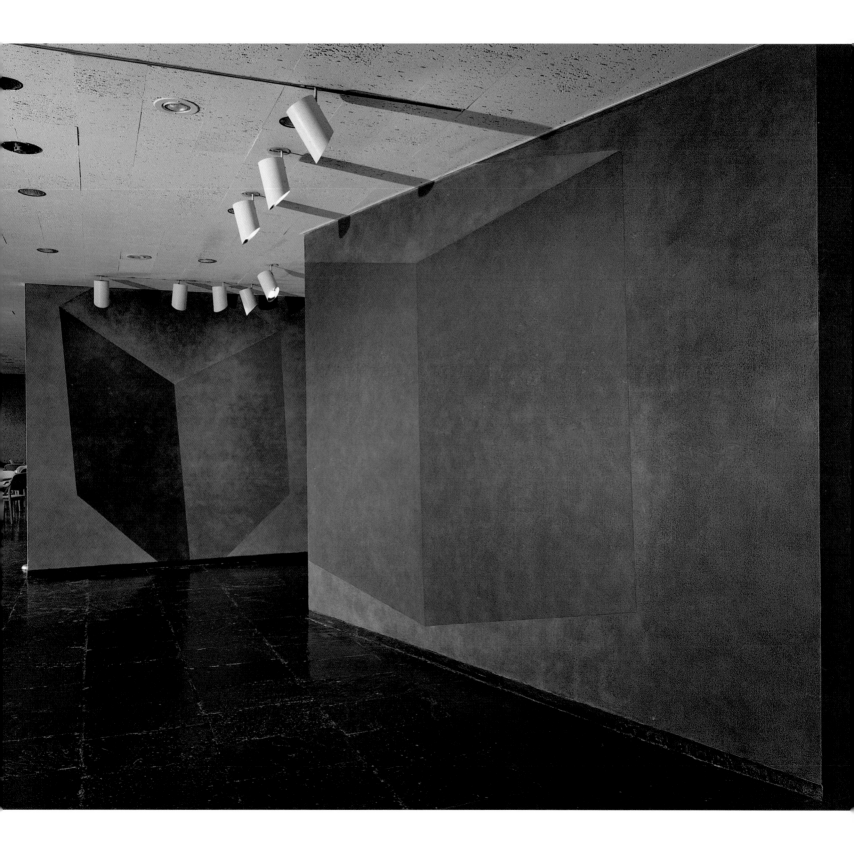

JÖRG IMMENDORFF

Brandenburger Tor Weltfrage [*Brandenburg Gate Universal Question*]. 1981 (Detail)

Pencil and watercolor on paper
No. 2 of 37 sheets, each 27 ⅞ x 23 ½"
(70.5 x 59.7 cm)
Galerie Michael Werner, Cologne

Jörg Immendorff was born in Bleckede, Germany, in 1945. He was educated at the Kunstakademie, Düsseldorf, between 1963 and 1968, where he studied stage design with Teo Otto and took classes and participated in Actions with Joseph Beuys. From 1966 to 1970 he carried out a number of political-artistic demonstrations under the invented name LIDL. While living in West Berlin in 1976 he met A. R. Penck (then living in Dresden), with whom he later collaborated on exhibitions and other activities aimed at bridging the gap between East and West. Immendorff began the extensive Café Deutschland series of paintings in 1976–77. Since the late 1970s he has been active not only as a teacher in the arts, but also as a member of the Green political party. He opened the Café La Paloma in Hamburg in the late 1970s; it became a center for gatherings of artists in that city during the 1980s. Immendorff was included in *Documenta 7* and *8*, Kassel (1982 and 1987), *Zeitgeist*, Martin-Gropius-Bau, Berlin (1982), and *The BiNATIONAL: German Art of the Late 80's*, in Germany and the United States (1988). His work has been exhibited in one-man shows at many museums and galleries in Europe and America including the Kunsthalle, Bern (1980), the Kunsthalle, Düsseldorf (1982), the Stedelijk Van Abbemuseum, Eindhoven, and the Kunsthaus, Zürich (both 1983), and the Museum of Modern Art, Oxford (1984). Immendorff has also produced a number of books, including *Brandenburger Tor Weltfrage [Brandenburg Gate Universal Question]*, with a poem by Penck, which was published by The Museum of Modern Art, New York, in 1982. Immendorff lives and works in Düsseldorf.

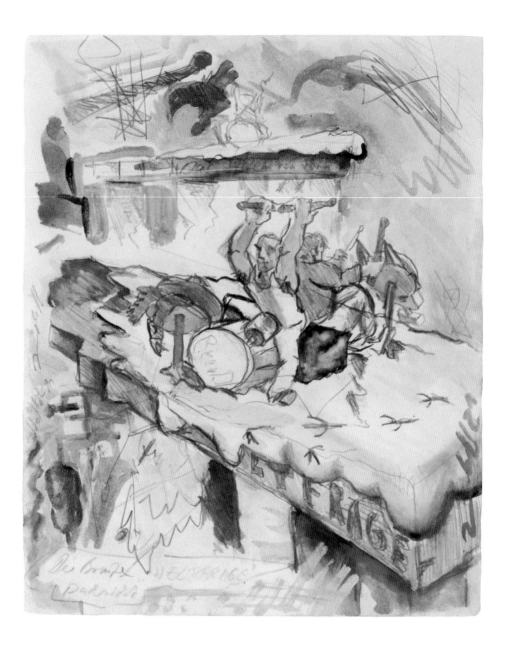

gesture. All of Twombly's work moves through drawing and painting; his touch is constantly diversified, whether by the richness of color, density, or sensitivity. His is a line of tension, wiry, "electrified," often retaining the vestiges of handwriting seeming to struggle toward verbalization. Twombly's mark is a sign; it speaks of distance and of frustrated desire, the desire to possess the sensual body through the fragment.

Beuys, on the other hand, a native of West Germany where he taught at the Düsseldorf Academy, was also responsible for a new attitude toward drawing — especially its new position in "major" work. For Beuys drawing was the ideal instrument for conceptualization and therefore for invention and instruction; it was also a form of autobiography and, very importantly, a form of freedom. It was an instrument for creating a revolutionary dialectic between art and life. In his hands (and in

the hands of the Pop and Fluxus generation) the terms of modernism were transformed, as the adoption of Actions (performances) changed its spatial and structural configuration, fundamentally transforming its very premises — a culmination of the twentieth-century interest in process rather than product. Beuys was thus at the threshold of the modern and the postmodern, when the forms of modernism had all but run out of meaning. By force of circumstance he had eluded the modernist aesthetic in which form is the primary content and relied instead on representational drawing, placing iconography at the center of his work. As he assumed an ethical stance, transforming the literal content in his prolific drawings to social allegory in his Actions, he delivered modernism's own radical antisocial aesthetic to the "social body," which Beuys conceived of as a work of art in itself. In this process the role of his drawings was redefined so that they became the building blocks of his all-encompassing "Social Sculpture."

In one way or another, following Beuys, German art has been a politicized art. At times it has been pictorial and conservative, as in Jörg Immendorff's *Brandenburger Tor Weltfrage* [*Brandenburg Gate Universal Question*] (page 18) in which he portrays himself sitting with A. R. Penck on the Brandenburg Gate in Berlin as Penck plays the drums that send a signal to the East. At its most compelling it is also part of a formal solution, as the motivation informing the structure of the work itself is socially driven.

After Beuys a new kind of drawing emerged that, like his drawing, extended the serial concept but was usually executed in an expressive and psychic mode: the making of many drawings on many pieces of paper, in a kind of stream of consciousness, in which no single drawing is more important than any other, and as though drawing obsessively and automatically could somehow be a form of control. This use of drawing is a model for postmodernism's preoccupation with the "unfinished" artwork — the fragment as opposed to the finished art object. It ultimately connects with the participatory aesthetic, with performance, Happenings, and Actions as models of the gestural, the unfinished, the artwork that extends in time. It also connects drawing as a language to allegory and an increasing tendency to re-create the structure of art as if it were a linguistic system.

By the 1980s a new interest in gestural and painterly handling, often combining with conceptual concerns or overtaking them, was apparent. The collage aesthetic, too, remained strong as the primary vehicle of the mechanical mark and the admittance to art of reality and representation. The debate over the death of painting (or more precisely of the autonomous object, which must include sculpture and other mediums as well) grew more intense, despite the fact that, like the death of the novel, it was old news. It seemed to many artists — especially younger ones — to have already happened so long ago as to form a "remote past, and a desire to redeem it for the present,"[16] bringing forth the fundamental conditions for a true allegory of modernism itself. Appropriation and shifting referents, "copying" the original and changing its context, thus changing its meaning while still alluding to the original

SIGMAR POLKE

Paganini. 1982

Synthetic polymer paint on fabric
6' 6 ¾" x 14' 9 ⅛" (200 x 450 cm)
Thomas Ammann, Zürich

Sigmar Polke was born in Oels, Germany (now Olesnica, Poland), in 1941. His family fled to Thüringen in 1945, and in 1953 emigrated to West Germany, eventually settling in Düsseldorf. Polke studied glass painting from 1959 to 1961 before entering the Kunstakademie, Düsseldorf, where he studied under Karl-Otto Goetz and Gerhard Hoehme. In 1963 he joined Konrad Lueg (Fischer) and Gerhard Richter to announce a movement called *Kapitalistischer Realismus* [*Capitalist Realism*], which began with a one-evening exhibition in a rented storefront in which the artists sat on pedestals surrounded by pieces of furniture, film reels, and other objects. Three years later he won the German Youth Art Prize. In 1969, with Chris Kohlhofer, he made a film titled *. . . Der ganze Körper fühlt sich leicht und möchte fliegen* [*. . . The Whole Body Becomes Light and Would Like to Fly*]. In 1970–71 Polke was a guest teacher at the Hochschule für bildende Künste, Hamburg, and in 1972 he moved to the Gaspelhof in Willich. During the early 1970s Polke concentrated on various photographic projects, including a series on beggars, some made during a 1974 trip to Pakistan and Afghanistan. In 1977 Polke was appointed Professor at the Hochschule für bildende Künste, Hamburg, and a year later moved to Cologne. Polke's work has been widely exhibited. It was included in *Documenta 5, 6,* and *7,* Kassel (1972, 1977, and 1982), *A New Spirit in Painting,* Royal Academy of Arts, London (1981), *Zeitgeist,* Martin-Gropius-Bau, Berlin (1982), *An International Survey of Recent Painting and Sculpture,* The Museum of Modern Art, New York (1984), and the Venice Biennale (1986). Among his most recent one-man exhibitions are a retrospective of drawings at the Städtisches Kunstmuseum, Bonn (1988), an exhibition of photographic work at the Staatliche Kunsthalle, Baden-Baden, and a traveling retrospective of paintings and drawings organized by the San Francisco Museum of Modern Art (1990–91). Polke has received numerous honors for his work, including the Will Grohmann Prize of Berlin (1982), the Kurt Schwitters Prize of Hannover (1984), and the Golden Lion Prize for Painting at the Venice Biennale (1986). Polke lives and works in Cologne.

and all that is known about it, are characteristic of the 1980s. This differs from "being influenced" in that often there is little or no attempt to disguise or transform the original source, or else that source is left bare and transparent as the ground for the new.

As the ambition to revitalize painting began to overshadow other practices, the conception of drawing as the generator of images became important, especially for pictographic work, or "sign" painting and drawing, such as Penck's, and for multilayered-image painting, such as Sigmar Polke's.

Polke has adopted a new attitude toward subject and style, which renders distinctions between traditional modes irrelevant. His new strategy, based on an old illusionist game, the reflection of light, is nevertheless an experimental attitude toward art-making that sets the terms for much contemporary work. Like a number of other artists, he works on several mediums simultaneously; the artist's career is no longer represented by a smooth development in a single medium or style over the course of time. In Polke's work (pages 21, 22, and 25) the mechanical and the hand-made interact, producing a virtual catalogue of current practice. As he works simultaneously in several disciplines he creates a new montage-based aesthetic out of a number of disparate, often contradictory modes and historical antecedents, utilizing the interpenetration of different means and techniques of representation: the figurative and the abstract, the mechanical and hand-drawn, the printed and the photographic, the painting and the drawing, the automatic, the deliberate, and the accidental.

On his larger canvases (and on the stitched-together printed cloth that he often uses as a support for large paintings) as well as in his photographic work, Polke's drawing becomes apparent as a major subject of his art. Included in the term "drawing" are his various graphic modes as well as the graphic impulse and conception in which the interplay between eye and mind, hand and "mechanism," light and material all play a part. Polke's drawing practice has been fundamental to the change in the structure of art and to the new attitude toward drawing in relation to current practice. He starts with an outpouring of drawings on paper, which he produces parallel to his paintings both as studies and as autonomous drawings, and finishes in quite another place.

Polke turned the small Beuysian drawing away from the transcendental and romantic, with its appeal to the universal, and began to use Pop images to make ironic, corrosive, and politically motivated jokes. The images in Polke's drawings, like those of Roy Lichtenstein and others, are copied from advertisements in popular magazines and other printed sources. His early drawings are intentionally unartistic outsider work that goes beyond the degraded images of its models, beyond the cartoon style, burlesquing its sources. The term "outsider" usually denotes the art of the "primitive," the mentally ill, or the disenfranchised; and Polke's "naughty" adolescent drawing and collage verges on the maniacal, while claiming innocence. He

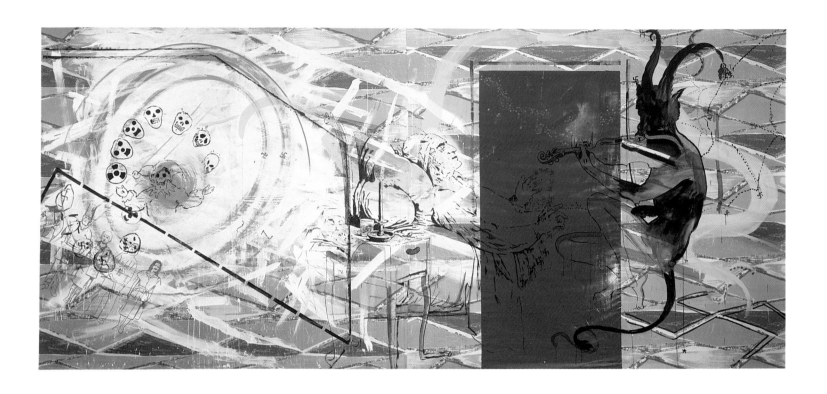

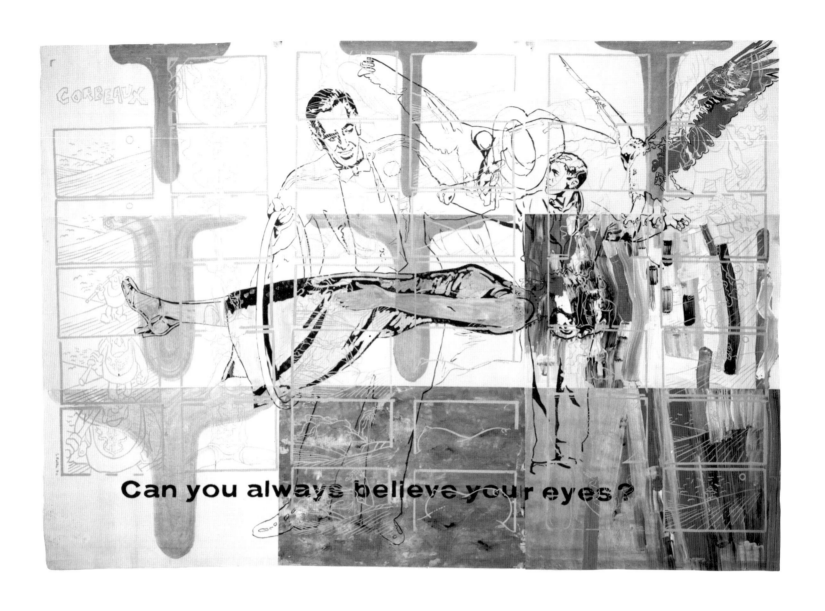

reverts to early modernism, to Dada, and even to its predecessor in Alfred Jarry's burlesque classic of reversion, his proto-Dada play *Ubu Roi*. The vehicles of reversion are the collage aesthetic, the ready-made image, the drawing in comics and advertisements, and the late Surrealist schizophrenic style of Francis Picabia's transparencies. An important European precedent for Polke's early collage-style narrative was Oyvind Fahlström's creation of a disjunctive satirical narrative out of cartoon images. In Polke's work these are used to comment on the German condition, about which he can be both savage and funny.

Polke's depictions are not fond parodies like so much American Pop art; he is confrontational and provocative. Early in his career he shared the same conceptual stance as two other emigrés, Gerhard Richter and Konrad Lueg (Konrad Fischer), with whom he collaborated on a project called *Kapitalistischer Realismus* [*Capitalist Realism*] in which they delighted in subverting the painting culture using the mass culture of advertisements through savage parodies. These probably seemed overwhelmingly bizarre both in their dangerous banality and their ubiquity — as bizarre as the preciousness of painting. Polke's early drawings are quite deliberately drab, on the cheapest pulp paper; they are "dumbly egalitarian,"[17] reflecting the naiveté and poverty of hicks from the East looking at the riches of the West. Polke is a master of the mechanized mark. Even his early small, rather loosely drawn drawings could be described as psychologically mechanistic; the second-hand aspect of his received imagery leads to second-hand marking. The mixing of drawing, painting, photographic and print techniques, and the random procedures involved in all of them are hallmarks of his early style that continue to the present. So also is repetition — a concept he borrows from the mass media — the reuse of the same images over and over until they seem to be emptied of specific meaning, resuscitating them through double entendres and asking, "Does meaning create relationships or do relationships create meaning?"[18]

Polke is a figurative artist, but because of his mode of drawing his figuration often borders on abstraction (it works abstractly as well as figuratively for compositional purposes), and he can operate both figuratively and abstractly, subjectively and objectively, in the same work. He also apposes figuration — the subject portrayed and the ostensible subject of the picture — with the material and with technique, which is in fact the formal subject of the picture. Polke is not concerned solely with the delineation of contours; he is also interested in the profile of line itself and uses it interchangeably as object, contour, and line of direction. He is especially interested in volume and the limitless layers of flat spaces that open, linear "overlay" drawing produces. Uniting his drawing and painting processes, Polke often seems to make painting out of drawing writ large — thus, he can have a limitless space and still refer to the flat, modernist picture plane.

In earlier large-scale drawings, Polke had drawn rather loosely with a brush; and this technique has been transferred to canvas, where the line, together with thin paint washes — transparent, though viscous, varnishes and amorphous undelineated

SIGMAR POLKE

Can You Always Believe Your Eyes? 1976

Mixed mediums on paper
6' 9 ½" x 9' 8 ⅞" (207 x 297 cm)
Crex Collection, Hallen für neue Kunst,
Schaffhausen, Switzerland

SIGMAR POLKE

Artaud: Two Drawings. Late 1970s

Mixed mediums on paper
53 ½" x 7' 10" (136 x 239 cm)
Collection Josef W. Froehlich, Stuttgart

forms — often remains within the bounds usually ascribed to watercolor. Polke is interested in material and its effects. In his large, recent "wash" paintings the light comes from within; the support as a source of light is one of the key factors in creating the effect of light and volume. He remains an artist linked to the material and nonmaterial dimensions of his discipline, to the given as well as the invented, to the mundane as well as the cosmic. Thus Polke may be experimental and open-minded in his handling of materials while holding to a strict conceptual limitation in his choice of images. Like Richter, his primary reality is painting itself.

Polke's early paintings, enlargements of reproductions, beginning as early as the 1960s, depended upon photographic projection. This had the effect of enlarging the dot matrix of the print sources that he used (as did Lichtenstein) — to the point at which the dots became abstract and operated as subjects in themselves. In his *Rasterbilder* (screen-process pictures), he blew up the dot matrix and corroded its edges, destroying the integrity of the image. Some of his earliest pictures are a conjunction of conceptualist rigor with Magritte-like surrealistic juxtaposition of images. In these paintings he was (like Andy Warhol) clearly interested in imitating not only the mechanical mark as a system, but the equality of subjects and of mark and ground that the visual effects of printed graphics produce. With the use of the dot matrix two codes, iconographic and material, merged. This destruction of the image, however, and the focus on its component parts (an interest shared with Richter) as well as its alienation from its sources was unlike anything in Pop art in America, as was his later interest in the ephemeral effect of light, in how to reproduce it and its changes in paintings and in paint itself.

In Polke's work the linking of new modes of information with traditional painting relies on the transparency of projected light. In drawing from a projection, the edge of the light area creates a silhouette that is traced; an aesthetic based on projection is therefore necessarily dependent on outline drawing. Like early Pop paintings, many of these silkscreen canvases seem like large drawings in which the hand-drawn contour is as interesting as the graphic quality of the ground marks over which it is drawn. Basic to Polke's strategy in making these varied elements work is the transparency that comes from outline drawing and the layering it engenders. He returns consistently to this strategy involving juxtaposition and apposition as he relies on photographic projection for the registration of images and, conceptually, as a structuring device — indeed, as an aesthetic in itself. In fact, as his interest in process and material transformation became more important, he temporarily ceased drawing as such to work with photographic means, drawing on the photographs and manipulating its techniques — marking them in process, as well, and using them as "drawings."

If there is an elusive coherence to Polke's structure, despite the diversity of its images and variety of mediums, it is attained through this manipulation of light, the factor that controls all photography, video and cinema, and ultimately all reproductive modes. Many of Polke's images are structured in imitation of the television

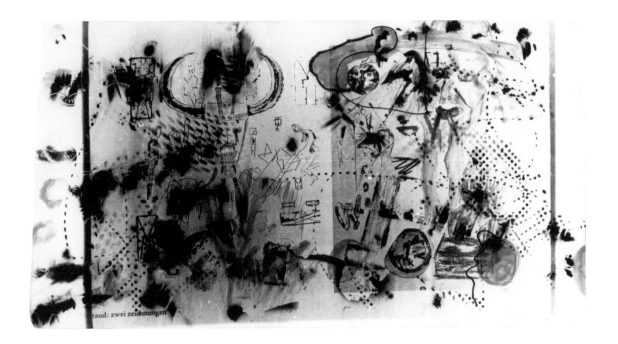

taud: zwei zeichnungen

screen in which we are given unlimited images from everywhere. In Polke's work this creates a juxtaposition of different worlds as images slide over and around one another in overlapping spaces. A time-space warp is created through this light path in which unrelated events may be linked without apparent logic. The images received are — or may be — simultaneous with events that they record, or an instantaneous "magical" relationship may be established between things widely dispersed in both time and space. As a result all things may seem familiar and the familiar made exotic as the artist conceives of himself as a medium — a receiver or transcriber of images and impulses.

Polke's initial interest in photographic imagery had been in the facility with which a photographic image selects, transposes, and isolates a segment of reality from the continuous fabric of the world. But like Duchamp and Beuys before him, Polke dabbles in magic and alchemy, and he seems to have become fascinated with the transformative processes inherent in photography, montage, and the possibilities of manipulating images through them. From that eventually came an interest in light as a "medium."

Indeed, if the primary subject of all painting is light, with Paul Cézanne reversing the role of light in twentieth-century art from that of reflection off the surface of objects to light that emanates from the support (as drawing takes its support for granted as the source of light) to establish a new sense of space and placement, Polke may be said to have changed the function of light in painting yet again. His technical

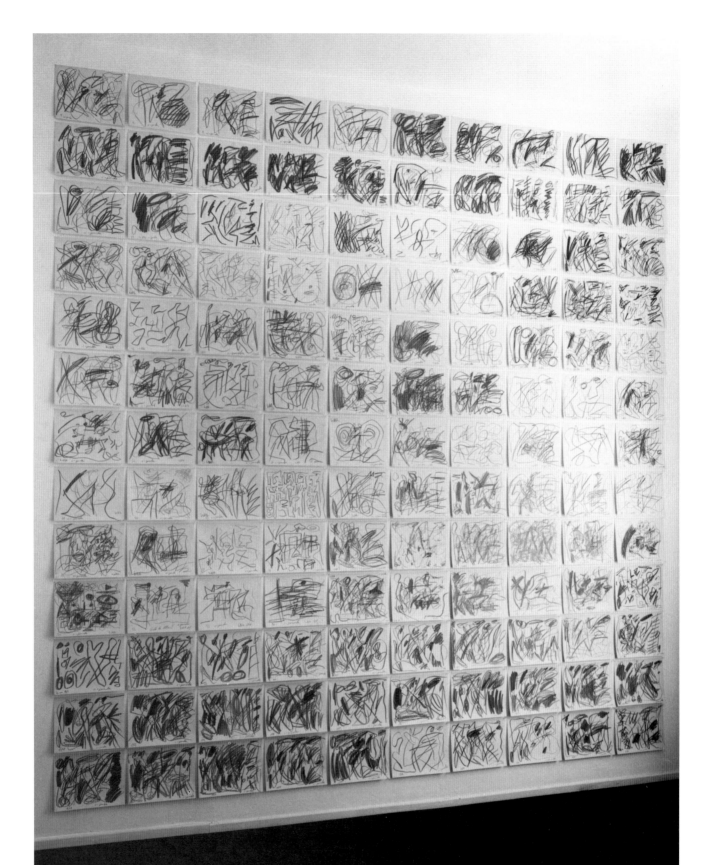

experimentation carries over the chemical process of photographic development into painting. Taking the light from the support as a given, he makes it a function of alchemy, transposing it from his initial interest in projected light and light implied in photographic processes to light and transparency in paint; to an interest in color; and to the deliberate introduction of its ephemeral, aleatory physical effects into painting through chemical changes in paint itself, making paint and light one medium. Polke now uses materials that, as they are exposed to light, slowly develop and continue to change over the life of the work, coloring or fading independently of the artist's will. Through this process chance and time become subjects of the work, and the two codes, the material and the iconographic, again cross as Polke arrives at a new sense of light in painting and a new kind of painting.

There is, similarly, an intersection of the political and the aesthetic in Polke's work. Its disjunctions mirror the political situation of Germany up to 1990, when the Berlin Wall was torn down. The constant crossing of codes is also symptomatic of the peculiarly postmodern phenomenon of fragmentation: pictorial organization tantamount to a political act. Polke confronts this fragmentation, which, despite the unification of Germany, continues to be "the daily madness, with the wit of a formal solution."[19] The double reading imposed by Polke's montage aesthetic contains the threat of dissolution inherent in its double reading as it refuses the illusions of a fixed system of representation and the reading of time as sequential. The double reading extends in two directions, collapsing time along the way: one to the source of the image, "the fragment perceived in relation to its text of origin," and the other to its incorporation "into a new whole, a different totality,"[20] as even montage creates a new whole from its fragmentary components. Postmodernist critics argue that the totalizing vision of modernism is inherently repressive. If it takes (or seems to take) the modernist position, can art speak of freedom? In the formal solution, the culminating masterpiece, the totalized vision of painting goes out the window; and painting, like drawing, is conceived of as a fragment in itself, part of a larger set of fragments alienated from their sources, which find continuity in the exhibition setting as part of the terms in which they move from the studio to the marketplace.

And for Polke the exhibition has become a form of discourse, regarded as an entity in which reality is reconstructed as an allegorical cross-reference of ideas, people, and places the artist has portrayed; of paintings, drawings, and photographs he has made; and of new ones produced to fit them all together for the occasion. As traditional drawing became unneccesary for him a new vocabulary and aesthetic had already taken over. It rendered representation as *functionless*, that is, without specific iconographic meaning; it reconstructed meaning out of a welter of images in a methodology of chance encounters that proceeded according to the famous conjunction invented by the Comte de Lautréamont (Isidore Ducasse) and celebrated by the Surrealists: "the chance encounter of a sewing machine and an umbrella on a dissecting table." Reality itself is dissolved through the transparency of light into a series of fragmentary, only contingently related temporal episodes, what has been

A . R . P E N C K

Welt des Adlers [*World of the Eagle*]. 1981 (Detail)

Pencil on paper
130 of 472 sheets, each 11 ⅞ x 15 ¾"
(30 x 40 cm)
Galerie Michael Werner, Cologne

A. R. Penck was born Ralf Winkler in Dresden, Germany, in 1939. Rejected by the art academies of Dresden and East Berlin in 1955, he began an apprenticeship as a designer in 1956, and had his first exhibition of paintings in Dresden. His 1957 works on the theme Rembrandt Reconstructions were followed approximately three years later by the first of the Stripe Men—bold hieroglyphs of striding figures that treat themes of conflict and domination. Stimulated by his reading between 1963 and 1965 about new developments in mathematics, physics, and cybernetics, he painted the first of his World Pictures. In 1966 he first formulated the idea of "Standart" (combining standard and art), a personal philosophy of the relation between art, the mind, and society, which he elaborated in later statements and publications. In 1969 Penck first exhibited at Galerie Michael Werner, Cologne, an important showcase for German art since the 1960s, using the pseudonym "A. R. Penck" (after the geologist Albrecht Penck). Following his participation in *Documenta 5*, Kassel, and his first exhibition of drawings in the Kunstmuseum, Basel, in 1972, Penck was drafted into the army but dismissed a year later. He was awarded the Will Grohmann Prize in 1976, and in the same year moved back to Dresden. His first sculptures in wood were made in 1977. Penck emigrated to West Germany in 1980, settling near Cologne. In 1989 he was appointed Professor at the Akademie der bildenden Künste, Düsseldorf. Since the early 1980s Penck's work has been widely shown in group exhibitions in Germany and abroad, including *A New Spirit in Painting*, Royal Academy of Arts, London (1981), *Documenta 5, 7, and 8*, Kassel (1972, 1982, and 1987), *Zeitgeist*, Martin-Gropius-Bau, Berlin (1982), *An International Survey of Recent Painting and Sculpture*, The Museum of Modern Art, New York (1984), the Venice Biennale (1978 and 1984), and in many one-man exhibitions, often accompanied by concerts, at the Kunsthalle, Cologne (1981), the Nationalgalerie, Berlin, the Kunsthaus, Zürich, and the Kestner-Gesellschaft, Hannover (1987). Penck lives and works in Dublin, London, Düsseldorf, and Cologne.

A . R . P E N C K

TM. 1974–76 (Detail)

Ball-point pen and watercolor on paper
Six of twenty-four sheets, each
approximately 16 ⅝ x 23 ⅜"
(42.2 x 59.5 cm)
Galerie Michael Werner, Cologne

Top, left to right:
Untitled, *Spaltung* [*Split*]

Center, left to right:
***Weisse Stiefel* [*White Boot*],**
Oder Fettecke von Beuys: Sun
***Arise* [*Or Fat Corner by Beuys*].**

Bottom, left to right:
***Fernseher* [*Television*], Untitled**

called in another context, "a rush of filmic images without density."[21] And the transparency in mechanical, multiple image-making processes had also created the conditions for a newer, still higher reality, operating in a new space. If on the one hand the images are without density, infinitely manipulable as they dissolve into one another, on the other hand their dissolution repositions them, placing them in a limitless prelogical field whose operations are anarchic and psychologically mechanistic, and in which the phantasmagoric rules, preparing the way for nonrepresentational painting. Polke has said about his images, relationships, and methods, "It is not I who have thought them up but *they* which have made themselves felt in me."[22]

Like Polke, A. R. Penck emigrated from East to West in a divided Germany. Since 1974 his work has gained steadily in prominence and is now as widely known as that of Beuys, although his drawing practice is totally different from that of the older artist. Its premises originate in lack of freedom, lack of space in which to work, lack of free exchange with like-minded colleagues and the public, and from working in a "nonsocialist" forbidden mode.

Penck's drawings, executed in long series, are obsessive explorations of thought constantly transforming itself (pages 26, 29, and 30); his syntax is the course of line traveling between the formed and the unformed — a code with its structure projected as sequence. He transforms the notion of seriality, making it into a doubly focused tool for confrontation between the natural and the abstract, putting himself at the center of the debate that rages over the ideological premises embodied in each; repression on the one hand and freedom on the other are its operative distinctions. Repression is portrayed as inherent in the old appeal to instinct, as represented in the German Expressionist tradition, whereas freedom lies in the ability to abstract, to analyze, to stand away from instinct with its infantile and repressive demands and its calls to national identity.[23] Penck's is a syntax of figuration stretching out to transform itself into abstraction and back again; each drawing is a distinct semantic unit, a sign, a hieroglyph. His figures appear out of the process of manipulating the linear armature and planar field of modernism itself, as an aspect of the transformation of thought, or, as he calls them, signals to concrete visual forms. Some of these eventually become abstract signs, creating a parodic visual language that is skeptical of both the natural and the abstract, even as it establishes its credentials as a language by the counterpoint between the two levels of articulation as well as by its reference to other visual languages.

A desire to override the hierarchical relationship implicit in the traditional figure-ground relationship, which is particularly acute in line drawing on a white field, is basic to Penck's aesthetic. In his painting, narrative often moves from clearer forms toward more complex ones. As this happens the figure-ground relationships become more complicated, almost ambiguous, although not as in Pollock's large black drawings on white canvas with which Penck's have been compared. With Penck it is more a question of equalizing the weight of each, of creating the right optical mix. While his line traces itself into a figure, it never quite describes

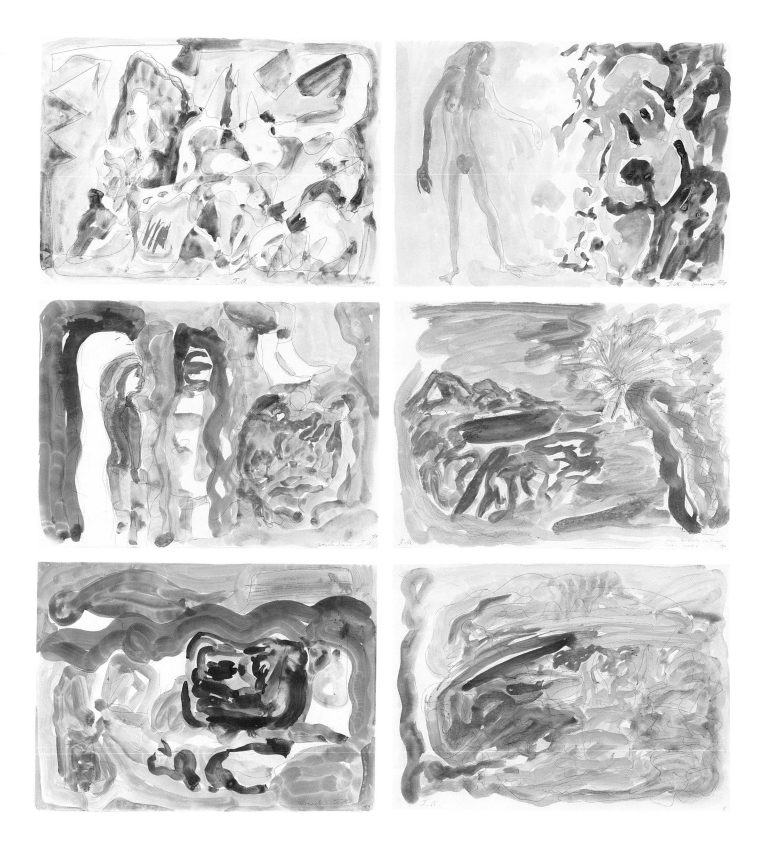

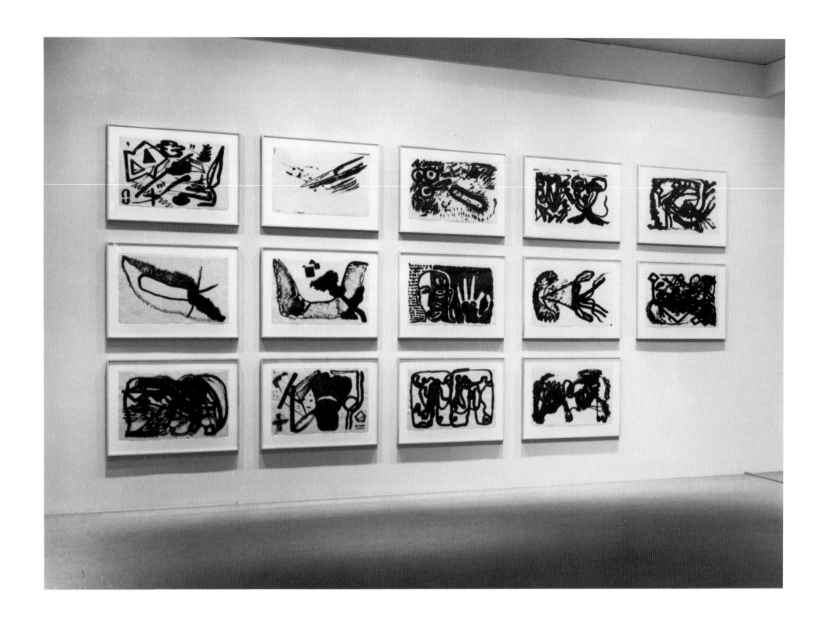

both itself and the changing edge of another adjacent figure; it never quite treads that ambiguous path between describing both the inside and the outside of itself at the same time as it describes a form or an edge in a double entendre on contour drawing. Penck is not a contour draftsman; rather, he reaches for a reciprocity between visual and semantic signs. His pictographs are archetypal, patterned after the symbols found in petroglyphs, via the late drawings of Paul Klee and the stick figures in certain canvases of Pollock, and even more closely in the schizophrenic drawings of the Swiss artist Louis Soutter. Pablo Picasso is quoted as the archetypical artist, and Pollock and Picasso form the parameters of Penck's considerable ambitions. His signs are eclectic and highly idiosyncratic, but socially and historically determined. They are culled from a variety of cultures and disciplines, mathematical and technical as well as artistic, modern as well as

archaic, but removed from direct functional association, as is poetry. He also describes himself almost as a form of scientist; his signs form pseudo-scientific classes. They bring the mark into systematic, nonhierarchical formations.

At the other end of the spectrum from his signs, the extreme end of the range, is the sense of drawing as a kind of scrawling linear energy-field that organizes form out of a primordial chaos produced by automatic drawing. Underlying this attitude is the suggestion of the artist as demiurge, although in the same kind of paradox that treated Pollock's urgent drips as mechanical Penck's automatic handwriting also tends to the mechanical. His signs are part of the mechanistic impulse of his hand, a product of the speed with which he turns out his drawings one after the other, relent-lessly. *Welt des Adlers* [*World of the Eagle*] (page 26) is a series of four hundred seventy-two small, tangled, self-involved pencil drawings created as a series for a book, through which a very long obsessive story constantly repeats itself in seem-ingly endless variations.

In other works color — watercolor — often acts as a sensuous relief, softening the effect of the tense gesture, even when it is most off-key. In fact, Penck's water-colors, in a kind of inversion of Matisse's use of black and white to rest from color, seem to be a rest from black and white (although in the work of both artists black is a color which comprises all others). Penck's sense of scale is oriented to his formats and is governed by a metaphysics of time that finds its realization in a dialogue between continuity and diversity — the unification of the natural and the manufac-tured — to produce the ultimate artifice, the work of art. His drawings and paintings are distinguished not by support alone but by their temporal structures. A series requires a temporal dimension in which to unfold. Yet in Penck's creation of his signs in a parody of a rebus, time is suspended as aesthetic apprehension asserts itself over linguistic reading. The large canvases on which he composes his signs represent an up-and-down, biaxial structural organization, which first demands an aesthetic reading and only afterward invites a linguistic reading.

Penck's sense of arrested time is the projection of a political predicament couched in poetic terms: art as a system for creating signs as urgent signals for per-sonal liberation. Yet if it were only personal or political, his art would be of limited interest. His answer — which like Polke's is a formal solution to his situation — is an artistic confrontation of meaning with deliberate meaninglessness, and irrationality, of the other through parody. Penck's distinctive solution gives a particular edge to the insistence on art as an objectified means of personal communication, to the notion of the artist as anarchist who becomes the architect of his peculiar destiny, organizing his own system as a model for others. As in Abstract Expressionism (which informs Penck's work, as well as that of Georg Baselitz) pictorial organiza-tion becomes moral although perhaps not universal. As a displaced person — a vic-tim and a traveler — he is innocent, worked upon rather than working upon. To confront his history, he must constantly begin over again, tough it out, assert his position, while disguising himself at every turn. Thus formally he relies on a

A . R . P E N C K

Fourteen ink and brush drawings. 1980
Ink on parchment paper
Fourteen sheets, each approximately 16 ⅝ x 23 ⅜"
(42.4 x 59.4 cm)
The Museum of Modern Art, New York
Gift of Ronald S. Lauder

Top, left to right:
Zeitlandschaft im Fluss [*Time Landscape in Flux*], *Die perfekte Illusion?* [*The Perfect Illusion?*], *Mikro O* [*Micro O*], *Angriff Hauptström* [*Mainstream Attack*], *System*

Center, left to right:
Entscheidung am Abend [*Decision in the Evening*], *Krater und Wolke* [*Crater and Cloud*], *T(?)*, *TTT*, *Korrektur des Untergrundes* [*Correction of the Substratum*]

Bottom, left to right:
Fight, Lollipops HH, Lalaby [sic] *of Birthland, T5*

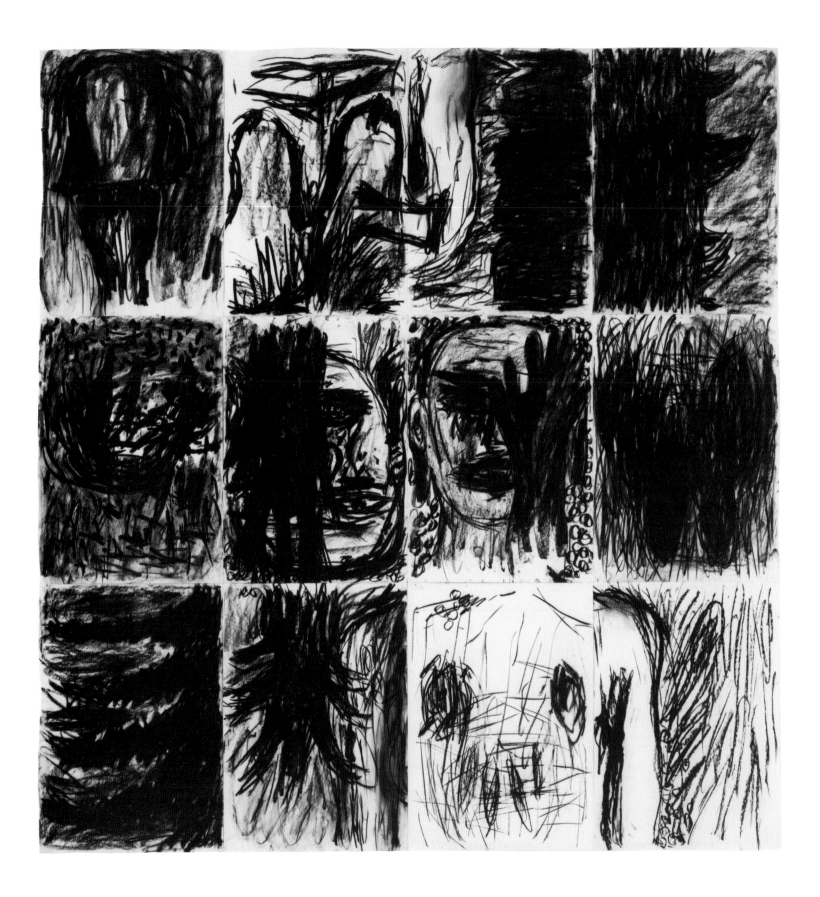

seemingly naive and brutal aesthetic, one that is governed by necessity. Its refinement lies in the distilled urgency imparted to the sign. While his urgent scrawl is associated with writing, it is not penmanship but belongs to another order of expression in which touch is generalized to become systematic and archetypal rather than personal and biographical.

Beuys, a native of the West, had experienced Germany's division as a wound; Penck, caught in the East, might be said to have experienced it as a closed room; and Baselitz seems to experience it as an inversion — the world turned upside down. Although time is a factor for Baselitz as well, the duration of experience is expressed as an interrupted destiny for the individual, as a German, and ultimately as a paradigm for the universal condition. Although his signatory upside-down figural motif is a painter's compositional ruse, it serves to destroy normal expectations of structure. It is a psychologically loaded trick used for expressive purposes that are broadly political in their implications. Contemporary German art is in a sense homeless, in that for most of the time during which it was being created Germany was split.

Baselitz works with "dramatic and overwhelming images"[24] — and he is the closest of any German artist under discussion here to the traditional roots of German art, or at least to twentieth-century expressionism and its drama of paint and heroic strokes of the brush. Baselitz believes in the Nietzschean will to power and its translation into heroic painterly imagery — the artwork, on the material and iconographic level, not simply as "testimony to an overflow of power . . . [but] as . . . an *embodiment and communicator of sensuous and sensual possibility.*"[25] Expressionism could be described as a style that is ruled by line, with the line acting not only as an embodiment of the sensual but as the expressive vehicle for the artist's state of mind as absolute and all-encompassing. But traditional Expressionism entails a belief in the natural as a form of salvation, with a concomitant return to a pastoral idyll of golden youth, that myth appropriated from German Expressionism by the Nazis to build the Third Reich through Hitler's *Jugend*. According to critic Donald Kuspit, the task these German artists have set for themselves is the rehabilitation of German culture — not as a revival as such but as a reclamation for and by contemporary means, and a rejoining of it to world culture and the present.[26] Baselitz's may be the most apparently straightforward, traditional approach in circumstances so distinctly divided that to talk of tradition in that sense is to empty the term of its meaning, unless one understands the tradition as schizoid — split in spirit as in fact. In a critique that Kuspit seeks to refute,[27] expressive paint is regarded as a form of "naturalism," conceived as imitation in the sense that painting apes nature,[28] restoring art to servitude, and making it politically and socially regressive by its very means. Baselitz's situation is one in which he knowingly gains freedom from a burdensome past — however illusory that freedom may be — through the use of regressive means. These means are apparently uncritical physical painting (or drawing) and figuration.

Baselitz has admitted to an important influence from de Kooning, and it is clear

GEORG BASELITZ

***Kampfmotive I* [*Struggle Motifs I*].
March 1986**

Charcoal on paper
Twelve sheets, each 39 ½ x 27 ¾"
(100.2 x 70.4 cm)
Collection the artist

Georg Baselitz was born Georg Kern in Deutschbaselitz, Saxony, in 1938. The painter, sculptor, and printmaker studied briefly at the Hochschule für bildende und angewandt Kunst, East Berlin, in 1956. Expelled for "sociopolitical immaturity," he moved to West Berlin in 1957 where he enrolled in the Hochschule für bildende Künste, and a year later changed his name. In 1961 and 1962, with artist Eugen Schönebeck, he organized two exhibitions, each accompanied by illustrated manifestos titled *Pandaemonium*, in a dilapidated storefront. The exhibitions helped define Baselitz's view of the artist in society. In 1964 West Berlin authorities confiscated two paintings from his first one-man exhibition at Galerie Michael Werner, Berlin, on the grounds of indecency. The following year Baselitz received a fellowship to study in Florence. After his return to Germany, he moved to Osthofen, where he produced numerous paintings on pastoral themes. In 1969 he painted his first inverted images, a characteristic of his later paintings, drawings, and prints. Despite regular exhibitions during the 1970s, including a retrospective of drawings at the Kunstmuseum, Basel (1970), Baselitz's work gained widespread recognition only during the 1980s. It has been featured in *Documenta 5, 6,* and *7,* Kassel (1972, 1977, and 1982), at the Venice Biennale (1980), in *A New Spirit in Painting*, Royal Academy of Arts, London (1981), *Zeitgeist*, Martin-Gropius-Bau, Berlin (1982), *An International Survey of Recent Painting and Sculpture*, and *BERLINART*, The Museum of Modern Art, New York (1984 and 1987), and has been the subject of numerous other gallery and museum exhibitions in Europe and America. Baselitz has also taught, first at the Staatliche Akademie der Künste, Karlsruhe (in the late 1970s), and later at the Hochschule der Künste, Berlin (1983–88). A large exhibition of his sculpture was organized by the Kestner-Gesellschaft, Hannover, in 1987. In 1989 he was honored by the French government with the Chevalier dans l'Ordre des Arts et des Lettres. Baselitz lives and works in Derneburg, Germany, and Imperia, Italy.

India ink on paper
Seven sheets, each approximately 8' 10" x 59"
(270 x 150 cm)
Installation view, Sonnabend Gallery, New York

Jannis Kounellis was born in Piraeus, Greece, in 1936. At the age of twenty he moved to Rome, where he studied at the Accademia delle Belle Arti, and was first exposed to modern art through the works of Alberto Burri, Lucio Fontana, and Jackson Pollock. In 1958, in a rebellion against the stylized, French-derived abstraction then dominant in Italy, he began the first of a number of large paintings on paper of simple signs, letters, and numbers, which he chanted while walking up and down the gallery in his first one-man exhibition at Galleria La Tartaruga, Rome, in 1960. From 1963 to 1965 he produced paintings that elaborated this theme by combining simple words, colors, words for colors, and occasional musical notations. In 1966 Kounellis appeared to turn away from conventional means in a series of *tableaux vivants* with birds and horses, and temporary installations using materials like coal, fire, and cotton. He became the leading figure in Arte Povera, a movement named for its use of commonplace materials, ephemeral installations, and occasionally nomadic artists. In the mid-1970s he began to incorporate copies of fragments of classical sculpture into his installations as part of an increasing interest in mythology and history. Kounellis's work was exhibited in the Venice Biennale (1978 and 1988), *A New Spirit in Painting*, Royal Academy of Arts, London (1981), *Documenta 7* and *8*, Kassel (1982 and 1987) and *Zeitgeist*, Martin-Gropius-Bau, Berlin (1982). Kounellis's first large museum exhibition, at the Museum Boymans–van Beuningen, Rotterdam (1977), was followed by numerous others, including those held at the Städtisches Museum, Mönchengladbach (1978), Stedelijk Van Abbemuseum, Eindhoven (1981), the Whitechapel Art Gallery, London (1982), the Städtische Galerie im Lenbachhaus, Munich (1985), the Kunsthalle, Basel (1986), the Museum of Contemporary Art, Chicago (1986), and the Stedelijk Museum, Amsterdam (1990). Kounellis lives and works in Rome.

in his art that as he worked his way through his "tradition," he was aided by de Kooning's example to guide him through to a new place in which nature is understood as a semblance, not an emotive primitive force or a salvation. His link to de Kooning would seem to be de Kooning's characteristic treatment of the figure as homeless, "ungrounded," or without specific moorings in place or "natural" space, living in paint, emerging from the brushstrokes. However like de Kooning's, Baselitz's color is unnatural, abstract; nature becomes an artistic effect, thus removing it to the sphere of culture. But if Baselitz's endeavor is the restoration of Germany's painting culture, it must imitate that painting's naturalism — its aura of archaism — which it does by reference to the "naturalism" of the brushstroke. Nevertheless it denies the naturalism of its motif by rendering it abstract through the painter's trick of turning the canvas upside down, so as to suggest that the motif at hand is not to be read as any more figurative, or abstract, than any other; it is simply a sign. Thus Baselitz's "voice" changes; it oscillates in a discourse between nature and culture as the very terms of its existence.

Baselitz's drawing is painterly in the extreme. His drawings are made for study purposes and are autonomous as well, with the latter gaining in prominence in more recent work where charcoal has been his medium for large-scale blocks of drawings. He is a superb watercolorist and is at home with a Rembrandtian use of pen and ink for coloristic effect, alternating in early work between drawings of bucolic scenes — sometimes of cows, sometimes of heroic figures in the guise of shepherds. The motif of the shepherd as a sign for Christ is an allegory of salvation that relates to the pathetic fallacy of nature as savior and to the mode of the pastoral and the primitive.

The pastoral mode continues into later work but in the wholly changed setting of homeless representation, as Baselitz takes on the stance of a postmodern painter. There it implies ironic self-awareness on the part of the artist and invites the viewer's empathy with the artist's situation. Translated into ambitious drawing, such as *Kampf-motive I* [*Struggle Motifs I*] (page 32), it becomes transparent as a strategy. The very pathos of the fragmentation and reduction of means played against the heroic brushstroke convey meaning on the plastic level, while the allusions to heroism in the theme (even to the shepherd David and perhaps to his representation in art) invite empathy with the artist as tragic hero and savior, and with his heroic endeavor.

Art historian Benjamin Buchloh has written that the "new European painting is the first international avant-garde in which reverberates the profound influence of American abstract expressionism. What makes Kiefer, Penck, and Baselitz so attractive to Americans (in particular) is that they teach a new art history lesson, one that begins with Picasso and Matisse, passes through German expressionists and the surrealists . . . and then decisively registers the extraordinary impact of Still, de Kooning, Kline, and Pollock."[29] Buchloh's observation targets an important aspect of past art as it is used in current art, even though it is meant pejoratively. (He called the resurgence of "handcrafted luxury objects" in art, under the banner of nationalism, an "aesthetic mirage which as with all colonialized representations and

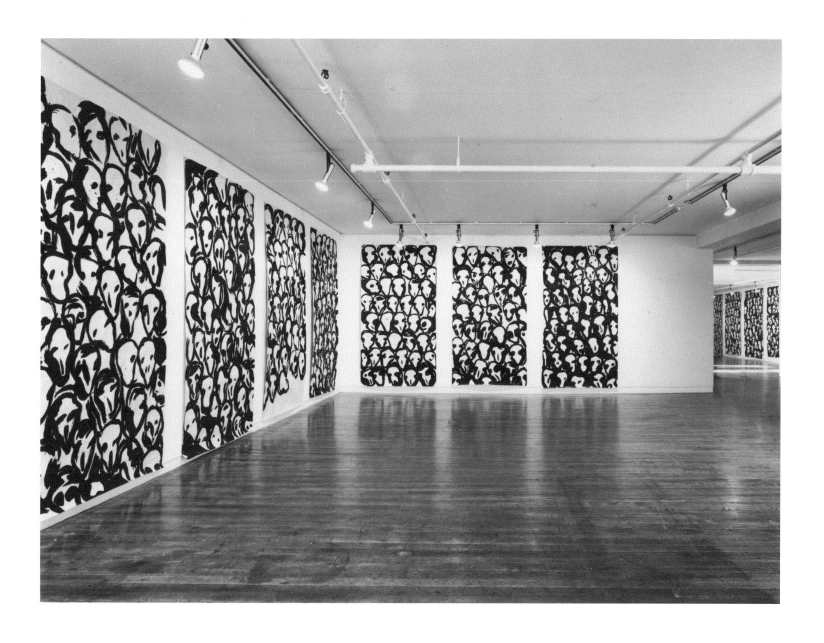

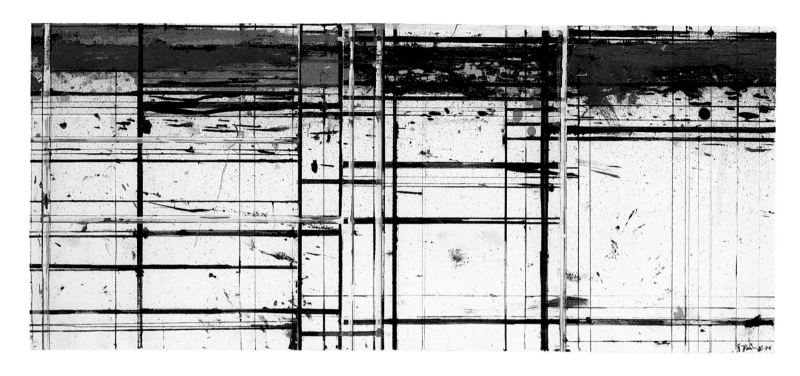

BRICE MARDEN

Masking Drawing 20. **(1983–86)**

Oil and ink on paper
14 x 32 ⅞" (35.7 x 83.5 cm)
Anthony d'Offay Gallery, London

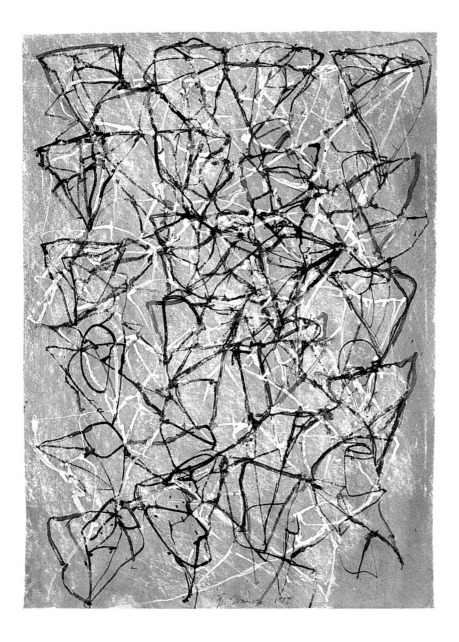

BRICE MARDEN

Drawing for Conjunctions. 1988–89

Ink and gouache on paper
16 x 11 ¾" (40.6 x 29.8 cm)
Private collection, New York

Brice Marden was born in Bronxville, New York, in 1938. He studied at Florida Southern College, Lakeland, Florida, in 1957–58 and in 1961 received a B.F.A. from the School of Fine and Applied Arts, Boston University. He spent that summer at the Yale Norfolk Summer School of Music and Art, Norfolk, Connecticut, and in 1963 received an M.F.A. from the School of Art and Architecture, Yale University, New Haven. In the fall of 1963 Marden came to New York City and was hired as a guard at The Jewish Museum, where he saw the work of Jasper Johns. His first one-man exhibition was held in 1964 at the Wilcox Gallery, Swarthmore College, Pennsylvania. From the mid-1960s to the early 1980s his work was composed of single or multiple color panels executed in encaustic and grouped in series. The Backs (1968), Grove Group (1972–76), Annunciation (1978–80), and Thira series (1979–80), are key series of this phase. Marden returned to working in oils in 1982. A major transformation occurred in his work during 1985–86 when he began to make gestural works that invoke oriental calligraphy. These culminated in the Cold Mountain paintings, drawings, and prints of 1987–90. During the early 1970s Marden taught painting at the School of Visual Arts, New York, and the Skowhegan School of Painting and Sculpture, Maine. Marden's work has been exhibited in a number of large group exhibitions, including *Documenta 5*, Kassel (1972), the *Biennial*, Whitney Museum of American Art, New York (1973, 1977, 1979, and 1989), *Drawing Now*, The Museum of Modern Art, New York (1976), *A New Spirit in Painting*, Royal Academy of Arts, London (1981), and the *Carnegie International*, Museum of Art, Carnegie Institute, Pittsburgh (1985, 1988, and 1989). One-man exhibitions of his work have been organized by The Solomon R. Guggenheim Museum, New York (1975), the Kunstraum, Munich, and the Institut für Moderne Kunst, Nuremberg (1979), the Stedelijk Museum, Amsterdam, and the Whitechapel Art Gallery, London (1981), and the Musée d'Art Moderne, Paris (1986). In 1991 the DIA Center for the Arts, New York, organized *Cold Mountain,* a large exhibition of paintings, drawings, and prints. Marden lives and works in New York and Greece.

hierarchies and myths of individual freedom . . . emphasized the cultural legitimization of nationalism as an essential feature of . . . individualism.")[30] In Buchloh's estimation, the current art in question is regressive because it imitates the old means of production, the creation of painting, drawing, and sculpture as the self-sufficient consumer object, the "image" of the culture of "excellence,"[31] which escapes (or seeks to escape) its economic function. The mission of art is thus to operate in the social realm, taking account of its own manipulation by the media and by repressive social structures and turning them on themselves. Polke and Gerhard Richter fulfill this requirement, according to Buchloh, and represent one pole of current practice. Baselitz and Penck are two of the figures at the opposite pole of this critical discourse. However, as it evolves (and embraces younger artists as well), this critical conflict may not be as diametrically oppositional in its artistic strategies as proponents at each end claim.

In 1980 two extraordinary series of drawings emerged, both by artists in the Italian milieu: Jannis Kounellis's Untitled (page 35) and Francesco Clemente's series of eighty-two pastels on Pondicherry paper (see pages 62 and 65). The appearance of two such series at virtually the same moment creates an opportunity to see a contemporaneous situation in terms of two artists of different generations. Kounellis's drawings are heroic in scale, on large sheets of brown paper cut from rolls and pinned to the wall; Clemente's are tiny but are also pinned to the wall. Each is made up of several sets, to be shown set by set, or preferably, especially in the case of Clemente, as a whole. Kounellis's work is engaged in one form of theatricality, Clemente's in another. For while they appeared at the same time, the work of each is qualified by the necessities of his own generation. Nevertheless Kounellis's work must be read as fundamental to Clemente's, but not to Clemente specifically. Kounellis is an artist who emerged in the 1960s, and his attitude stands at the threshold of postmodernism, slightly anterior to Clemente's concerns; it is the legacy that Clemente and his generation inherit. For these reasons I will take up Kounellis's work first and Clemente's in further detail later.

Allegory and theatricality work together. Performance and the gallery as theater are at the heart of Kounellis's work, as they have been at the heart of much work since the 1960s, making the exhibition form itself the artwork. An essential aspect of Kounellis's performance is his sense of himself as a traveler, a migrant from his native Greece to Italy. Greece was a fragmented, invaded civilization of ruins, and Kounellis moved from the region of the conquered to that of the possessor. His own life thus takes on an allegorical significance as he moves through space and time; he (and others), like Beuys, regards the artwork itself as a nomadic form and time as nonlinear. Fragments of installations are carried from place to place, their placement and relationship changing each time. (Kounellis's sense of the fragment as a genre originated in his participation in the 1960s in the Arte Povera movement, for whose aesthetic the fragment was the essential component.)

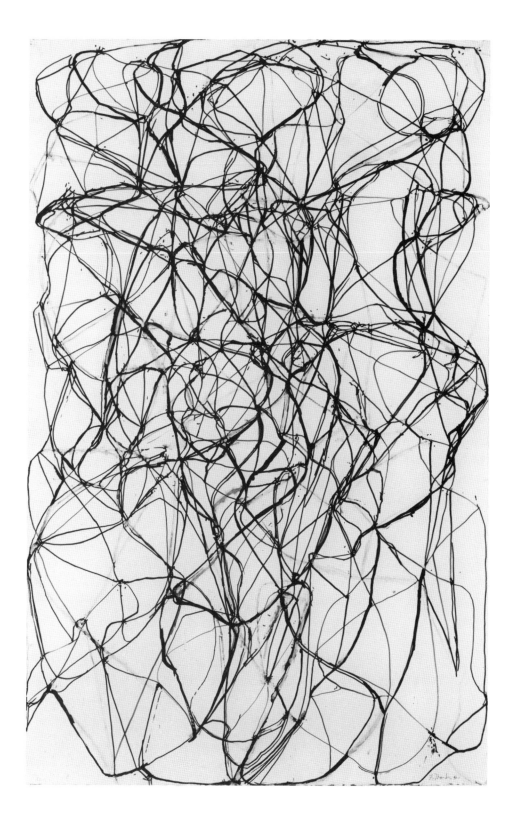

BRICE MARDEN

Venus. 1990–91

Ink and gouache on paper
40 x 25 ½" (101.6 x 64.8 cm)
Private collection

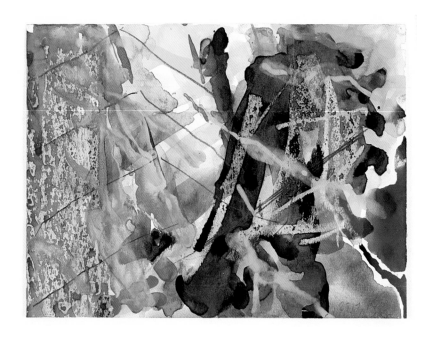

GERHARD RICHTER

G.E.L.S. 1984

Watercolor and graphite on paper
7 x 9 ½" (17.8 x 24.1 cm)
Collection Laura and Marshall B. Front

Felsenlandschaft [Stony Landscape]. 1984

Watercolor and graphite on paper
15 ¾ x 11 ⅞" (40 x 30.2 cm)
David Nolan Gallery, New York

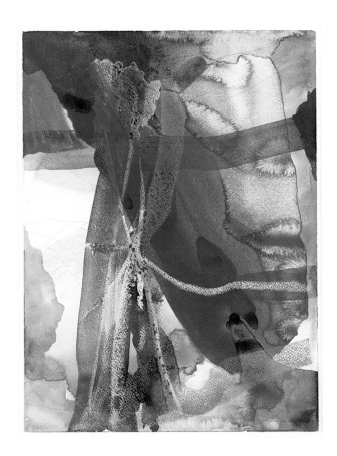

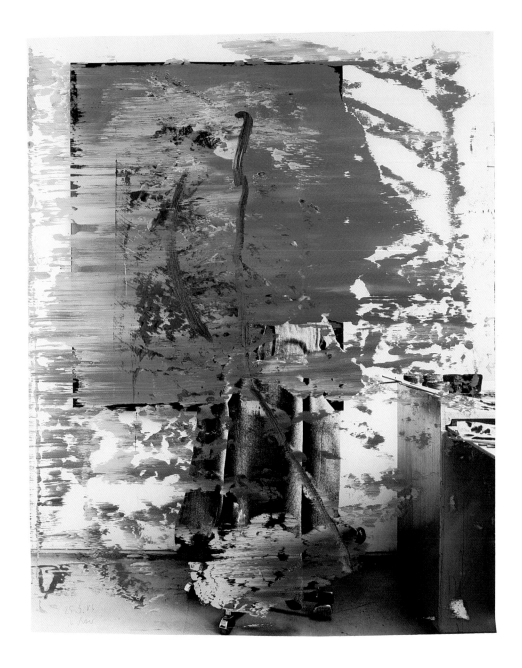

GERHARD RICHTER

25.3.86 (Self-portrait). 1986

Oil on photograph
39 ½ x 23 ¾" (100.3 x 60.3 cm)
Matthew Marks Gallery, New York

Gerhard Richter was born in Dresden, Germany, in
1932. After working as a scene painter for a theater
and a sign painter in a factory in his late teens he
entered the Hochschule für bildende Künste,
Dresden. Trained in the Social Realist style, he first
worked on official commissions, including public
murals. His interest in Western art and controversy
over his own work led him in 1960 to emigrate. In
1961 he enrolled in the Kunstakademie, Düsseldorf.
A year later he destroyed his early work and in 1963
joined with Sigmar Polke and Konrad Lueg (Fischer)
to form a movement called *Kapitalistischer Realismus*
[*Capitalist Realism*], which began with a one-evening
exhibition in a rented storefront in which the artists
sat on pedestals surrounded by pieces of furniture,
film reels, and other objects. In the same year the
artist made his first "photographic" paintings based
on illustrations in popular magazines. In the late
1960s and early 1970s he added subjects like color
charts and city views, and painted "finger paintings"
and "cloud studies." In 1976 he made his first
"abstract paintings." Since 1971 Richter has been
an influential teacher as Professor at the
Kunstakademie, Düsseldorf; in 1978 he was Guest
Professor at the Nova Scotia College of Art and
Design. Among the large international group exhibi-
tions in which Richter has participated are
Documenta 5, 6, 7, and *8,* Kassel (1972, 1977,
1982, and 1987), the Venice Biennale (1978 and
1984), *A New Spirit in Painting,* Royal Academy of
Arts, London (1981), and *An International Survey of
Recent Painting and Sculpture*, The Museum of
Modern Art, New York (1984). In addition to numer-
ous one-man exhibitions at galleries and museums
around the world, Richter's work has been honored
with the Oskar Kokoschka Prize of Vienna. An instal-
lation of his portraits is on permanent view at the
Museum Ludwig, Cologne. Since 1973 Richter has
lived and worked in Cologne.

The seven untitled drawings from 1980 have been variously installed, sometimes with one of Kounellis's fire sculptures, and their number has not always been constant. As Thomas McEvilley has written, "The politics of Kounellis's work lies in its constant pointing to the loss of social totality and the need to regain it within history — the themes wrapped in a tight seed in his use of fragments."[32] An inner iconographic coherence is apparent in Kounellis's work; the assembly and re-assembly of the work is a metaphor for the constant dissolution and reconstitution of the social structure, which is inherent in his Greek psyche. The stacked heads in these drawings relate to his sculptures of stacked stones, with their theme of blocked vision. As he piles stones up to block doors and windows, fragments of classical sculpture are the repeated icons of Kounellis's oeuvre. The fire pieces, torches which leave the trace of smoke, refer to man as both the primal artist and the modern fabricator. The stones themselves allude to the ruins of civilization, the classical head to the death of humanism. In the ghastly heaping of death's-heads, the stones are transformed into a barrier of skeletons that not only blocks vision but returns the stare from empty eyes or from those that are themselves sightless. The loss of social wholeness may be inferred by a cyclical historical process relating not only to modern times but back beyond them to Greek tragedy. In this sense, the drawings are sculptural models; they are not drawings of sculpture, nor studies, nor even drawings alone, but serve as a subtext to the stone sculptures, forming a parallel construction that is a combination of what Kounellis calls "structure," or inorganic form, and sensibility, which to him is organic presence. As McEvilley notes with regard to another of Kounellis's structures: "The situation is an allegory for human presence within an unforgiving causal structure."[33]

Kounellis presages in a more classically distanced and poetic manner the sense of tragic drama that Anselm Kiefer would like to convey with regard to Germany's past; allusion to visions of the Holocaust are inescapable. Kounellis is older and also belongs to a much older tradition, and he is displaced — albeit voluntarily — from one long dead, historically shattered civilization to the site of another. His allegory is based on multiple layers of fragments, created of metaphor and allusion, smoke and substance. Kounellis is an initiator of the present represented as profoundly melancholy, perhaps because he is trapped in a romance with the fragment, "the ruin, which [Walter] Benjamin identified as the allegorical emblem par excellence. . . . 'In allegory the observer is confronted with the *facies hippocratica* [countenance at the time of death] of history as a petrified, primordial landscape. Everything about history that, from the very beginning, has been untimely, sorrowful, unsuccessful, is expressed in a face — or rather in a death's-head. And although such a thing lacks all "symbolic" freedom of expression, all classical proportion, all humanity — nevertheless, this is the form in which man's subjection to nature is most obvious and it significantly gives rise to not only the enigmatic question of the nature of human existence as such, but also of the biographical historicity of the individual. This is the heart of the allegorical way of seeing.'"[34]

Brice Marden's primary interest is in the mark, and he too meditates on nature and culture and spends time in the Mediterranean and Caribbean regions contemplating their flora and fauna. Marden's work (pages 36, 37, and 39) is deeply steeped in visual culture; for some time he has been interested in both Chinese calligraphy and Pollock. His drawings consist of those begun in front of the landscape, others from observation of shell patterns and branches, and still others from calligraphic sources, as contemplations or studies of the things themselves. There are also studies for paintings drawn from these sources. Then there are autonomous, "finished" abstract drawings that do not begin from direct study of nature, although like the others they are drawn with sticks and twigs from trees. The twigs he uses are varied in thickness, determining the mark by their flexibility and the amount of ink they can carry. Marden invites and uses accident by this method. More recently he has deliberately distanced his hand from his drawing, using a long stick in emulation of Matisse working on the drawings for the chapel at Vence. Marden notes, "By getting farther away, with a delicate instrument . . . in a way it becomes closer . . . the slightest move is reflected."[35] Borrowing from painting, he corrects with white gouache and more recently with other colors, constructing several layers of connectives. His drawings are worked in series, although not always systematically; those that emerge from sketchbooks tend to build, sheet by sheet, to a climax.

For Marden, despite the similarities in his drawing and painting, drawing is about the first experience. In a recent interview he said: "A painting is about refinement of image. . . . Drawing is more fugitive. It's like little scribbles. . . . These [drawings] are not pictures of specific places or things . . . they're about particular places and inspirations. . . . For me, drawing is about the state that the person would be in who's standing in the drawing looking at the mountain, it's about sensing that. I find that interesting about the Chinese . . . paintings and drawings evolved in a kind of inspired state. . . . There's usually somebody in the picture undergoing some sort of experience, or on a pilgrimage towards an experience. They depict it, I'm depicting it in another way."[36]

Marden's early work was a process of the layering of paint to make densely material layers that covered the surface of his work; tending to gray and absorbing light, they asserted surface and material over space. He had for a long time paralleled these works with open calligraphic drawing; recently this became the basis for a new style. In these drawings and in the paintings for which they are studies and parallel thoughts, layering becomes a metaphor as well as a process. The monochromes of his earlier work have been transformed with the translucent ground for the overlays of his loose abstract "grids," as one aesthetic recedes to form the stage for another. It is as if the edges of his early rectangles are now multiplied into a calligraphic grid of rectangles, each an obsessive amplification of the one preceding it, each work elaborating the process of the paintings being produced in series as though they were drawings.

Marden has noted that he imposes a kind of grid structure — probably implied by the gridlike structure already inherent in the motifs he chooses, whether calli-

BRUCE NAUMAN

Model for Animal Pyramid II. 1989

Cut-and-taped photographs
7' 8 ½" x 61" (235 x 160 cm)
The Museum of Modern Art, New York
Gift of Agnes Gund and Ronald S. Lauder

Bruce Nauman, sculptor, printmaker, draftsman, collagist, video artist and filmmaker, performance artist, and creator of environments, was born in 1941 in Fort Wayne, Indiana. He received a B.A. in art from the University of Wisconsin, Madison, though he first studied mathematics. After receiving an M.F.A. from the University of California, Davis, in 1966, he created his first sculptures, performances, and films. His first one-man exhibition, which featured fiberglass sculpture, was held at the Nicholas Wilder Gallery, Los Angeles, in 1966. During that year Nauman made several films and taught in the summer at the San Francisco Art Institute. In 1968 he had his first New York one-man exhibition at Leo Castelli Gallery, where he has since exhibited regularly. In the same year he received a grant from the National Endowment for the Arts to make videotapes. Nauman taught sculpture at the University of California, Irvine, in the spring of 1970 and received a summer grant from the Aspen Institute for Humanistic Studies. Nauman's work was included in *Documenta 4, 5,* and *6,* Kassel (1968, 1972, and 1977), the Venice Biennale (1972), and the *Biennial,* Whitney Museum of American Art, New York (1977, 1985, and 1991). In 1972–73 a major one-man exhibition was organized by the Los Angeles County Museum of Art and the Whitney Museum of American Art. In 1981 the Rijksmuseum Kröller-Müller, Otterlö, the Netherlands, organized a retrospective of his earlier work. The following year his neon reliefs were shown in a one-man exhibition at The Baltimore Museum of Art. In 1986 a large traveling retrospective of his drawings was organized by the Museum für Gegenwartskunst, Basel. In 1990 he was awarded the Max Beckmann Prize at the Städelschen Kunstinstitutes, Frankfurt, and a large traveling exhibition of his sculpture and installations was organized by the Kunstmuseum, Basel. Since 1979 Nauman has lived and worked in New Mexico.

graphic or natural. He manipulates both the inherited and imposed grids, bringing them together. The grid is not about the language, nor is it about writing or trying to make a language; rather, Marden returns the grid to calligraphy and calligraphy constantly to its source in nature, and round about again, in a constant discourse between nature and culture. For Marden, "If the form is resolved, it's beautiful. . . . Maybe beauty is too easy. It doesn't deal with . . . political issues or social issues. But an issue that it does deal with is harmony."[37]

Gerhard Richter, too, has approached the question of the beautiful, that is to say the world as a sensuous body. Richter, like Polke (and Bruce Nauman) has brought together conceptual, mechanical, and painterly concerns in work particularly involved with an interrogation of reality as imitation, as it is mediated by photography and a peculiar notion of verisimilitude to appearance. Polke and Richter seem to share certain root preoccupations; despite different solutions, both are still concerned with painting as a medium for transcendence. According to Richter, "If we describe an event or give an account or photograph a tree we are creating models without which we would be animals. Abstract paintings are fictive models because they show a reality that we neither can see nor describe, but whose existence we can surmise. . . . Accustomed to recognizing something real in pictures, we rightly refuse to recognize only color in all of its variety as the represented and instead allow ourselves to see the ungraspable, that which was never seen before and which is not visible. This is not an artful play but a necessity because everything unknown frightens us and makes us hopeful at the same time. Of course, figurative painting has that transcendental character too. The less 'function' representation has, the more forcefully it shows the mystery because every object as part of an incomprehensible world embodies this."[38]

Thus Richter seems to be concerned with establishing the reality of painting as painting itself, in light of the notion that (as Susan Sontag has written in another context), "a painting, even one that meets photographic standards of resemblance, is never more than the stating of an interpretation, a photograph is never less than the registering of an emanation (light waves reflected by objects) — a material vestige of its subject in a way that no painting can be."[39]

Richter, also from East Germany, has described his total lack of familiarity with modern German art, that is to say German Expressionism. He has also described his early training in Socialist Realism. His first contact with modern art, after he had left Dresden for Düsseldorf in 1961, was with Abstract Expressionism, then with Pop art; both were (and are) basic to his art, which is also governed by reproductions, photography, and projection onto the canvas. Like Polke, he has worked with deliberate limitations; his subjects are "Socialist Realist," although at one remove, which renders them all abstract and therefore not viable as Socialist Realism. This puts him in position to deal with a new idea of reality in painting and of perception. Richter's career is one of a deliberately cyclical interchange of styles and genres (abstraction and representation), worked in distinct series, as a systematic catalogue through the

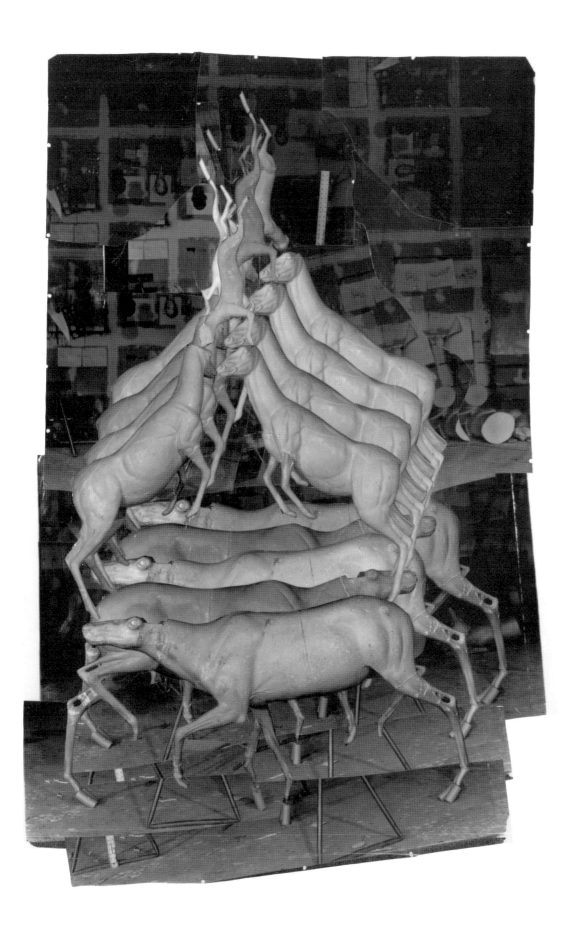

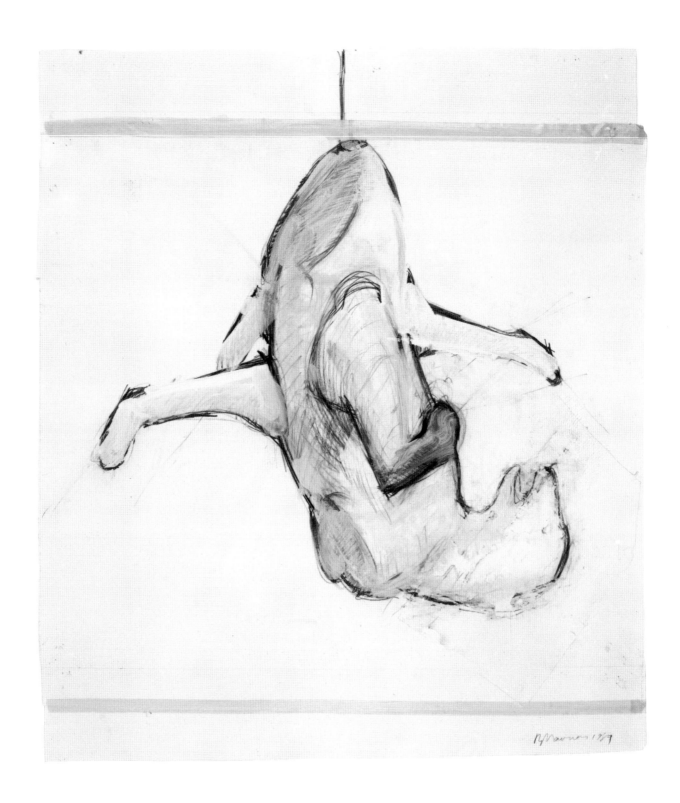

limits he has imposed on painting. All, however, have been based on projection, or on a dialogue with reproductive techniques and drawing. Photography is a fundamental part of Richter's system of information, of appropriating images, and of distancing himself both from nature and his hand, just as drawing is his fundamental means of making use of the information. Thus Richter is both consumer and producer. The opposite of Polke's phantasmagoria, Richter's approach is systematic and almost matter-of-fact, "neutral" in its obsessive examination of his modes.

Richter's paintings have characteristically begun with drawing, sometimes with sketches done freehand onto the canvas, or more usually by drawings traced from projected photographs; often an assistant will make the first tracing. His technique changed in 1967–68, when he introduced an abstract series painted without the intervention of projection, probing increasingly into the nature of painting itself. His first watercolors were used as "photographic" images, motifs to be projected onto canvases for abstract paintings. Richter has been ambivalent about his hand, and for a long time he created very few independent pencil drawings; in his painting and especially in his abstract series he has deliberately depersonalized it. In these paintings he uses the edges of large boards to pull the paint across the canvas, imitating brushstrokes. He has rarely shown his drawings, and only in 1983–84 did he "have the confidence" to make his first independent watercolors (page 40). These are a conflation of painterly and photographic means — an outgrowth of his concerns with surfaces and appearances as they depict the reality of painting in terms of color. Richter mediates two realities, the trace of reality that resides in photography and what is for him the reality of painting (see page 41). This concern with the nature of perception and its materialization in painting carries through all the mediums in which he works; small watercolors and other small pictures provide him with its details. The close examination of the structure of his painting yields layers of still greater detail and luminosity. He works through the superimposition of different realities — photograph, pencil drawing, watercolor, and painting — and then back again to constantly re-examine the structure of the details.

The intense polychrome range of the watercolors is analogous to high-key process color. They are small — the early ones no larger than large photographs, and the watercolor and ink are for the most part poured rather than brushed onto them. The allusion is to Pollock's late puddled drip paintings, but the method is not gestural and expressive; although automatic and accidental, it is "mechanical," "photographic," pseudoscientific, while at the same time absolutely traditional. The manipulation of wash in these watercolors involves a pseudoscientific process of investigating how the medium will behave, how the various viscous layers will move to reveal the imagery in the material. (This process seems to mimic the photographer's manipulation of the sheet in a developing bath.) The puddled paint and ink are superimposed in layers over a pencil skeleton; in some of the layers a varnish has been added to create a more viscous quality. Often they are overdrawn in chalk and again in pencil. The date and signature become part of the work.

BRUCE NAUMAN
Drawing. **1989**

Mixed mediums on cut-and-taped paper
38 ⅜ x 33 ½" (97.5 x 85 cm)
Private collection

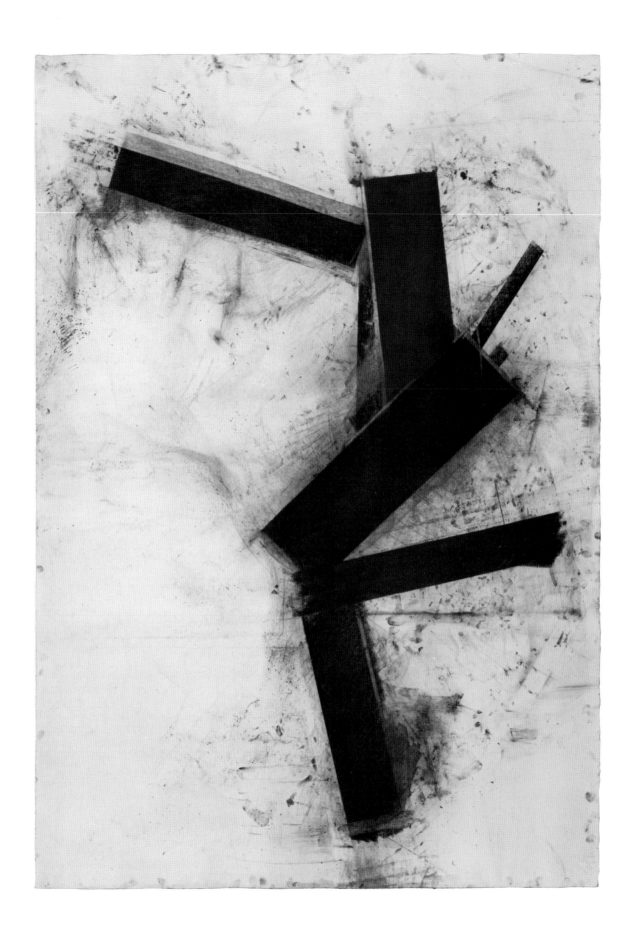

The painted layers form a coded structure, signaling Richter's distance from direct expressive painting and his interest in it as language interrogating reality. This view of reality has its roots in the nineteenth century, in the Realist movement and, specifically, in questions about the nature of reality brought to the fore through photography. Richter seems to feel about the body of modernism as the great French realist Honoré de Balzac felt about the human body. As Susan Sontag has written, Balzac believed that "a body is composed of an infinite series of 'ghostly images' . . . [and] that a person is an aggregate of appearances . . . which can be made to yield, by proper focusing, infinite layers of significance. To view reality as an endless set of situations which mirror each other, to extract analogies from the most dissimilar things, is to anticipate the characteristic form of perception stimulated by photographic images."[40] Richter's approach to art-making mirrors Balzac's notion that "the spirit of an entire milieu could be disclosed by a single material detail,"[41] and that the various layers of appearance themselves constitute reality. Paralleling some aspects of this nineteenth-century attitude toward photography (particularly the idea that the human body was composed of layers of reality which the photograph captured), Richter seems to believe that the body of painting consists of a series of layers corresponding to various layers of reality. For him, the first layer is photographic, the photograph itself retaining the material vestige of its subject. In subsequent layers that material vestige is transformed into the material reality of painting itself, and its details are examined.

In the nineteenth century just what constitutes reality became the central question in terms of photography; this produced a crisis that challenged all the other arts and is still with us today. The need to get up close and scientifically examine the thing named (in Richter's case specifically painting and the whole of modern art), isolating its details (using photography itself), leads to drawing as part of a kind of scientific journal and the use of watercolor as a kind of X-ray examining reality, veiling and exposing it at one and the same time.

It is clear by now that in current practice the fragment is itself a mode, and reproduction and photography its primary agencies. Dual readings are a continuing theme, along with sensation, scale, space, and most prominently, the collage aesthetic, the power of language, the sign, and allegory in unexpected places. Bruce Nauman has been constantly involved with all of these, though not until recently in overt allegory; previously allegory had been for him more of a question of approach. His has been typical of a career that depends on a cyclical investigation of "style" through a number of modes, rather than on the linear development of style through one mode. His practice is a paradigm for postmodernism's preoccupation with the "unfinished" artwork — the fragment as opposed to the completed art object. This connects directly with his autonomous sculpture, with performance, Happenings, Actions, and video as models of the gestural, with the unfinished, and with the artwork that extends in time and circles back upon itself in constant repetition (both vocal and pictorial).

JOEL SHAPIRO
Untitled. 1988

Charcoal and chalk on paper
7' 4" x 60" (223.5 x 152.4 cm)
The Museum of Modern Art, New York
Acquired with matching funds from the
Robert Lehman Foundation, Inc., and the
National Endowment for the Arts

Joel Shapiro was born in Queens, New York, in 1941. He studied at New York University, where he received a B.A. in 1964. After two years with the Peace Corps in India, where he became interested in sculpture, he returned to New York University, finishing an M.A. in 1969. Shapiro's early work, first shown at the Paula Cooper Gallery, New York, in 1970, countered the trend toward expanding scale inherent in Minimalism with small works in lead, steel, and limestone. In 1973–74 Shapiro further broke with contemporary practice by introducing into his sculpture imagery of chairs, houses, and trees, although he continued to produce nonobjective works. It was around 1980 that he first made geometric sculptures of figures and increased the scale of his work. Since the late 1970s Shapiro's work has been widely exhibited in America and Europe. It was included in *Documenta 6* and *7*, Kassel (1977 and 1982), the *Biennial*, Whitney Museum of American Art, New York (1977, 1979, 1981, and 1989), the Venice Biennale (1978), and *An International Survey of Recent Painting and Sculpture*, The Museum of Modern Art, New York (1984). He has had one-man exhibitions at the Museum of Contemporary Art, Chicago (1976), the Whitechapel Art Gallery, London (1980), a retrospective exhibition at the Whitney Museum of American Art (1982), a traveling exhibition of sculptures and drawings organized by the Stedelijk Museum, Amsterdam (1985), and a large exhibition organized by The Des Moines Art Center (1990) that toured America and Europe. Shapiro has received a number of awards, including the Brandeis Award in 1984, the Skowhegan Medal for Sculpture in 1986, and the Award of Merit Medal for Sculpture from the American Academy and Institute of Arts and Letters in 1990. Shapiro lives and works in New York.

SUSAN ROTHENBERG

Untitled. 1990

Charcoal on paper
59" x 6' 11" (150 x 211 cm)
The Museum of Modern Art, New York
Purchase

Susan Rothenberg was born in Buffalo, New York, in 1945. She received a B.F.A. from Cornell University, Ithaca, New York, in 1967. The following year she briefly enrolled in the Corcoran School of Art, Washington, D.C., but left to travel in Spain and Israel. She returned in 1969, settling in New York, where she first made sculpture influenced by Richard Serra and Eva Hesse, and later made geometric pattern paintings. In 1973 she began to draw the motif of the horse, which became the focal point of an extensive series of paintings in the late 1970s. Her first one-woman exhibition was held at an alternative space, the 112 Greene Street Gallery, New York, in 1975. The National Endowment for the Arts awarded her a fellowship in 1979, and the following year she received a grant from the John S. Guggenheim Memorial Foundation. In 1983 she was honored with an award from the American Academy of Arts and Letters. Rothenberg's work was included in the *Biennial*, Whitney Museum of American Art, New York (1979, 1983, and 1985), *A New Spirit in Painting*, Royal Academy of Arts, London (1981), and *An International Survey of Recent Painting and Sculpture*, The Museum of Modern Art, New York (1984). Among the numerous one-woman exhibitions of her work are those organized by the Kunsthalle, Basel (1981), the Stedelijk Museum, Amsterdam (1982), the Los Angeles County Museum of Art (1983–85), and the Rooseum Center for Contemporary Art, Malmö, Sweden (1990). Rothenburg lives and works in New Mexico.

Like Kounellis, Nauman is concerned with masking and what lies behind reality — the obverse and reverse in his word-game drawings. In his work, the importance of the body and language come together with drawing in what appears at first to be a quite traditional manner — drawing as idea, and drawing as a handmade artifact. Nauman has described drawing as a "place" in which he can connect to the tradition of art. Despite this remark however his drawing expands tradition, going beyond it in several ways. Often sculptural and graphic concerns are conflated, and the drawing comes to have a plastic dimension, either actually or conceptually. Nauman tapes his supports together, creating a physically concrete metaphor for disjunction by interrupting and re-connecting the surfaces of his drawings. They are concerned with sculpture; study drawings are either plans for the fabrication of his neon pieces or traditional studies that serve as plans and models. In some cases the drawings are models for models; in others, they act as reflections on a completed piece — drawings after sculpture. They return to the experience of the piece and to providing a secondary level of information about it. They envision things that do not at first — if at all — materialize in the sculpture, but beyond that they serve a purpose that is unique to Nauman: "I think the point of the piece can be conveyed through the drawings as a more or less intellectual exercise. It could provide a back door to the point of the piece. Physically entering the piece gives another kind of information . . . emotional, physical, psychological. . . . I'm using two kinds of information simultaneously to build another kind of response or using two kinds of information to contradict each other and create a tension about knowing about the piece, about the experience, using the tension as a focal point of the work rather than using the information or the object."[42]

Nauman has only recently allowed the representation of the body back into his drawing, after a long hiatus during which the absent subject and his own range of perception and consciousness were his primary concerns. Going a step further, in the photographic collage studies made for a monumental outdoor sculpture, *Animal Pyramid*, the self is projected empathically to the animal ("I am another") with allusions both to the heroic mode of traditional outdoor animal sculptures and to the hunted, dead, and strung-up animal, as represented in after-the-chase genre paintings. This sort of empathy strikes a note of civic virtue insofar as empathy is necessary for experiencing the pain of others as the first step toward its amelioration and toward political anger (there is certainly an allusion to more than one kind of slaughter and torture). These animals refer back to a drawing of Nauman's in which the tortured subject was absent but was represented by the hanged chair, striking the message "D-E-A-D" on the tonal scale as it hit a ring surrounding it. If in Nauman's work one technique for expressing duality is his language games — calligrams and anagrams[43] — a more subtle discourse is involved in the studies for *Animal Pyramid* as multivalent culture/nature opposition, for these works originate in his discovery of the local taxidermist's forms in Pecos, New Mexico, where he lived for some time, and where hunting trophies are important cultural

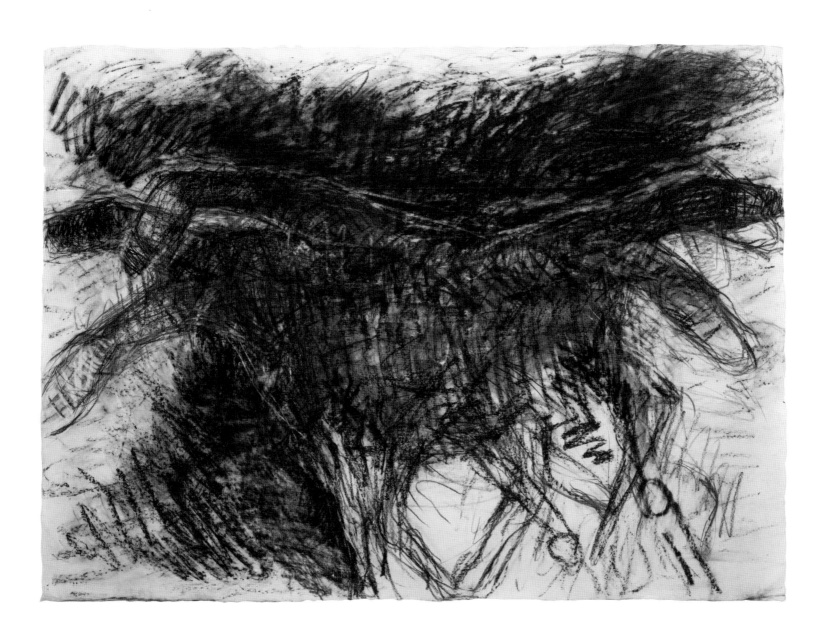

TERRY WINTERS

Schema (65). 1985–86

Watercolor and graphite on paper
12 ¼ x 8 ⅝" (31.1 x 21.9 cm)
The Museum of Modern Art, New York
Gift of Richard E. Salomon

Terry Winters was born in Brooklyn, New York, in
1949. He was educated at Pratt Institute, from
which he received a B.F.A. in 1971. During the late
1970s Winters's work was seen in various group
exhibitions at alternative spaces. Plane of Incidence,
one of his first major series of paintings (1981), was
followed a year later by the Botanical Subjects
series, which established his repertoire of symbolic
forms reminiscent of insects, honeycombs, spores,
and seeds. The Schema series, a corpus of seventy-
six drawings, was executed between 1985 and
1986. In 1988 he made a series of drawings to illus-
trate a special edition of Edgar Allan Poe's Eureka.
Winters's work was included in An International
Survey of Recent Painting and Sculpture, The
Museum of Modern Art, New York (1984), and the
Biennial, Whitney Museum of American Art, New
York (1985 and 1987). His first one-man exhibition
was held at Sonnabend Gallery, New York, in 1982.
Later one-man exhibitions include one at the
Kunstmuseum, Lucerne (1985), Eight Paintings at
The Tate Gallery, London (1986), and traveling retro-
spectives organized by the University Art Museum,
University of California, Santa Barbara (1987), and
the Whitney Museum of American Art (1991).
Winters lives and works in New York.

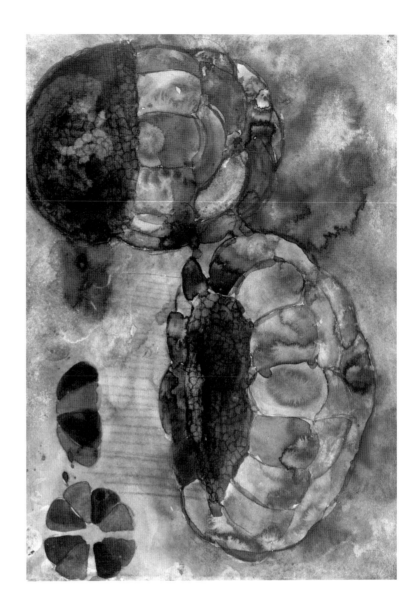

symbols. They are also allied to the European tradition of the allegorical hunt sculpture.

The collage technique conflates a number of formal concerns — sculptural, painterly, and graphic — using photography as an intercessor among mediums and a representation of all of them. In this case, as in Nauman's sculpture, there is an absence of the author. The hand is absent from the means of representation but not from the contextual control, the structure. The collage is transformed into a drama, whose content emerges as an allegory of the sculpture it purports merely to study. The setting of Model for Animal Pyramid II (page 45) is the artist's studio; it is rem- iniscent of Gustave Courbet's painting of the mid-nineteenth century Interior of My Studio, a Real Allegory Summing Up Seven Years of My Life as an Artist, or at least seems to be in the same tradition. We see work in progress stacked around the stu- dio, hung on walls and from the ceiling, ghostly spectators — heads severed from their bodies — as well as other sculptures and drawings by Nauman, which act as

silent witnesses (page 46). Because the scene takes place in the artist's studio, it is a reflection upon and an allegory about the morality of the artist's act of making art. But the artist is now absent; he looks at his work from outside. Those watching him have been returned, as well, to their proper place outside the picture.

The way in which the individual photographic studies for *Model for Animal Pyramid II* are cut and pieced constructs a dizzying baroque spiral that, through the means of joining, draws the eye into the space that the photographs portray. Moreover, acting as a physical model for the actual outdoor sculpture, it suggests the viewer's path around it; the drawing is scaled so that it presents itself as a life-size physical object. If the photograph recalls a mechanical language of nostalgia for the pastoral and historical, and of distanced representation, the collage is more immediate and physical. It refers to the abstract and formal aspect of making art. Several kinds of space are involved here, together with differing sensations and differing levels of seeing and knowing, as historical and modern ideas about space are conflated. The space of memory, seen as three-dimensional in the photographic medium, and the three-dimensional space the sculpture occupies within the room are opposed to the surface of the picture plane asserted by the fragments of the collage, despite the fact that they also disrupt the flatness of the sheet and the integrity of the plane.

Nauman's work occupies a crucial position in current practice owing to his affiliating Conceptual art with the allegorical impulse and his ability to render the conceptual as transparently theatrical and "sensational." For Nauman categories are open-ended; art itself is not a closed rational system for representing the world; things may connect without apparent logic, return, and re-connect.

Joel Shapiro, Pat Steir, and Susan Rothenberg have each in different ways deduced a gestural mode of drawing from a conceptual base. Each works close to the traditional heart of drawing, particularly to its mark-making function and the notion of art as process. For Shapiro, as for Nauman, drawing has meant the process of extracting information from his sculpture, which has been largely constructivist in tenor and radical in its address. His earlier study drawings worked out problems concerning sculpture itself. His autonomous drawings (page 48), large as they are, are not constrained by the physical problems of sculpture (mass and weight), yet the two-dimensional medium has its own constraints, which Shapiro overcomes by taking advantage of them to suggest a range of pictorial possibilities surrounding the sculpture but not necessarily inherent in it. These drawings connect Shapiro with art as process and with the tradition of coloristic outline drawing, subtended by sfumato charcoal shading. All of these allusions are suppressed, although minimally present, in his sculpture. As objects, his drawings relate most closely to his relief sculptures of 1979. They operate on two planes, the abstract and the representational, as does his sculpture. As a result, they oscillate between pure form and recognizable image, as the geometric forms of which they are composed and the figures they portray interchange. Shapiro's sculptures are poised in disequilibrium at the critical moment of an arc of movement; the dislocation of the forms suggests the continuance of that

JONATHAN BOROFSKY

I Dreamed a Dog Was Walking a Tightrope at 2,715,346. 1981

Environmental installation, Los Angeles County Museum of Art

Jonathan Borofsky was born in Boston in 1942. He studied industrial design at Carnegie Mellon University, Pittsburgh, from 1960 to 1964, ultimately switching to fine arts. After a summer at the École de Fontainebleau near Paris in 1964 he entered Yale University, where he received an M.F.A. in 1966. Borofsky moved to New York the same year. In 1969 the artist began counting to infinity, at first writing the numbers on sheets of paper stacked to form sculptures, and later adapting this practice as a system for numbering his works. He had his first one-man exhibition at Artists Space, New York, in 1973, and since 1975, when he exhibited the entire contents of his studio there, has exhibited regularly at the Paula Cooper Gallery, New York. During the late 1970s he began to make the large wall drawings that he would later combine with sculpture (sometimes motorized), small drawings, videos, ping-pong tables, stacked sheets of numbers, propped paintings, and other objects. This continued through the mid-1980s. Borofsky's work has been widely exhibited in the United States and Europe. It was included in the *Biennial*, Whitney Museum of American Art, New York (1979 and 1981), in *Documenta 7* and *8*, Kassel (1982 and 1987), and in *BERLINART*, The Museum of Modern Art, New York (1987). He has executed major installations at the University Art Museum, Berkeley (1977), Portland Center for the Visual Arts, Oregon (1979), the Venice Biennale and Hayden Gallery, M.I.T. (both 1980), the Whitney Museum of American Art (1981), the Kunstmuseum, Basel (1981 and 1983), The Museum of Modern Art (1978 and 1982), and many other museums and galleries in America, Europe, and Japan. A large traveling retrospective of his work was organized by the Philadelphia Museum of Art in 1984. Borofsky has taught at the School of Visual Arts, New York (1969–77), and the California Institute of the Arts, Valencia (1977–80). Borofsky lives and works in Maine and Los Angeles.

movement, and of the history of figurative rendering from Cézanne through Matisse and de Kooning. The sfumato of the charcoal ground, deliberately marked with the artist's fingerprints and with dragged and smudged passages, erasures, and pentimenti of corrected outlines, excites the air around the figures. The impression of atmosphere suggests that the sheet is the equivalent of the void of the gallery space. These fingerprints were already present in his early conceptual drawings, arranged gridlike on giant sheets of paper. Shapiro, who worked in miniature scale for some time, could be said to have taken the scale of his sculpture from the thumbprint and then to have moved up again in scale to life-size sculpture and these very large drawings in which the fingerprint again plays a role as a protagonist and a sign. The artist's imprint has been a recurring sign in late twentieth-century art: from the handprint of Pollock, through Johns's hand and body prints, to Manzoni's thumbprint impressions, all of which asserted the artist's identity, whether as an ironic sign in the midst of his mechanistic withdrawal or as a nostalgic emblem of lost possibility — of distance from the artist's signatory role.

Pat Steir is interested in art as a continuing process of research — the construction of verbal and visual information systems. Often poetry is scrawled into the surface of her works, and extends into and merges with the drawing itself. Her drawings have consistently been essays in pure illusion as it is filtered through what she calls the net of style and subject matter as well as what slips through from the long tradition of art and the conventions of each period to make each artist's personal gesture. For Steir there is no "innocent" eye; one's viewing is inevitably conditioned by one's past viewing, and "the repetition of a subject or image is very human and binding."[44] A group of drawings made in 1984, "quotations" after works by Hokusai and Courbet titled *The Wave*, were about drawing itself and its ability to evoke illusion, specifically that of water. At that time I wrote: "As her marks accumulate and begin to create darker areas, little sparks of light appear at the intersections of the lines; the play between dark and light areas creates a movement like that of light playing on the surface. Space appears around the lines. Each frame, or 'field,' demands a different kind of concentration. One demands concentration close up within its confining outline; it fills the visual field with greater incident of detail. The other demands the conceptualization of a total image. The dual representation elicits a complex interplay of reflex and reflection, close involvement and detachment. . . . The line comes alive; it is both line and wave: the very stuff of illusion."[45]

During a recent interview with Marden, Steir asked him if the relationship between viewer and object was formalized, that is to say, ritualized; but it seems not so much a question for him as an observation of her own feelings. For Steir the pencil mark has defined drawing, and "drawing is just marks which pretend to do something else."[46] The notion that a pencil mark, any group of such marks, a line or a cluster of such lines, could represent something else or could in itself have meaning is absurd.[47] But the illusion that marks evoke meaning is the center around which the act of drawing becomes a necessity.

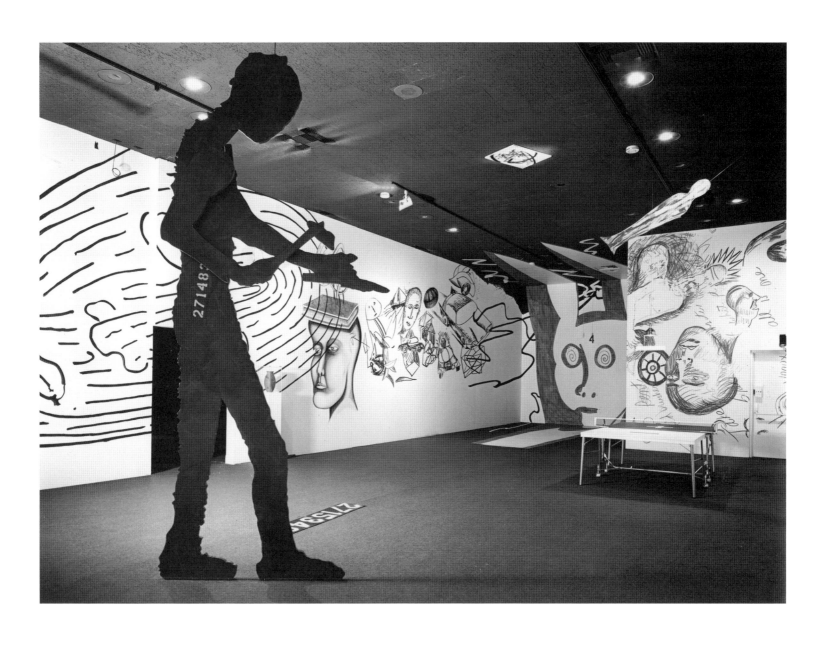

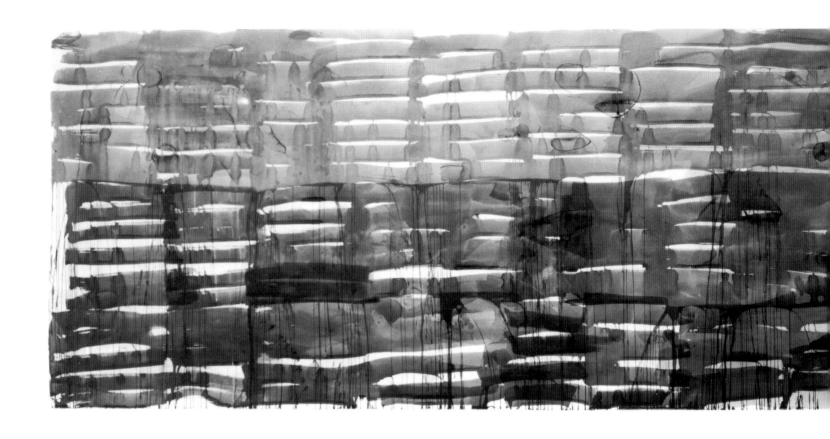

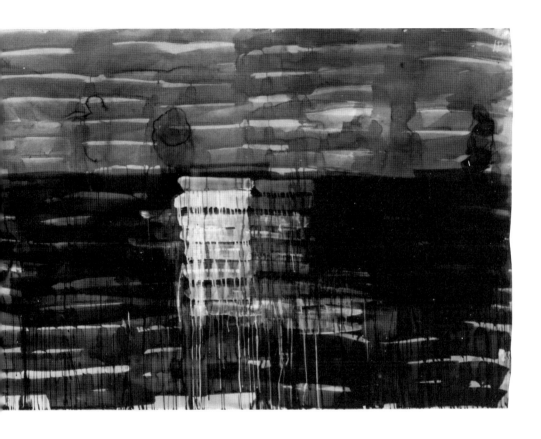

PAT STEIR

Untitled. 1987

Mixed mediums on paper
60" x 18' 1 ¾" (152.4 x 553.1 cm)
Robert Miller Gallery, New York

Pat Steir was born Patricia Sukoneck in Newark, New Jersey, in 1940. She attended Pratt Institute, Brooklyn, New York, where she received a B.F.A. in 1961. Her teachers included Philip Guston and Richard Lindner, whose own work encouraged Steir by its combination of precise figuration and abstraction. Her first one-woman exhibition was held at the Terry Dintenfass Gallery, New York, in 1964. During the 1960s Steir earned a living as a graphic designer, serving as Art Director at Harper & Row from 1968 to 1970. Between 1973 and 1975 Steir lived in Los Angeles and taught at the California Institute of the Arts, Valencia, then a new institution with an innovative curriculum. In 1975 she joined with Sol LeWitt and a group of other artists and writers to found Printed Matter, which grew to be the principal publisher and distributor of artists' books in the next decade. In 1975 Steir also helped to found *Heresies*, the first journal for feminism and the arts. Since the early 1980s Steir's paintings, drawings, and prints have been widely exhibited in America and Europe. Her work was included in the *Annual Exhibition* (1972) and the *Biennial*, Whitney Museum of American Art, New York (1973, 1977, and 1991), and in *New Work on Paper 3*, The Museum of Modern Art, New York (1985). In 1983 the Spencer Museum of Art, Lawrence, Kansas, organized a traveling exhibition of her drawings and prints, while her paintings were shown at the Contemporary Arts Museum, Houston. The Breughel Series was exhibited in 1984 in the Grand Lobby at The Brooklyn Museum, New York, and traveled for three years in the United States, Switzerland, and the Netherlands. During the last decade Steir has also worked extensively in printmaking. She lives and works in New York and the Netherlands.

In her new drawings (pages 56–57), she has reflected on a group of poured paintings which themselves resulted from a material transformation of the watery metaphors in the earlier "wave" drawings. She characteristically draws with a painter's gesture, which originates from the center of her body and uses its full sweep. The mark is the conclusion of the movement; the gesture is ritualized by the painter's dance.

Susan Rothenberg (page 51) works on the edge between the personal and the objective, using the mark and line quite literally as signs that oscillate between the two. Her multiplication of outline relates her to the tradition of Cézanne; she uses outline as he did, to situate an object in space. That said, Rothenberg is not a neo-expressionist although her work is dominated by darting nervous marks and expressive line; her line is too distanced mechanistically from the emotion for which it is a sign to be expressionist. However her drawing is a direct expression through its medium of a personal viewpoint, and is in a sense "innocent" in that its distancing is a matter of necessity rather than of strategy. There is an authenticity and visible effort, a kind of morality of picture-making in Rothenberg's work, as she retains in the multiple outlines of her image the traces of her struggle to make the iconic figure (with its traditional figure-ground relationship) function in a nonhierarchical manner. The multiplication of strokes, of limbs and fractured bodily parts that are evidence of her struggle to make figure and ground equal, results in a seeing of other things on a less conscious level — an opening to the inside. There is a kind of phallic joking around, a kind of frenetic intensity, repressed except at the edges, and a trafficking between the expressed and the repressed that, together with her determination to resurrect painting, admits her work to distinctly contemporary concerns.

Allegory is a structural premise of Terry Winters's work. He is a master of the gouache technique, which he employs on paper as a parallel to painting, using its density to "build" his surface as a "wall" painted over many times in series of small drawings. Like Marden, Winters (page 52) makes study drawings from nature but his iconography is specifically of things vegetative and fossilized. His concentration on process evokes a reflection on age-old time and a nostalgia for the well-made artwork.

Elsewhere I have outlined how drawing came to the fore in the 1970s as an independent medium[48] and earlier in this essay shown how it forms the ideal ground for allegory, first as a paradigm for pentimenti, and then as it extends and merges the concerns of written form with those of visual representation, and as it engages the concerns of other mediums and disciplines — although not as a means of study, or even as idea, but as a transparently integrated structural constituent. I have also indicated the role played by series in displacing the singular culminating object. In the 1980s the hierarchy of mediums, the exclusivity of disciplines, and the notion of the culminating object, already long under siege, finally gave way. A new attitude toward painting developed, one much more contingent and based on the notion that the painting, too, is only a fragment, one thought along the way. As a concomitant

of this attitude toward painting (and toward other classes of art objects), site-specific installation work continues to be an important component of current practice.

Jonathan Borofsky (page 55) is among those who have devalued discrete modes of art-making, producing installations in which drawing plays a key role. He has made the transition from a purely conceptual art form, consisting of the obsessive accumulation of numbers in sequence on a gridlike time frame, to a figurative, linear and open-ended, pictorial environmental form, by means of several mediums. Chief among them have been automatic drawing and writing, based on the techniques of Freudian analysis: free association and dream therapy. Quite simply, Borofsky has made an art of counting, then drawing, and then the writing of little stories. The drawings and stories were of dreams, which he arranged in quasi-cinematic sequences, paralleling the narrative sequence of dreams and carrying forward the numbering from his conceptual work without dropping a number. The numbering simply continued as his obsessive control — the marching order, as it were — of fantasy and of a special image-making facility let loose. The transition from one mode to another was not simply the association of number sequences with pictorial sequences; rather, it was the projection of one mode onto another. And projection at many levels, in a literal manner as well as in a psychological sense, is the driving force behind Borofsky's art.

Borofsky took his cue from Beuys's small drawings, LeWitt's wall drawings, and Lichtenstein's projection techniques, pinning his numerous small drawings to the wall and projecting and drawing these dream images on the walls and ceilings to develop complex installations that include large sculptures with mechanically moving parts. Mechanical sounds and spoken dream poems are also part of these installations, and he has also made videos with animated line drawings in them. In his environmental installations, the spectator often has a strong sensation of feeling as if he were inside a television set, with the artist's dreams projected on walls around him. This is fantasy projected in a literal manner. It could in fact be said that the dream is Borofsky's chief medium in which images project beyond the real into an imagined space, looming large as nightmares. In practice, the abrupt changes in scale between the drawings on paper and those made from projections and their distortions contribute to this sort of surreal spatial disjunction. The enlargement also creates an intriguing change in the handwriting of the drawings. Enlargement and tracing onto the new surface make the line into a stereotype; unlike the lines in his large drawings, those in his small drawings are very personal and quirky, made with fingers and wrists. It is this "personality" of the line that is enlarged and stereotyped.

Borofsky's imagery recounts regression and, as with Polke, light controls the whole phantasmagoric construction. He projects a universal and infantile paranoia, which he personalizes and expresses in terms of "bad guys," in particular Nazis, the stereotypical evildoers of his childhood. As in the work of Tim Rollins + K.O.S. (Kids of Survival), drawing is used as the instrument to satisfy the most infantile of human fantasies, those of control, destruction, and re-creation. As a strategy, he revives

aspects of Surrealism, appropriating its psychological landscape but transposing it into environmental installations.

In these installations, Borofsky has taken advantage of two aspects of drawing peculiar to it alone. The first is its special intimacy — that aspect in which it is revelatory of the artist's most personal thoughts and which makes it the perfect instrument for the projection of fantasy. He has allied this with drawing's capacity to form a network of lines, literally a structure parallel to the network of thought itself, or even to television's electronic landscape. This has enabled Borofsky's infantile fantasies to be projected as the total control of the environment; drawing was transparent to thought in a way that would not have been permitted by the density of paint. Thus drawing served for Borofsky not only as an initial impulse but as a total instrument with which to construct a new plastic reality.

Francesco Clemente makes drawing a synesthetic equivalent to the bodily senses he depicts. The bodily process is the artist's process: if sex is creation, art is its double, and the artist is constantly re-created in a variety of personae, even as a transsexual, as his imagery crosses the boundaries of gender. Clemente has been called a sexual "commuter";[49] his drama is his own persona, and its acting out is confined to the narcissistic portrayal of himself and the parts of his body.

Clemente's drawing verges on the obsessional — verges because in actuality his work is an ironic commentary on obsession; it both parodies it and acts it out as a kind of self-mocking narcissism. His is a true collage-aesthetic sensibility, contingent and fractured: the infantile breaking up of bodily parts (and of parts of the world) to devour and internalize them, only to spit them back out as drawings that are extraordinarily elegant, although almost repellent in their seduction.

Clemente was destined by his family to be a poet, and his drawings arose out of a poetic context. He began working primarily on paper, with drawing. Clemente is essentially a gifted draftsman whose best work proceeds from draftsmanship. His collage installation of individual pastel drawings, the Pondicherry pastels, burst onto the New York scene at their first showing in 1980 (pages 62 and 65). These tiny drawings pinned to the wall without frames placed the fragment in a new context; the microscopic structure became a world model. Laid out in six fragmented sequences on the walls, they required the spectator to re-create the artist's own narcissistic act of arranging them in a tableau as an act of connoisseurship.

In the postmodern world the fragment is taken as both the manifestation and emblem, the symptom and symbol, of dissolution — of the breakup of the old order, which is inevitably seen as decadence. Clemente balances the curious relationship of verbal, visual, and body language that forms the center of late twentieth-century art as a factor of the pictorial. His is the cult of the adolescent's fantasy of sexual power. He is fundamentally a Symbolist like the poet-painter Odilon Redon, and has acknowledged the spell of Antonin Artaud and Louis-Ferdinand Céline, celebrating chaos and decadence.

Clemente's circuit is the reciprocal relationship between self and the world outside.

He is like the traveler who arrives back at the same place only to find it different, only to know it for the first time; like Heraclitus's stream, it is never the same, even at the same place. Art is the body, the self in question; it is the dying corpse cannibalized. The artist's journey through the self recapitulates his journey through the body of modern art itself in order to recover the fragile poetic spirit of modern painting, which in its turn flows from ancient and exotic sources. Clemente is an eclectic dandy, constructing a family resemblance and a mythology of primal origin across time and space. He looks back to modern art, to Egon Schiele, Max Beckmann, Paul Klee, and Marc Chagall; to his own contemporaries Jean Michel Basquiat, Keith Haring, Julian Schnabel, and David Hockney; and to historic sources — Byzantine, baroque, Renaissance; the frescoes of Pompeii, the caves of Ajanta, the contemporary drawings on the streets of Madras, and the ongoing tradition of the Indian miniature.

Robert Storr writes, "Clemente's art is everywhere keyed to . . . awareness of fragility and metamorphosis. His chosen materials are at extremes of brittleness or fluidity. The surfaces of his oils are scrofulous; the contours of his ink drawings crackle and splinter; his watercolors bleed, and the atomized pigments of his pastels blur on the page. Everything in the facture of his best work tends to dissolve into its support and mix with that which is adjacent, just as the images themselves shift, fuse and transmute. The primary tension is between that which seems ephemeral and yet is in some way essential, discursive yet still iconic, powerfully imagined and yet physically slight."[50]

The relationship between Clemente's delicate grounds and his ephemeral images is allegorical — a twice-told tale. But there is another layer to the allegory, as language continues to play a powerful part in late twentieth-century art. Clemente has characterized his own work as "objectively poetic," the objective poetry residing in the spaces between his poetic titles and the works themselves. His titles for the six sections of the Pondicherry pastels form an objective poem of their own, composed of poetic fragments — really signs for poems. The first title, *The Sick Rose*, from William Blake, seems to create a context for the rest: *From Near and from Afar, Silenus, Myriads* (see pages 62 and 65), *Happier than Piero, Around and Very Close*. Clemente's ironic humor extends to the edges of burlesque, or even orgy, as he eliminates genres just as he eliminates sexual distinctions. But his sense of poetry pulls him back as he creates art as a total, imagined purgative environment.

Nancy Spero, for whom Artaud is the essential reference, foretells much of the allegory of current art, and is a precursor of Clemente. In Codex Artaud, a series made over several years, from 1969 to 1972 (pages 72–73), she appropriated the image of Artaud, the pariah who was imprisoned by madness but who turned the case inside out, returning madness to society. She has taken his self-portrait with his tongue sticking out as a vehicle for the expression of a similar rage. One level of her anger is about the "impossibility of 'feminine' decorum and propriety in a world not of woman's making."[51] She takes Artaud's madness as a paradigm for women's condition, but also ultimately for all those who are forced to extremes of rage by a society that conceives of them as voiceless, "using Artaud's persona like a tragic

mask."[52] Registering this madness as a dysfunction, as a product of dissociation, Spero withholds her hand, conceiving of her work as "automatic" and depersonalized; it is "outside" of consideration. She creates a catalogue of victimization through collages of stamped images, reaching back through time to aboriginal, Etruscan, and Greco-Roman art. Although her stamps are not ready-made like Johns's stencils (she draws the images that are made into stamps), she does withhold the signatory personal gesture. In Spero's work freedom and spontaneity are absorbed into the mechanically repetitious, erasing individual worth and creating women as signs, mimicking the self-absorption of society. Spero's work is allegorical in its scroll-like format; it is made to be read as an exposure of cultural dominance and the subjugation and violation of Woman's body — her constant subject. Its signs are "domesticated" to abstraction; as Thomas Crow noted with regard to a similar strategy in Richard Prince's work, by "their uniform scale and wide separation on an austere white ground"[53] they become "a manipulation of sign *qua* sign. This provides us with the opportunity for acts of discriminating comparison analogous to the process that originally occupied the artist. We can indulge in our well-rehearsed ability to see that a manufactured commodity, a mechanical instrument of male pleasure, is being equated with the female body,"[54] as Spero turns male dominance on itself.

Projected fantasy and automatism, and the female body as an instrument, are hallmarks of David Salle's work (page 69). Both he and Julian Schnabel work in the genre of heroic painting, trying to bridge the distance between the skepticism of the moment at such a venture and their desire to effect a reconciliation with painting as a mode and to redeem painting for the present.

Salle, referring to Polke, and to Francis Picabia of the 1930s, uses the new technical vocabulary as a bridge back to psychological painting. He has said: "As for Expressionism, the style — I think it's interesting if you're a painter. It's an extremely important technical idea, to form an image through a painterly process, instead of drawing an image, then painting it in. It has to do with realizing an end through means that are hard to control."[55] Yet, like Polke, Salle works with projections, layers, outline drawing, and washes without density — grisaille imitations of black-and-white photography and film stills — producing with his overlays "the collision and superimposition of different ontological worlds."[56] He is fascinated with technique, as in "commercial art," and is interested in presentation, not representation. Images are materials, to be used as one limits one's palette; thus one gains distance and control over one's fantasy, which in Salle's case, as he explained in 1988, is about the body as a "location of human inquiry,"[57] affiliating his pictorial ideas with performance and conceptual art. Salle's images are fabricated for the occasion; he poses his figures according to images in his historical reference base, photographs them, then works from projections. Often his imagistic fantasy seems split, plastically as well as iconographically, between the high art of the nude and the low art of the pornographer; it is voyeuristic in the best film-noir sense. There is also the tendency to see bodies[58] — cropped and headless — as objects and to sexualize curvaceous objects

FRANCESCO CLEMENTE
Silenus. 1979

Pastel on handmade paper
Twelve sheets, from 6 ⅜ x 3 ½" (16.2 x 9 cm)
to 13 ¾ x 13" (33 x 35 cm)
Anthony d'Offay Gallery, London

Francesco Clemente was born in Naples, Italy, in 1952. He studied classical literature and philosophy in secondary school, and briefly enrolled as an architectural student at the University of Rome in 1971, the same year he had his first one-man exhibition at Galleria Valle Giulia, in Rome. In 1973 he made his first trip to India, and the following year traveled to Afghanistan with the artist Alighiero Boetti. From 1975 to 1980 Clemente spent considerable time in India, particularly in Madras, where he made drawings, pastels, and handmade books. In 1983 he moved to New York. In addition to working in drawing, printmaking, oil painting, sculpture, and fresco, Clemente has undertaken several projects with the collaboration of local craftsmen in Madras. In the United States he has collaborated on illustrated folios with poets John Wieners, Allen Ginsberg, Robert Creeley, and Rene Ricard. He helped found Hanuman Books, a small press specializing in poetry and artists' writings, with Raymond Foye. In 1985 he executed an elaborate temporary fresco for the Palladium nightclub in New York. Clemente's work was exhibited in *Documenta 7*, Kassel (1982), *New Work on Paper 2*, The Museum of Modern Art, New York (1982), *Zeitgeist*, Martin-Gropius-Bau, Berlin (1982), and *An International Survey of Recent Painting and Sculpture*, The Museum of Modern Art (1984). His illustrations to Alberto Savinio's *The Departure of the Argonauts* were the subject of an exhibition at The Museum of Modern Art in 1986. The many one-man exhibitions of his work include a show of pastels at the Nationalgalerie, Berlin (1984), a retrospective of paintings at The John and Mable Ringling Museum of Art, Sarasota, Florida (1985), a large exhibition of watercolors at the Museum für Gegenwartskunst, Basel (1987), *The Funerary Paintings*, DIA Art Foundation, New York (1988), and *Francesco Clemente: Three Worlds*, a retrospective exhibition of work on paper, Philadelphia Museum of Art (1990). Clemente divides his time among New York, Rome, and Madras.

FRANCESCO CLEMENTE

Myriads. 1979

Pastel on handmade paper
Nineteen sheets, from 6 ⅜ x 3 ½" (16.2 x 9 cm)
to 13 ¾ x 13" (35 x 33 cm)
Anthony d'Offay Gallery, London

as "bodies." These images rehearse desire, conquest, dominance, and death seen through the filtering apparatus of the lens and projector. Salle's hand is at its best when, like Polke's, it seems to be tracing an outline phantasmagorically, when, because it is drawn on the edge of a shadow, it is slightly out of register and looks a little as if it were slipping out of control. For this reason, Salle's imagery looks best in large scale, when his arm can move freely and his depicted spaces work as virtual spaces, so that one experiences the work as both a psychological extension of the artist's fantasy and an invitation to enter it physically.

As products of "soft" brush drawing, Salle's images are also soft, like Claes Oldenburg's soft sculpture. His porn is soft porn; his work is a collage that, like Clemente's, projects the infantile fantasy of the erotic fragment in which bodily parts are ingested, to be re-created as whole in a creative act of separation. However, in Salle's work the erotic, the pornographic, the bad-child aspect is brought to the surface, *seeming* to mirror the most unacceptable kinds of sadistic fantasies, as the female softness of his images butts up against that classical modernist male image of dominance, the hard-edge abstract painting.

In an essay whose title, "Jack Goldstein: Distance Equals Control," is in itself revealing, Salle in effect seemed to sum up his own preoccupations and strategy when he wrote of Goldstein's work that it is "an ongoing process: the play of private fantasy, which itself grows out of the intersection of psychic necessity (desire) with the culturally available forms in which to voice that necessity (automaticity) becoming linked in a work of art to everyday public images which then re-enter and submerge themselves, via the appropriative nature of our attention, into a clouded pool of personal symbols. . . . To consider this work at all involves thinking about a way to stand in relation to the use of images both rooted in and somewhat distanced from cultural seeing. What this thinking should lead to is an outline of what constitutes a *sensibility*, and the use of sensibility as a concept in discussing work requires that its elements be larger and more pervasive than the mechanics of a single piece, or even the work of a single artist."[59]

Thus sensibility is once again an issue, but it is now at a distance from what it desires. As Thomas Lawson has written, "Salle records a world so stupefied by the narcotic of its own delusionary gaze that it fails to understand that it has nothing actual in its grasp. Amid seeming abundance, there is no real choice, only a choice of phantasms."[60]

If for Salle sensibility is the issue, for Julian Schnabel it is the death of painting as he revives heroic painting (and drawing) in an ambitious attempt to take up the cudgels of modernism and to outdo any previous heroic painting. Schnabel's heroism is a grand artifice; his ambition to resurrect painting and the artist as the true hero in a search for the absolute is played out through a thoroughly painterly genius. However, Schnabel's painting is part of the postmodern world, and each of his paintings, rather than creating a single culminating moment, is one culminating moment piled on another, rendering them as fragments in a continuing quest for

JULIAN SCHNABEL

Flamingo. 1990

Engraving and oil on paper on canvas
7' 3" x 68" (221 x 173 cm)
The Pace Gallery, New York

Julian Schnabel was born in New York in 1951. His
family moved to Brownsville, Texas, in 1965. After
receiving a B.F.A. from the University of Houston in
1973, he moved to New York to attend the
Independent Study Program of the Whitney Museum
of American Art. After a brief return to Texas in
1975, and a one-man exhibition the same year at
the Contemporary Arts Museum, Houston, he
traveled to France and Italy in 1976. After spending
most of 1977 in New York, he left again for Europe,
traveling in Germany, Italy, and Spain, where he
studied the architecture of Antonio Gaudí. Schnabel
first exhibited paintings that incorporated broken
plates, antlers, and other objects at the Mary Boone
Gallery, New York, in 1979. In the early 1980s he
began to work in cast bronze, making monumental
sculptures. Since then Schnabel's paintings,
sculpture, and drawings have been widely exhibited
in individual and group exhibitions. His work was
included in the *Biennial*, Whitney Museum of
American Art (1981, 1983, and 1991), *A New Spirit
in Painting*, Royal Academy of Arts, London (1981),
the Venice Biennale, and *Zeitgeist*, Martin-Gropius-
Bau, Berlin (both 1982), *An International Survey of
Recent Painting and Sculpture*, The Museum of
Modern Art, New York (1984), and the *Carnegie
International*, Museum of Art, Carnegie Institute,
Pittsburgh (1985). Among the many one-man
exhibitions of his work are those organized by the
Stedelijk Museum, Amsterdam, and The Tate
Gallery, London (1982), the Whitechapel Art Gallery,
London (1986), the Musée d'Art Contemporain,
Bordeaux, and the Museo d'Arte Contemporanea
Luigi Pecci, Prato, Italy (both 1989). The
Recognitions Paintings series was exhibited at the
Cuartel del Carmen in Seville, Spain, in 1988. In
1990 the Museum für Gegenwartskunst, Basel,
organized the first retrospective exhibition of his
drawings. Schnabel lives and works in New York and
Montauk, Long Island.

"completion." Pollock and Beuys are often invoked with regard to Schnabel; yet his relationship to these artists is complex, more than an imitation of their solutions. Schnabel, like Pollock, forms an image through painterly means. He often works in series, basing painting on the material — the voluptuousness of paint against chunky fragments of plates or the graphic mark of a paint-soaked rag as it is flung at the support. For Schnabel it is not line but ground, material, and technique that are protagonists. His ground is primary, often an image itself, often ready-made, painted or printed, and sometimes collaged with wonderful color reproductions. If he cannot find a ready-made ground with the kind of imagery or accidental markings of experience and age he wants, he will manufacture it, often going to great lengths to do so, even dragging tarpaulins along a road so that tar and dirt will "draw" marks on them. The very meaning and use of "ground" changes as Schnabel's images are in a sense simply successive layers of grounds. This is the result of the refusal of his cloth marks and forms to resolve themselves into specific figures. Thus they hover between figure and ground. This attitude, more often seen in drawing, is a concern of Schnabel's that often makes his paintings look like drawings, while his drawing sheets can be pristine.

Schnabel's plate paintings were his first solution to the problem of physically securing figuration to the surface of an allover field. In these works figuration is absorbed into an allover, densely material surface resembling Pollock's *Full Fathom Five* (1947); it emerges as a pattern of scattered broken fragments. In *The Trial* (page 68) the terms change as the dirt and marks representing the ravages of time form an overall chiaroscuro ground in which Schnabel "finds" images, and a more linear impulse comes to the fore. Schnabel seems to pay homage to the graphic painting of James Ensor, perhaps also recognizing in his phantasmagoric imagery the seeds of Surrealism, Walt Disney, and comic books.

For Schnabel, as for Beuys, Pollock, and de Kooning, the graphic is a question of the grand physical gesture but also of touch; it is about the dryness or delicacy of a line on canvas but also about the juiciness of a paint mark on paper (page 66). Primarily it has to do with the relationship of drawing to the fragmentary, to the suggestive gesture and the suggestive emptiness, to the incomplete rather than the finished and resolved, even at heroic scale.

Drawing and painting series alternate, jostling for attention in a situation in which the manner of presentation rather than medium or facture creates the difference between disciplines, as distinctions between them are broken down. The drawings on paper, often collages, are elaborately framed to make them into objects. It is as though the object, not just the image, has transformed itself, become a kind of transvestite, dressed up in others' clothes. Painting (or drawing) on a grand scale has become the production of increasingly ambitious fragments as shows of Schnabel's work are mounted, particularly in Europe, in ancient monuments as environmental/theatrical decors.

JULIAN SCHNABEL

The Trial. 1985

Oil and modeling paste on canvas tarpaulin
9' 1 ⅞" x 17' 7 ¾" (279 x 538 cm)
Private collection

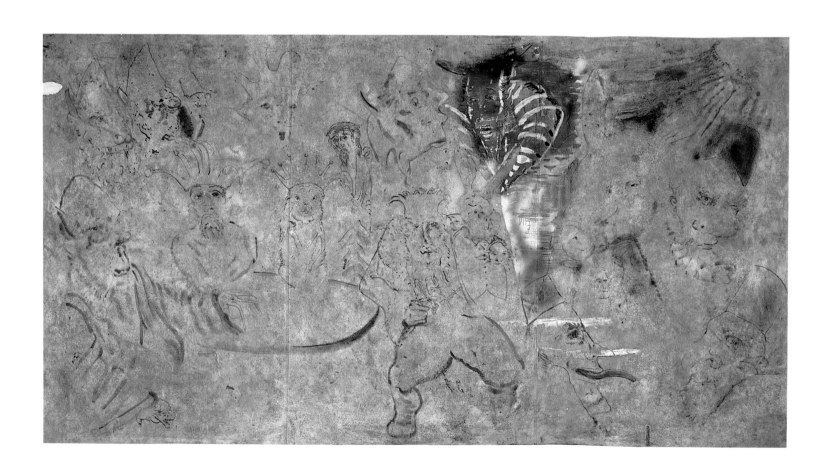

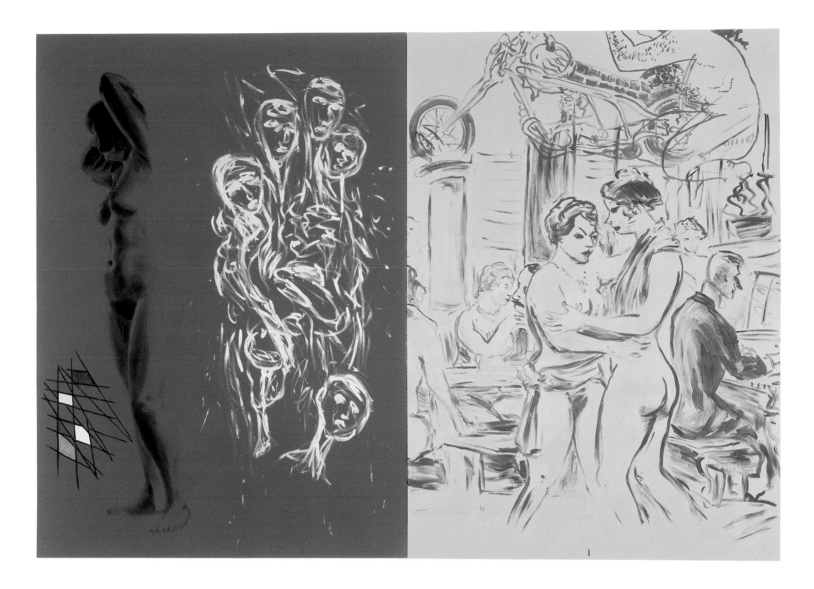

DAVID SALLE

A Couple of Centuries. 1982

Synthetic polymer paint and oil on canvas
Two panels, overall 9' 2" x 13' 4"
(279.4 x 406.4 cm)
Collection Robert and Rosalyn Papell

David Salle was born in Norman, Oklahoma, in 1952. He apprenticed briefly as a newsreel camera-man in 1967, and in 1970 entered the California Institute of the Arts, Valencia, where he experiment-ed with performance, assemblage, and combina-tions of photography and texts, receiving an M.F.A. in 1975. He then moved to New York, where he first saw films by R. W. Fassbinder, Douglas Sirk, and Preston Sturges. At his first exhibition in New York, at Artists Space in 1976, he showed large works on paper using photographs and other elements of col-lage. In 1977 he was appointed Assistant Professor at the Hartford Art School, Connecticut, where he taught a course with Sherrie Levine on Sirk's films and aesthetic theories of melodrama. In 1976 Salle turned to work on canvas, often juxtaposing panels painted in different styles. In 1979 he began to use the technique of overlaid images, and he joined the Mary Boone Gallery, New York. From 1981 to 1983 he taught at the School of Visual Arts, New York. Beginning in the early 1980s, Salle's imagery expanded as he incorporated images from varied sources in earlier art and the mass media. In 1985

he traveled to Paris, where he worked with the print-er Aldo Crommelynck on a series of etchings. His work was included in the Venice Biennale (1982), the *Biennial,* Whitney Museum of American Art, New York (1985 and 1991), *Zeitgeist,* Martin-Gropius-Bau, Berlin (1982), and *An International Survey of Recent Painting and Sculpture*, The Museum of Modern Art, New York (1984). Among the one-man exhibitions of Salle's work are those organized by the Museum Boymans–van Beuningen, Rotterdam (1983), the Institute of Contemporary Art, University of Pennsylvania, Philadelphia, and the Fundacion Caja de Pensiones, Madrid (1988). Salle has also worked extensively in theater design, collaborating closely with the choreographer Karole Armitage. He divides his time between New York City and a home on the upper Hudson River.

From the moment that art went into the streets, the mark dominated the 1980s and became a matter of public concern as new graffiti appeared nightly on the subways and in the streets of New York and debates raged over the propriety and aesthetic value of graffiti art. This graffiti movement started outside the boundaries of "art" as a vernacular expression of "street kids" asserting power. Graffiti art, however, was also made by a number of amazingly gifted and very young artists, such as Keith Haring and Jean Michel Basquiat, who formed groups and started to work on walls too. They were sophisticated about art history and the tradition of graffiti and street art as a popular art, as it had been elaborated by Jean Dubuffet, as de Kooning and Rauschenberg had brought it indoors to the studios of New York, and as the *affichistes* had created politicized collage versions in Paris and Italy in the last years of the 1950s and the early 1960s.

Haring, together with Kenny Scharf and Jean Michel Basquiat, was among the most publicly prominent artists of the time. His large, friezelike murals, some of them more than sixty feet long, were drawn automatically with ink and brush on paper pinned to the wall — a practice requiring the continuous physical and mental control of a dancer. Their structure is pictographic, subsuming a grid. The large figures were placed first, then the spaces between were filled in. Line (walking, like Klee's line) made itself into figures, and a whole class of linear squiggles, dashes, and coded marks derived from hatching filled spaces between figures (even the randomness of the doodle was rendered formal and "illustrational"). There are drawings in which the linear obsession to make itself into figuration fills every rift and every fold with figures. The system of drawing, as a new form of conceptual art and as fully developed in its way as LeWitt's, seems to have enabled the artist, as if by magic, to

KEITH HARING

Untitled. May 13, 1982

Sumi ink on paper
Two sheets, overall 6 x 56' (182.9 x 1,706.9 cm)
The Estate of Keith Haring, Inc.

Keith Haring was born in 1958 in Kutztown,
Pennsylvania. He attended art school in Pittsburgh
in 1977–78, and then moved to New York and
enrolled in the School of Visual Arts for two years.
His first one-man exhibition was held at the
Pittsburgh Center for the Arts in 1978. In 1980
Haring made his first drawings using the images of
the flying saucer, dog, and "radiant child." In the
same year he moved into a studio on Times Square
with artist Kenny Scharf. Haring participated in *The
Times Square Show*, a quasi-underground exhibition
organized by the artists' group Colab (Collaborative
Projects) and Fashion Moda and held in an aban-
doned massage parlor in 1980. An admirer of graffiti,
from 1981 to 1986 Haring made his own drawings
on black paper in frames usually reserved in subway
stations for advertising. His first mural, for a school-
yard on the Lower East Side of Manhattan, in 1981,
was followed by numerous others in New York,
Chicago, Atlanta, Sydney, Melbourne, Rio de Janeiro,

Amsterdam, Paris, and Berlin. In 1986 Haring
opened the Pop Shop, a retail store in SoHo that
sells a wide variety of products and editioned works
by Haring; a Tokyo branch was opened in 1988. He
participated in *Documenta 7*, Kassel (1982), the
Biennial, Whitney Museum of American Art, New
York (1983 and 1991), and the Venice Biennale
(1986). Haring's art has been widely exhibited,
with one-man exhibitions at the Musée d'Art
Contemporain, Bordeaux (1985), the Stedelijk
Museum, Amsterdam (1986), and in a full-scale
touring retrospective organized by the University
Galleries, Illinois State University, Normal (1991).
Haring campaigned widely on behalf of those suffer-
ing from AIDS and established the Keith Haring
Foundation, a charitable organization, in 1989.
Haring died in 1990 in New York.

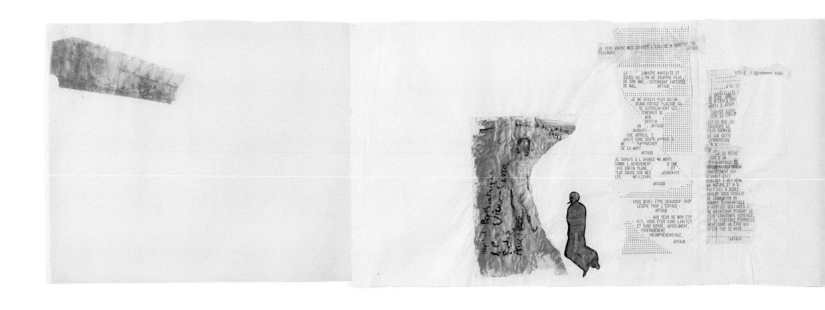

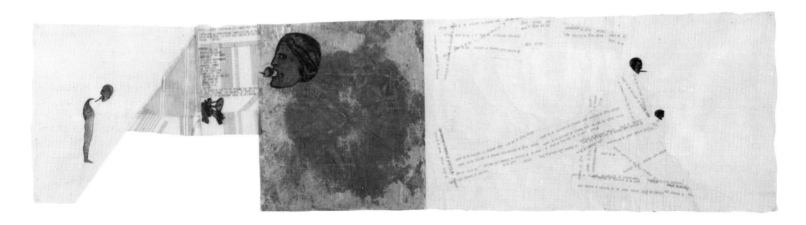

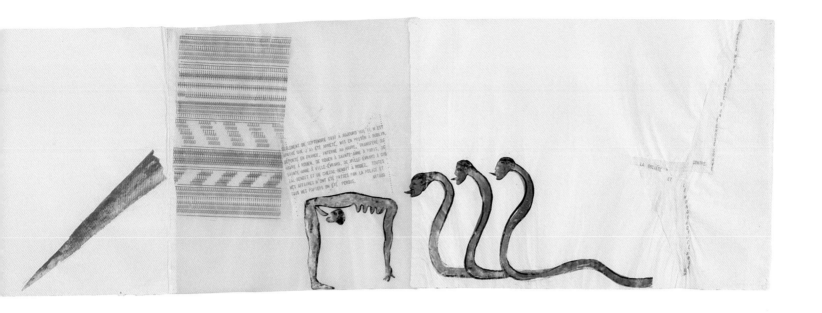

NANCY SPERO

Codex Artaud (VI). 1971

Cut-and-pasted paper, typewriting, gouache,
and ink on paper
20 ½" x 10' 4 ½" (52.1 x 316.2 cm)
Josh Baer Gallery, New York

Codex Artaud (I). 1971

Cut-and-pasted paper, typewriting, gouache,
and ink on paper
23" x 7' 5" (58.4 x 226.1 cm)
Josh Baer Gallery, New York

Nancy Spero was born in Cleveland, Ohio, in 1926.
After receiving a B.A. from The Art Institute of
Chicago in 1949, she went to Paris, where she stud-
ied at the École des Beaux-Arts and at the atelier of
the Cubist painter André L'Hôte. After living in
Chicago, New York, Greece, and Italy, she moved to
Paris in 1959, where she had her first exhibition of
Black Paintings at the Galerie Breteau in 1962.
Spero returned to New York in 1964. Opposed to the
Vietnam War and dissatisfied with Pop and Minimal
art, she began the War series and became an
activist, joining in the activities of the Art Workers
Coalition from 1966 to 1969, and the Women
Artists in Revolution (1969). From 1969 to 1972
she worked on the Artaud Paintings and the Codex
Artaud, a key cycle of thirty-four friezelike drawings
using collaged texts. In 1971 she helped to found
Artists in Residence Gallery (A.I.R.), the first cooper-
ative gallery for women in New York, where she had
a number of exhibitions over the next decade,
including *Torture of Women* (1976), *Notes in Time
on Women* (1979), and *The First Language* (1981).
In 1978 Spero began to use a stamping technique
for her drawing. She used it extensively in series like
Re-Birth of Venus and Sky Goddess during the
1980s. Spero's first retrospective was organized by
the Institute of Contemporary Arts, London, in
1987. In the same year, a traveling retrospective
was mounted by the Everson Museum of Art,
Syracuse. In 1988–89 she made her first large
stamped installations in Toronto, Los Angeles, and
Frankfurt. The most recent large exhibition of her
work is a retrospective organized by the Haus am
Waldsee, Berlin, and the Bonner Kunstverein, Bonn
(1990). Spero lives and works in New York.

JEAN MICHEL BASQUIAT

Untitled. 1982

Oilstick on paper
60 x 40" (152.4 x 101.6 cm)
The Estate of Jean Michel Basquiat,
courtesy Robert Miller Gallery, New York

Jean Michel Basquiat was born in Brooklyn, New
York, in 1960. He spent much of his childhood draw-
ing pictures but was never formally schooled in art.
In 1975 he left high school, and two years later left
home to join a band of friends who made graffiti in
subways and on the Brooklyn Bridge. Their sprayed
drawings and murals were conceived as advertise-
ments for an invented religion called "Samo," a word
which also appeared as the signature "tag" in their
work. In 1980 Basquiat created a large mural for
The Times Square Show, began to decorate a wide
variety of found objects with his words and images,
and started a rock band called Grays. His first one-
man exhibition was held in 1981 at Annina Nosei
Gallery, New York. In 1984 he collaborated with
Francesco Clemente and Andy Warhol on a series of
canvases, and a year later produced an elaborate
temporary decor for the Palladium nightclub in New
York. Among the large international exhibitions in
which his work was included are *Documenta 7,*
Kassel (1982), and *An International Survey of
Recent Painting and Sculpture,* The Museum of
Modern Art, New York (1984). Basquiat's paintings,
drawings, and collages have been the subject of a
number of exhibitions at galleries and museums,
including the Institute for Contemporary Arts,
London (1985), Museum Boymans–van Beuningen,
Rotterdam (1985), and Kestner-Gesellschaft,
Hannover (1987). Basquiat died in 1988.

reproduce his figures rapidly, with the figures seeming to reproduce themselves as the line flowed from the brush under his hand. There was no differentiation in technique, whether the supports were wall, paper, or canvas.

Haring took up the notion inherent in Pollock's friezelike formats to prolong the experience of movement and transform it from a kinetic movement of the eye to a bodily movement over a physically extended space, thus carrying twentieth-century automatic linearism to a new extreme. He took its aesthetic to the edge of banality, but magically rescued it, doubling back to reinvigorate it with real physical and mental excitement, as his figures fight each other to a standstill, forcing each one to maintain its tightly assigned space.

Haring's figures are in the same genre as Penck's and Pollock's stick figures, the important difference being that Haring's drawings are public, not private, signs, although they were meant to mediate between the two. His highly decorative works operated as public murals, a whole class of drawings executed in white on blank, black-papered subway advertising spaces, inserted into the field of media communication. Others served as moral lessons on walls in public playgrounds. Their motifs are derived from the comics and often have a specific political twist. His long work (pages 70–71) with figures astride a phallus/bomb, angels in the corners, and diagrams of the structure of the atom (or the image of a mushroom cloud on TV) is a kind of ecstatic apocalyptic vision, reminding us of Slim Pickens riding an atomic bomb out the bomb-bay doors and shouting "Yahoo!" in Stanley Kubrick's film *Dr. Strangelove.* It seems to suggest that we party our way through the breakup of the world, as it deals with how to live with the atom bomb and the potential total shattering of civilization.

Haring's imagery, too, belongs to the wayward and mischievous class — again the body (and the work as a body) is central. He made direct connections between body-painting and his "pattern" painting; in one work he painted his body and every surface and every object in a room in a kind of allover savage camouflage — the confrontational and comic, deadly serious kind, with the adolescent as an idiot-savant, proclaiming redemption through the most unlikely means. Artists, no longer satisfied to merely comment on media manipulation or to be its objects, took over from the media their function of defining reality for the public and determining its perceptions and actions.

Regression as an attitude and working tool was endemic to the 1980s. Jean Michel Basquiat's work, too, was totally tied to drawing. At the same time it is different from Haring's in that it reflected his more old-fashioned, high-art ambition and genius (pages 75 and 76). It proceeds by way of the conventions of primitivism and of the child as primitive within modern art, pushing them to new accommodations. Basquiat's is the child's urgent drawing made before the conventions are learned, the sort of drawing encouraged in progressive art classes where the goal is self-expression. Yet Basquiat's art is not that of a precocious child. His work is hip; as part of the graffiti team that signed itself "Samo," he initially worked on the

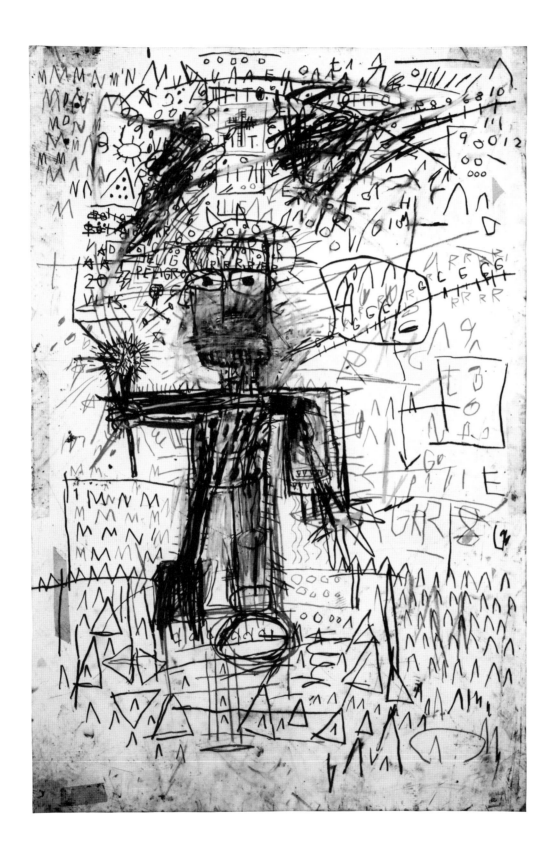

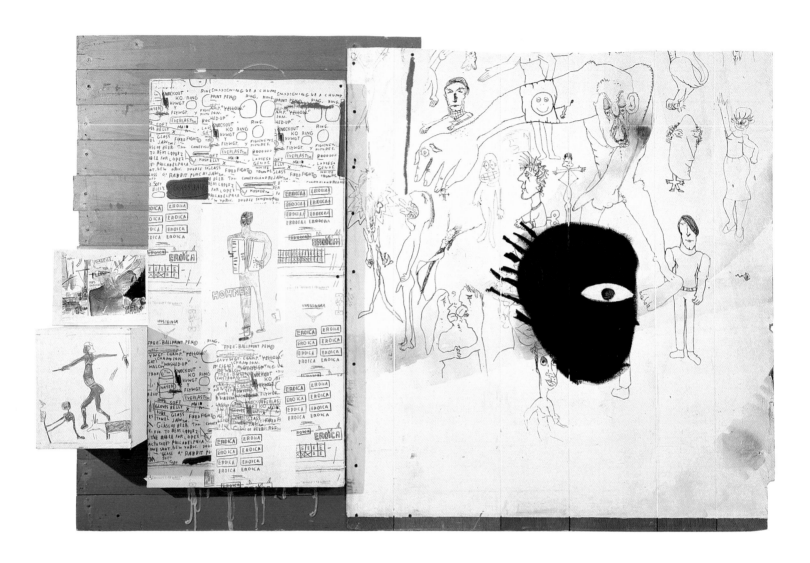

streets. Adapting the street vernacular and co-opting a modernist vocabulary to go with it, he quickly developed his characteristic, nervous, charged drawing gesture that acts as the agent among language, body language, and sign-making, letting him generate not only figuration but portraiture. Basquiat's work seems to have the vernacular and the desperation of the streets; but it also has a suavity and elegance that are part of the art of our time and also peculiar to Basquiat. His street experience accrues to his supports; the accidental marks on them are an aesthetic of experience. His quotations — both visual and verbal — run from modern sources, inside and outside high art and literature, cartoons, Rauschenberg, Dubuffet and *l'art brut*, street poetry, Langston Hughes, and back to the art of Egyptian friezes and funerary portraits; through the art of the Renaissance (a Madonna after Bellini with African features); to Haitian voodoo images (part of his mixed African-Haitian-Puerto-Rican-American-child-of-the-New-York-streets heritage). Recharging all these with the energy of his endangered generation, he even imparted some of that energy to his elder colleague Andy Warhol. Clemente's style is based on living on nerve, it is an "as if"; Basquiat also based his style on running fast, but he really did live on nerve, burning himself out at an early age.[61] Basquiat's symbols tend toward hieroglyphics; and he constantly reproduced his images, figuratively and literally, as he photocopied drawings and attached them onto a variety of supports, then drew over them in paint, crayon, and chalk. He constantly alluded to being described as "Black." Punning on blackboard drawing, he painted canvas black and drew black-featured portraits on it. Appropriating the appropriated, Basquiat portrayed a gallery of "primitives," including himself. His heroic image is the "wired" street-smart primitive (with drawing as the wire). His pastoral mode is strictly urban; if a contemporary version of the pastoral is indeed the reconciliation of the sophisticated with the simple, it is also no longer merely about a cultivated nature but about the darker underside of the pastoral — being "out there" in the wild, living on the streets, on nerve. In modern urban society we all do this to some degree. Basquiat shows us how to do it as an art form, at an extreme, taking his style — his formal vocabulary — "off the walls" from the street or inside the museum.

The pastoral posits an opposition between the natural and the cultural, the spontaneous and the mechanical. As Mike Kelley has noted (linking the idea to caricature, which is next to parody), it suggests that modernism itself resorts to caricature — a distorted portrait — of its own modes of operation. "Modernism," he has said, "distorts, and predominantly in one of two modes: through expressive abstraction or through reduction . . . binary methods of producing art objects."[62] Drawing is no longer natural in any sense (and line does not exist in nature, in any case), even as it imitates gesture. We have come to the point at which the layering of the imitations of imitation and its romance with the mechanical take on new meaning and lead in several directions: to Sherrie Levine, Richard Prince, Mike Kelley, Martin Kippenberger, George Condo, Tim Rollins + K.O.S.; to Stephen Prina, and Allan

JEAN MICHEL BASQUIAT
Embittered. 1986

Assemblage: cut-and-pasted papers and crayon on wood
49 ¾" x 6' ⅜" x 11 ¾" (126.5 x 184 x 30 cm)
Collection José Mugrabi

SHERRIE LEVINE

Sherrie Levine was born in Hazleton, Pennsylvania, in 1947 and grew up in St. Louis, Missouri. She studied at the University of Wisconsin, Madison, where she received a B.F.A. in 1969 and an M.F.A. in 1973. After spending two years in Berkeley, California, she moved to New York in 1975. Four years later she met Richard Prince who, like her, had been making photographs from magazine advertisements. In 1980 she began re-photographing works of photographers including Eliot Porter, Edward Weston, and Walker Evans from book reproductions. Her first one-woman exhibition, at Metro Pictures, New York, in 1981, featured copies of works by Walker Evans. A year later she began to make copies — first in watercolor and later in other mediums — from book illustrations, of works by various modern artists. In 1984, for *The 1917 Exhibition* at Nature Morte Gallery, New York, she juxtaposed works based on those by Kasimir Malevich and Egon Schiele. In 1985 she executed two series of works: Golden Knots, made of plywood with gilded knot holes, and the Broad Stripe paintings. In the late 1980s she moved into sculpture with a series of installations related to Dada and Surrealism. Levine was artist-in-residence at the Nova Scotia College of Art and Design, Halifax (1982), and has also taught at the California Institute of the Arts, Valencia. Her work was exhibited in *Documenta 7*, Kassel (1982), the *Biennial*, Whitney Museum of American Art, New York (1985 and 1989), with Robert Gober at *The BiNATIONAL: American Art of the Late 80's*, in Germany and the United States (1988), and in *A Forest of Signs: Art in the Crisis of Representation*, Museum of Contemporary Art, Los Angeles (1989). Levine has had numerous gallery exhibitions, and her work was the subject of a one-woman exhibition organized by the High Museum of Art, Atlanta (1988). Levine lives and works in New York.

McCollum. It leads also to photo-collage seen in a new light in the work of Doug and Mike Starn.

Sherrie Levine (page 79) works in a curious space between the reproduction and the copy in which her hand, as a surrogate for another's, subordinates it to her desire. Like Spero, Levine does not just appropriate, she appropriates male images and images of male desire, considering great modernist works as representations of that desire. Levine uses critical theory as a direct mechanism for producing artistic subjects for her works. If theory and criticism are the productive mechanisms in her work, appropriation is its mode of production. Levine's is a not-unconventional notion of artistic creativity at this time, although it is a creative reading; it takes its cue from the primacy Duchamp gave to the intellectual and from his strategy of appropriation (Levine has recently reappropriated Duchamp, "recasting" his found objects in precious materials). It refers also (among other things) to Walter Benjamin's famous essay, "On the Work of Art in the Mechanical Age," which for some time was extremely influential in advanced art circles. Levine uses appropriation as a tool; her photography has been instrumental in pointing out the levels of imitation in other styles. For example, critic Douglas Crimp notes that Levine's photographs of Edward Weston's photographs point up "the appropriation by Weston of classical sculptural style."[63] If her appropriation is instrumental in this sense, to what end are her drawing appropriations instrumental? The whole of her work points to the notion of originality as a trope, as a figure of speech — that element which has formed the constant subtext to modernism and to modernist drawing. Here allegory is revealed not merely as something added on but as inherent in the work. Levine appropriates originality itself, supplementing its meaning, as Owens notes, by emptying individual works "of their resonance, their significance, their authoritative claim to meaning,"[64] and supplanting it with her own text on originality.

Levine's copies of drawings and watercolors, whether abstract or figurative, are "ghosts of ghosts; their relationship to the original images is tertiary."[65] Traced from reproductions of the original picture already photographed several times, her work is reduced from the original but typically maintains the size of the book plate from which it was traced, as well as the appearance of the reproduction, in a process that compounds the leveling that reproduction has already imposed on its subject.

But Levine is not primarily concerned with leveling her subjects; she levels them only in order to give them new life, as in her own delicate, almost tentative hand she revives them as ghosts. Questioning and yet affirming the life cycle of works of art in the mechanical age, she gives new life to outworn images in the cycle from original to reproduction to reuse.

She has noted: "When I started doing this work, I wanted to make a picture which contradicted itself. I wanted to put a picture on top of a picture so that there are times when both pictures disappear and other times when they're both manifest; that vibration is basically what the work's about for me — that space in the middle where there's no picture."[66] If there is a certain poignancy to this enterprise, it is in

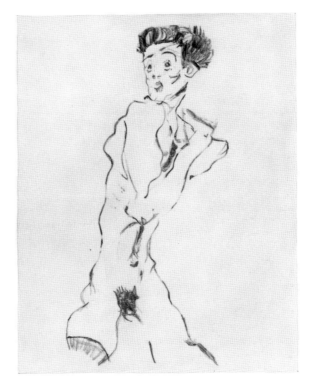

SHERRIE LEVINE

Four works from *The 1917 Exhibition*, Nature Morte Gallery, New York. 1984

Untitled (after Kasimir Malevich)

Pencil on paper
Image: 5 x 5 " (12.7 x 12.7 cm)
Collection the artist

Untitled (after Kasimir Malevich)

Pencil on paper
Image: 5 x 5 " (12.7 x 12.7 cm)
Collection the artist

Untitled (after Egon Schiele)

Pencil on paper
Image: 7 ¼ x 5 ⅛ " (18.4 x 13 cm)
Collection the artist

Untitled (after Egon Schiele)

Pencil on paper
Image: 8 x 6 ½ " (20.3 x 16.5 cm)
Collection the artist

ELLEN PHELAN

Neighborhood. 1990

Watercolor on paper
27 x 37 ¾" (68.6 x 95.9 cm)
The Museum of Modern Art, New York
Gift of Edward R. Broida

Ellen Phelan was born in Detroit, Michigan, in 1943.
She attended Wayne State University, Detroit, where
she received a B.F.A. in 1968, an M.A. in 1970, and
an M.F.A. in 1971. From 1969 to 1972 Phelan
taught art at Wayne State University. Her first one-
woman exhibition was held at the Willis Gallery,
Detroit, in 1972. Her work was first exhibited in New
York at Artists Space in 1975 during the second
year of a teaching appointment at Michigan State
University, East Lansing. Phelan continued to teach
until the early 1980s, holding positions at various
institutions including the California Institute of the
Arts, Valencia (1978–79 and 1983), Bard College,
Annandale, New York (1980), New York University
(1981), and the School of Visual Arts, New York
(1981–83). Since 1985 she has exhibited regularly
at Barbara Toll, New York. An exhibition of her draw-
ings was organized by The Baltimore Museum of Art
in 1989. Her paintings were included in the *Biennial*,
Whitney Museum of American Art, New York (1991).
Phelan lives and works in New York.

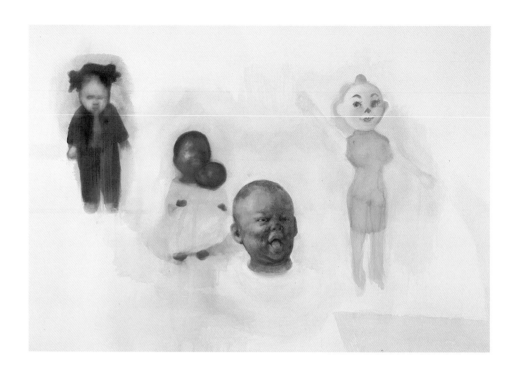

her mourning the "uneasy death of modernism,"[67] perhaps seeing modernism as a lost world in which originality did not seem to be a question of manipulating all the other pictures.

Traditionally, drawing is a skill learned through copying from both reproductions and originals as an academic exercise. Its incorporation into the notion of originality follows from the notion of mastery. Although the sense of drawing as idiosyncratic has existed at least since the Renaissance, modernism placed a particular emphasis on originality in the sense of both invention and individuality; valuing spontaneity above skill, it required every artist to invent his own drawing just as he had to invent his own style. Like Levine, Ellen Phelan and Rosemarie Trockel confront aspects of this tradition differently, as do Mike Kelley and Christopher Wool.

Ellen Phelan, too, brings the dead back to life although in a wholly different way from Levine; her doll models are inanimate and could be taken for dead (see above). Copying is personification, representation of a particular order: one definition of copying is to work from some object before the eyes and re-create it on the sheet. Phelan (like Kelley) copies from old used dolls. As projections of fantasy, dolls are primarily vehicles of personification; susceptible to every kind of anthropomorphism and endless manipulation, they act as the embodiments and representations of primary fantasies. Dolls are the first play things; as our first whole inanimate extensions of self we endow them with our own longed-for life, our hopes and fears.

Phelan brings her experience as a landscapist to her doll portraits; they are seen through veils of watercolor, establishing a deep indeterminate space through atmospheric perspective. The dolls themselves are treated as masses; all details are suppressed, and the scale is indicated by the "touch" of the brush, which in its turn is adjusted to the larger mass that veils them. Phelan's earlier works — landscapes — had been pearly tonal grays and blacks; her recent color treatment grows out of this chiaroscuro, as she blurs the formal and tonal definition of her objects, suggesting an atmosphere that places them at a distance. This traditional landscape approach, transposed and contrary to expectation, yields a structure typically postmodern in its ambiguity and in its emotional yearning toward the foreclosed past, which in this case is specifically adolescent and feminine. However, the dolls and their drawings function on two levels. As personifications, they are not only about the play of fantasy but its control of dread and death. A number of Phelan's drawings portray old-fashioned dark-skinned dolls — some tender babies, some with angry faces, sometimes alone, and sometimes in ensembles with white dolls, which the artist calls "princesses." All these figures are alienated from one another, as in her portrayals of families; nevertheless, this kind of integrated portrayal is unusual. Expressing as it does both fear and desire, controlled by being expressed through surrogates, it discloses ambivalence on a larger scale. If Basquiat shows us one stereotype from the point of view of his Caribbean-African-American background, it seems that Phelan shows us another from the white middle-class view, going back in time to allude to the idealized fiction of *Gone With the Wind*. Exposing the stereotype, she creates a typology that ponders the fear of the "other" as a distinctly sociopsychological phenomenon. Functioning also as a shuttle among classes of objects (the human and the manufactured, the real and the made-up), it is a device that joins irreconcilable objects in an apparently seamless but psychologically alienated space, suggesting no escape.

Copying is not just repeating; it is also, more generally, imitation, working in a tradition or imitating someone's style. Martin Kippenberger's *Die Welt des Kanarienvogels* [*The World of the Canary*] (page 83) is a blatant parody of Penck's signatory primal scrawl in *Welt des Adlers*. Inner necessity creates Penck's scrawl; its automatism is due to its "naturalness." Imitating Penck at exactly one-quarter scale, Kippenberger found this sort of drawing unnatural, and had to work hard at it. As a result, each of his drawings is carefully constructed, almost Cubist in its careful adjustment to the edges of the sheet and reference to its center of gravity, and in its linear pattern. There is also the difference in touch between drawing from the wrist at Kippenberger's scale and drawing more from the whole arm at Penck's scale. The smaller scale, as well as the difficulty of "tracing," results in a more careful, thought-out drawing line. Both series of drawings were conceived as artist's books, so that the Penck is a long loose series of some four hundred seventy-two images and the Kippenberger is a series of one hundred fifty-six; both were ultimately made into books.

Parody is a kind of homage. Kippenberger's is wry and political in art-world terms, in that it is addressed to a contemporary working within the same local

ALBERT OEHLEN

Study for *Tannhäuser.* 1987

Cut-and-pasted printed papers, pencil,
and ink on paper
11 ½ x 8 ¾" (29.2 x 22.2 cm)
The Museum of Modern Art, New York
Gift of R. L. B. Tobin

Albert Oehlen was born in Krefeld, Germany, in
1954. From 1970 to 1973 he was an apprentice in
book publishing. Together with artist Werner Büttner
in 1976 he founded the Liga für Bekämpfung des
widersprüchlichen Verhaltens (League Against
Contradictory Behavior), whose official journal, *Dum
Dum,* was first published in 1977. From 1977 to
1981 he studied at the Hochscule für bildende
Künste, Hamburg, with Sigmar Polke and Claus
Bohmler. Though primarily a painter, Oehlen has
worked extensively in collage and produced records,
books, prints, and stage designs, often in collabora-
tion with other artists. Among his books are *Mode
Nervo* (with Georg Herold, 1980), *Facharbeiterficken*
(with Werner Büttner and Georg Herold, 1982),
Ewige Feile (1983), *Angst vor Nice (Ludwig's Law)*
(with Büttner, 1985), *Poems, Part II* (with Martin
Kippenberger, 1987), and *It's Unappetizing to Swim
in Slime* (with Mayo Thompson, 1990). His
Procrustean Paintings were exhibited at the
Kunsthalle, Zürich, in 1987. In the same year he
collaborated with Reinald Goetz on a production of
Richard Wagner's *Tannhäuser* at the Theater der
Freien Hansestadt Bremen, contributing costume
and stage designs. His first one-man exhibition was
held at Galerie Max Hetzler, Stuttgart, in 1981. His
work was exhibited in *The BiNATIONAL: German Art
of the Late 80's*, in Germany and the United States
(1988). Oehlen lives and works in Vienna.

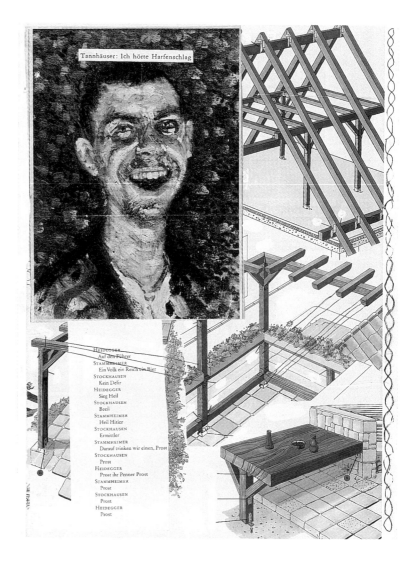

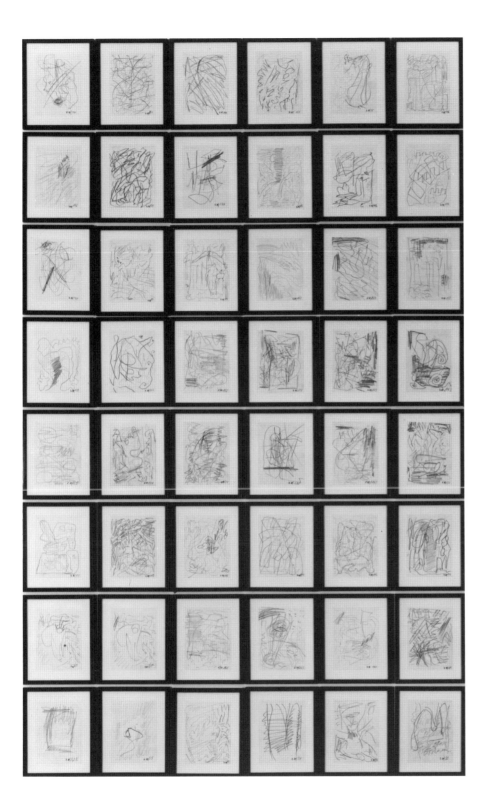

MARTIN KIPPENBERGER

Die Welt des Kanarienvogels [The World of the Canary]. 1988 (Detail)

Pencil on paper
64 of 156 sheets, each 5 ½ x 4 ⅛" (14 x 10.5 cm)
The Museum of Modern Art, New York
Gift of Walter Bareiss and R. L. B. Tobin

Martin Kippenberger was born in Dortmund, Germany, in 1953. He attended the Hochschule für bildende Künste, Hamburg, from 1972 to 1975, where he studied with R. Hausner and F. E. Walther. In 1978 he moved to Berlin and, with Gisela Capitain, opened Kippenbergers Büro (Kippenberger's Office), an exhibition space where he exhibited his own work and that of Georg Herold, Albert Oehlen, and Werner Büttner. A year later he opened the rock music club S.O. 36, named for its postal code. In the early 1980s he moved to Stuttgart, and in 1982 to Cologne. His collaboration with Büttner and Oehlen continued, most notably in the book and exhibition Wahrheit ist Arbeit [Truth is Work] at the Folkwang Museum, Essen (1984). In addition to his work in collage and drawing, for which he first became known, Kippenberger works extensively in painting, sculpture, and photography. He currently teaches at the Städelschule Staatliche Hochschule für bildende Künste, Frankfurt. Kippenberger has had a number of one-man exhibitions: at the Hessisches Landesmuseum, Darmstadt (1986), the Villa Arson, Nice, and the Fundació Caixa de Pensions, Barcelona (both 1990), and the San Francisco Museum of Modern Art (1991). His work was exhibited in BERLINART, The Museum of Modern Art, New York (1987) and in the Venice Biennale (1988). Among the numerous artist's books he has produced are Was Immer auch sei Berlin bleibt frei [Whatever May Be, Berlin Stays Free] (1981), Für Albert Oehlen . . . Abschied vom Jugendbonus! Vom Einfachsten nach Hause [For Albert Oehlen . . . Farewell from the Youth Bonus! Go Home with the Homeliest] (1984), Psychobuildings (1988), and Die Welt des Kanarienvogels [The World of the Canary] (1989), a homage to A. R. Penck's book Welt des Adlers [World of the Eagle] of 1984. Kippenberger lives and works in Cologne and Frankfurt.

GÜNTHER FÖRG
Untitled. 1990

Synthetic polymer paint on paper
8' 6 ½" x 59 ¼" (260.4 x 150.5 cm)
Luhring Augustine, New York

Günther Förg was born in Füssen, Germany, in
1952. From 1973 to 1979 he studied painting
under K. F. Dahlman at the Akademie der bildenden
Künste, Munich. His first works after leaving the
academy were wall paintings and installations par-
tially inspired by the works of Blinky Palermo and
Sol LeWitt. In 1983–85 Förg began to make archi-
tectural photographs of women as large-scale
independent works, and often used them in his
installations. Later he began to make paintings on
sheets of lead. Around 1987 he began to work in
bronze, producing freestanding and wall-mounted
reliefs that have surface structures similar to those
of his watercolors. Förg's work has been shown in
The BiNATIONAL: German Art of the Late 80's, in
Germany and the United States, the *Carnegie
International*, Museum of Art, Carnegie Institute,
Pittsburgh (both 1988), and in one-man exhibitions
at the Stedelijk Museum, Amsterdam (1985), the
Haags Gemeentemuseum, the Netherlands (1988),
Newport Harbor Art Museum, California (1989), and
the Museum Fridericianum, Kassel (1990), Förg
lives and works in Areuse, Switzerland.

Opposite:
GEORGE CONDO

Big White One. 1987

Charcoal and oil on canvas
8' 3" x 9' 10 ¼" (251.5 x 300.4 cm)
Collection Robert M. Kaye

George Condo was born in Concord, New
Hampshire, in 1957. He moved to New York in
1979. His first one-man exhibition was held at Ulrike
Kantor Gallery, Los Angeles, in 1983; the following
year he was given an exhibition at the Barbara
Gladstone Gallery in New York. His paintings have
been included in several large group exhibitions:
Artistic Paradise, Folkwang Museum, Essen (1985),
and the *Biennial*, Whitney Museum of American Art,
New York (1987). In addition to many gallery exhibi-
tions in Europe, America and Japan, he has had a
one-man exhibition, *The American Painter of the
20th Century in Germany*, at the Kunstverein,
Munich (1987). In 1991 he worked with printer Aldo
Crommelynck on illustrations for *The Ghost of
Chance* by William S. Burroughs. Condo lives and
works in Paris.

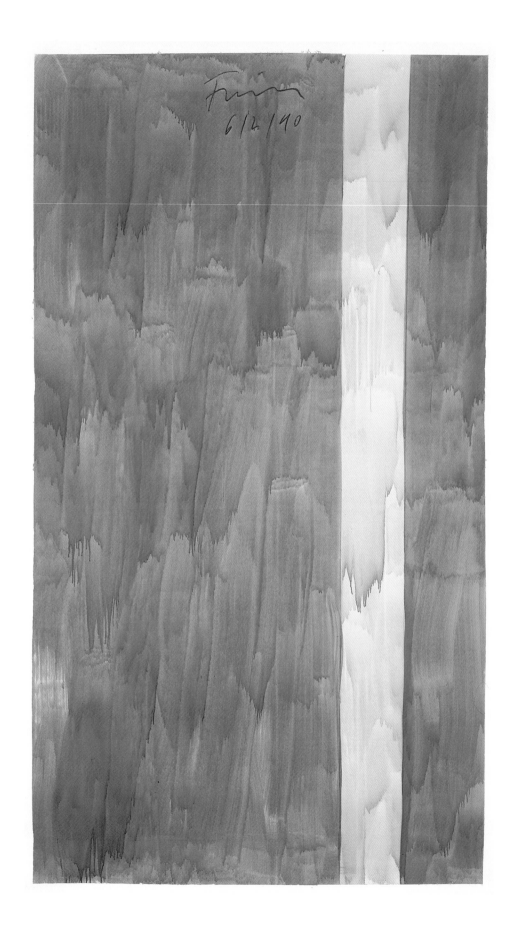

German scene while challenging Penck's solution and tradition. More importantly, it addresses the problem of signatory drawing and the "exhaustion" of images, and of the need to deplete them through repetition until they become arbitrary and ultimately bear new meaning (Kippenberger traced over his book pages, producing four more versions, two made by students). For Kippenberger, and his colleagues Albert Oehlen (page 82) and Werner Büttner, the German past is frequently approached through incisive parody. Their work is related to the political collage tradition of Baargeld (Alfred Grünewald) and Johannes Baader, rather than to expressionistic rendering, which Kippenberger usually saves for painting, thereby making a clear distinction between various technical traditions. Especially in Kippenberger's collages, images are pushed beyond mere Dada juxtaposition to a coded matrix of interwoven parts, echoing the matrix of communications media. The three artists started as collaborators in Hamburg, then moved to Cologne, and have worked collaboratively (and individually) on satirical, political artist's books, using collage and drawing as primary forms.

Christopher Wool's work (page 86) requires a different reading. He is interested in changing denoted meaning by disrupting the continuity of word-and-image patterns and rearranging them. The bearer of meaning in Wool's work is the disjunction of the wholeness of the continuous structure. His work focuses on the decorative details, on what is peripheral; the background comes to the foreground as a new subject, marking the depletion of the decorative tradition (much as Kippenberger marks the exhaustion of imagery as he lapses into abstraction) and its revival through reprocessing. His use of stamping rather than hand-drawing also points to the depletion of the tradition of both the handmade and the mechanical and the need to reinvigorate both through a new mechanical hand-process. Paradoxical as this may seem, it is in reality a new accommodation that is thoroughly in accord with the history of the mark as a mechanism. His permutations of stamped images point not simply to layers of meanings but, as in Jenny Holzer's work, to the exhaustion of images and language (in clichés), of originality, and finally, of meaning; for if nothing has its own identity, how do we know it?

Completely opposite in his approach, although he too is reworking "exhausted" images, is George Condo. His parody is not a challenge but represents a more nostalgic homage to the distant heroes of Abstract Expressionism, as he tracks Picasso's 1910 brushstroke through Arshile Gorky, creating in his painting *Big White One* (page 85) both an allusion to *Moby Dick* and a homage to Gorky's great drawing *Summation* (1947) as he embroiders the whole surface of the canvas with little pencil drawings, buried in among the paint strokes as if among waves. The drawing complements the painted areas; each re-creates the forms in the Gorky, echoing one another. Within the context of Gorky's biomorphic forms, various cartoon creatures are personified. These also re-create themselves as Picassoid and Cubist, retracing Gorky's steps. As the painting plays with Cubism's continuation of drawing into the painting process (although reversing it) and with the notion of Surrealist, automatic

CHRISTOPHER WOOL
Untitled. 1991

Alkyd paint stamped on paper
52 x 40" (132.1 x 101.6 cm)
Luhring Augustine, New York

Christopher Wool was born in Chicago in 1955. Although his work was included in several group exhibitions in the early 1980s and he had already worked in a variety of mediums including film, Wool considers his mature work to have begun in 1984, when he exhibited a series of poured paintings at the Cable Gallery in New York. From this he progressed to more deliberately mechanical techniques, using incised rollers, stencils, and stamps to execute paintings and drawings composed of words and phrases or floral and vine patterns. Wool's work has been included in a number of group exhibitions, including *The BiNATIONAL: American Art of the Late 80's*, in Germany and the United States (1988), *Horn of Plenty*, Stedelijk Museum, Amsterdam (1989), and the *Biennial*, Whitney Museum of American Art, New York (1989), for whose catalogue he designed the cover. *Cats in Bag/Bags in River* (1991), a one-man exhibition, was organized by the Museum Boymans–van Beuningen, Rotterdam, and the Kunstverein, Cologne. Wool has published a variety of books, often in conjunction with exhibitions, which include *93 Drawings of Beer on the Wall* (1984), *Empire of the Goat* (1985), and *Black Book* (1989). Wool lives and works in New York.

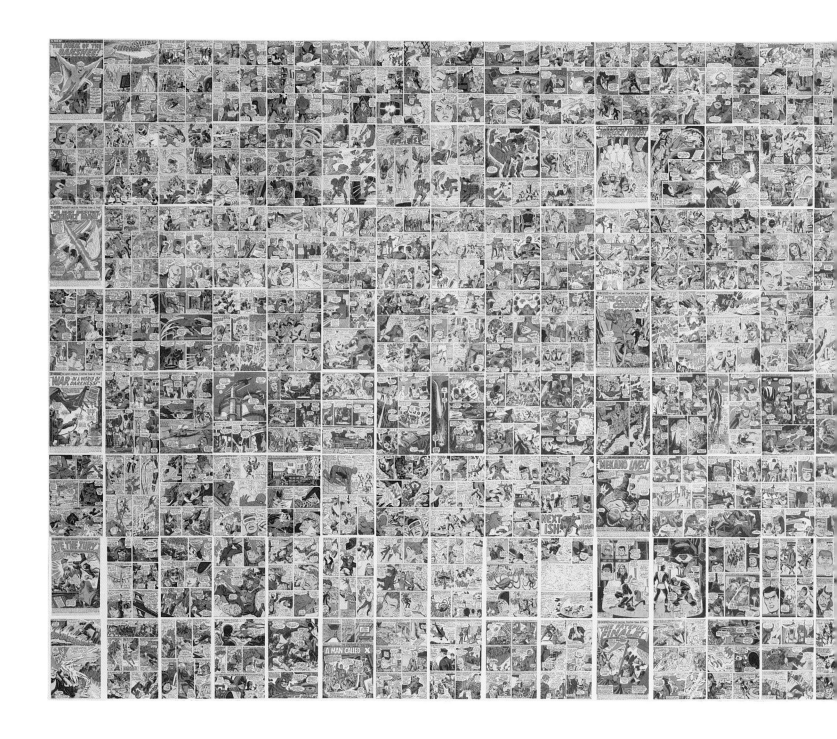

TIM ROLLINS + K.O.S.

X-Men 1967. **1990–91**

Cut-and-pasted comic-book pages on linen
6' 1 ¾" x 15' 9 ¼" (187.4 x 480.7 cm)
Collection Ari Straus

Tim Rollins, founder of The Art and Knowledge Workshop and its subsidiary Tim Rollins + K.O.S. (Kids of Survival), was born in Pittsfield, Maine, in 1955. He received a B.F.A. from the School of Visual Arts, New York, in 1978, and afterward studied with artist Joseph Kosuth in the Department of Art Education, New York University. Rollins was one of the founders in 1980 of Group Material, an organization of artists dedicated to social change. From 1980 to 1982 he taught in the Learning to Read through the Arts Program, a special project of the Board of Education, and from 1982 to 1987 was a special education teacher at a school in the South Bronx. The Art and Knowledge Workshop and K.O.S. began in 1982 as an after-school and weekend program for some of Rollins's teenage students. Under his leadership, the students discussed a variety of works of literature; out of this grew the group's practice of drawing directly on book pages. The group's first exhibition was organized by the Bronx Museum of the Arts and Hostos Community College in 1985. Their work was shown in the *Biennial,* Whitney Museum of American Art, New York (1985 and 1991), the Venice Biennale (1988), and *The BiNATIONAL: American Art of the Late 80's,* in Germany and the United States (1988). They have had exhibitions with Fashion Moda (1986), at the Walker Art Center, Minneapolis, and The Institute of Contemporary Art, Boston (both 1988), and at Riverside Studios, London (1988). *Amerika,* a series of monumental collage drawings done between 1984 and 1989 and based on Kafka's novel, was exhibited at the DIA Art Foundation, New York, in 1989. The group has received a number of awards, including the second annual Joseph Beuys Prize in 1990. Recently, they have begun working to establish the South Bronx Academy of Fine Art, with buildings designed by Aldo Rossi. There are currently eight active members in the group: Angel Abreu, George Abreu, Christopher Hernandez, Victor Llanos, Nelson Montes, Carlos Rivera, Nelson Savinon, and Lenin Tejada.

biomorphic drawing as it developed out of Cubism, a history of twentieth-century drawing is created. Condo refers specifically to Gorky's development of biomorphic form and his painting mark out of Picasso. More specifically, *Big White One* belongs in the same category as the psychological landscape, as it also quotes Yves Tanguy's strange biomorphs, Mark Tobey's birds (and Disney's Woody Woodpecker), and Pollock's drips; it is a wide-ranging history of automatism. It then leads right into Pop, enveloping real cartoon images and cartooning Picasso, to incorporate them as part of the history of Surrealist automatism and "Cubism" (and a good history of Disney would do much the same). It also makes a direct reference to Johns's earlier burial of cartoons in his painterly wax collages. Condo's hand is wonderfully tender as he creates this homage, almost a Garden of Eden of modernism at a particularly fecund moment — the birth of Abstract Expressionism, which he conceives of as his legitimate birthright.

Günther Förg (page 84) works rather differently with the influence of Abstract Expressionism. For him abstraction is a form of figuration, a "representation" of abstraction and a homage. The homage is to Blinky Palermo, Barnett Newman, and Color-Field painting — again to light in painting and photography, which he practices as separate modes although they are related through their interest in capturing light and in a curious manner in molten-relief sculpture (actually lead paintings). As he works, Förg reserves to each discipline its "proper" genre: his gouaches are abstract, his photographs figurative, and his sculpture seems to be about material, the received history of twentieth-century sculpture (the history of cast sculpture, since Rodin), and the dependence of twentieth-century sculpture on painting. Because Förg is creating a realignment of disciplines to form a new conceptual whole, he is at his most effective in one-man shows, in which works are installed according to medium, room by room. In these installations the works are arranged in monumental and cinematic progressions laden with tension, the architectural detail of the environment becoming part of the geometry of the work. Förg's relentless geometry presses the air out of the environment, and the space often becomes menacing despite the latent message of hope in the numinous halo of the work. For Förg, "Reality becomes a cage from which there is no escaping: it is a terrible vision which, intentionally or not, Paul Cézanne shares with Kafka. The idea of injecting meaning into abstract geometric forms as though it were a drug has to do with the furtive archaism of twentieth-century art. It is an archaism which Günther Förg is clearly at pains to track down, whenever, like Baselitz, Kirkeby and Kiefer, he treats modern elements in a hieratic way. . . . Förg works on this historical terrain . . . taking the old existentialist problem — the process of self-being in the world — and transcending it from outside."[68]

Rosemarie Trockel, following in Beuys's tradition, makes intimate and highly personal drawings that are one aspect of a body of work, including painting and sculpture, meant to be seen as a total structure. This refers to the notion of Woman's body and what constitutes the body of women's work in a male-dominated society

ROSEMARIE TROCKEL

Untitled. 1986

Ink on paper
46 ½ x 27 ⅛" (118.1 x 68.9 cm)
Collection Raymond Learsy

Rosemarie Trockel was born in Schwerte, Germany, in 1952. Though she was a student of painting at the Werkkunstschule, Cologne, from 1974 to 1978, her work there consisted almost entirely of drawings. She also had strong interests in anthropology, theology, sociology, and mathematics. Like her early influences, Joseph Beuys and Sigmar Polke, Trockel has kept free of any stylistic program, moving freely within a variety of mediums including traditional drawing, spray-painting, painted plaster, weaving, and knitting. Her subjects have been wide-ranging, from sculptures reminiscent of mummified creatures in anthropological or archeological collections, to vessels, to garments and knitted patterns that take up problems of feminism. Since 1983, when she had her first one-woman exhibition, she has exhibited regularly at Monika Sprüth Gallery, Cologne. Her first museum exhibition was held at the Rheinisches Landesmuseum, Bonn (1985), where she exhibited vase-sculptures, drawings, and knitted works. In 1988 a traveling exhibition was organized by the Kunsthalle, Basel, and the Institute of Contemporary Arts, London. In the same year her drawings and sculptures were exhibited as part of the Projects series at The Museum of Modern Art, New York, and in *The BiNATIONAL: German Art of the Late 80's*, in Germany and the United States (1988). In 1991 The Institute of Contemporary Art, Boston, and the University Art Museum, University of California, Berkeley, organized a traveling retrospective, while the Kunstmuseum, Basel, mounted a large traveling exhibition of her drawings. Trockel lives and works in Cologne.

(and especially the German art world). She creates not only highly personalized drawings on the natural and savage state of the psyche in images of apes or on the culturalization of the savage through images of pots, but also creates "knitted paintings" as representatives of that traditional body of women's work. The drawing represented here (page 91) is a study for the fabricators of these mechanically produced knitted works, which operate as a discourse on female subjugation: the superstructure of the grid is a metaphor for that subjugation. The transfer from a hand to a mechanical process exposes the "fascist" fallacy of women's place in the home as it alludes to women's work as units in a production system. She has even made a drawing machine which renders drawings with strands of the hair of various male colleagues — perhaps an allusion to Samson and Delilah.

As the 1980s progressed new conceptual strategies came to the fore, as artists (some of whom were partially involved with performance and installation work) re-examined painting. Mike Kelley initially worked in performance, but now works in painting and sculpture, although like other artists under discussion he strains the definitions of those disciplines. He rejects a distinction between modes based solely on material, or for that matter on support. As he points out, there is "a whole tradition of linear painting. . . . The whole discussion of drawing versus painting was based almost totally on materials . . . what kind of material you used. And then it sort of shifted into some kind of a notion of mediacy, or linearity. But that rather falls apart, because you know there is a whole tradition of linear painting. And there is a whole discussion surrounding Pollock about this drawing into painting or the collision of painting and drawing. It seems to me that after that the whole notion falls apart and all those kinds of definitions of drawing just go away, because if you start to, say, render expression or Conceptual art, where everything is basically illustrational, even randomness is illustrational. You can't make those definitions anymore. Even a machine can be programmed to be gestural."[69]

Although wary of such distinctions (he works basically with other conventions) Kelley, like Marden, differentiates between the preliminary aspect of drawing and the finished aspect of painting. When pressed, he also admits to seeing drawing initially as a matter of pencil and paper; his concerns are basically graphic, and those graphic concerns carry over into painting. He is interested in the graphic as an aesthetic category in itself. One group of his works played with the flatness of surface inherent in drawing by pinning huge black-on-white works on paper onto the canvas. Kelley conceives of drawing as a skill through which any graphic style may be appropriated if the artist is given sufficient time in which to practice. As a conceptual matter, this brings us back to leveling, and Kelley's style is based on the leveling of graphic conventions to re-create them as painting. Like the earlier Pop artists, he appropriates "low" stylistic conventions, running them through "high" ones. There are also political and social concerns. In the group of works that includes *Defamation: Soft and Hard* (page 99), the linear conventions of illustration and cartooning combine with the black drawing of early works by Lichtenstein to tell a

DOUG AND MIKE STARN
Crucifixion. **1985–88**

Toned silver print, wire, ribbon, wood, and tape
10 x 16' (304.8 x 487.7 cm)
Collection the artists

Doug and Mike Starn were born in Absecon, New Jersey, in 1961. They studied at the School of the Museum of Fine Arts, Boston, where they each received a diploma in 1984 and a Fifth Year Certificate in 1985. Their large photo-collages, which often reproduce in fragmentary form images of well-known historical works of art, were featured in the *Biennial*, Whitney Museum of American Art, New York (1987), *The BiNATIONAL: American Art of the Late 80's*, in Germany and the United States (1988), and in numerous photography exhibitions in America, Europe, and Japan. Among their joint exhibitions are *The Christ Series* at The John and Mable Ringling Museum of Art, Sarasota, Florida (1987), a touring exhibition of selected works organized by the Honolulu Academy of Art (1988), the *Anne Frank Group* at Leo Castelli Gallery and Stux Gallery, New York (1989), and a large traveling survey exhibition mounted by the Contemporary Arts Center, Cincinnati (1990). During the late 1980s the Starn twins began to combine their photographic work with sculpture, first in a series of wall constructions using pipes and clamps, and later in more elaborate three-dimensional constructions. Doug and Mike Starn live and work in New York.

story through the ideology of popular imagery and the personification often employed in cartooning.

Kelley is ideologically interested in communal imagery; the closest one can get to it is through the aesthetic conventions that he believes speak formally to even the most "innocent" viewer. His new project is a double narrative: the story of John Reed the communist and a school friend, John Reed, whose drawings Kelley admired and with whom he (and several other boys) worked to produce comic books drawn in pencil that personified objects — a scheme Kelley uses to this day as a primary formal device and which he believes in as the mainstay of all art production. His explanation of this project details ideas that inform all of his work. He copies his school friend's cartoon drawings and their style to tell the story of the historical John Reed in a conventional idealized fashion, like illustrations for kids' stories of heroes in a kid's style. The visual narrative, however, doesn't tell *the* John Reed story; it is the story of the personified blob as told by Kelley's adolescent friend.

This multipartite, semifictional work becomes both John Reed's story and Kelley's autobiography, one being read through the other, as Kelley, radicalized in his adolescence by the youth culture, was led into the world of "adult critical mentality." The experience of working communally with a group of adolescent friends was his first introduction to the idea that he would be an artist.

Kelley treats drawing as a form of biography; although he thinks that drawing as a form of biographical story is just a matter of reading the surface, it is more complex than he acknowledges. Kelley tells his stories in cartoon style, using the cross-axis between the visual and the verbal. He sees style as ideological; content is read through form. Going back to his formalist training, he thus makes allegory a formal principle. According to Kelley formal rules are just extensions of ideologies. Style is something to be adopted, in a sense, to be put on to suit the occasion. He has recently said of his newest project: "I've been researching John Reed the socialist and then the John Reed clubs that were named after him, where they kind of battle out the whole American notion of agitprop, which is so similar to the discussions now about political art. . . . So, it is very similar now to the discussion of how something like agitprop relates to the viewer, and who the viewership is: this whole notion of radicalism in art and class, and how it relates to lower forms, like advertising and cartooning."[70]

Style is an essential component of the modernist message as well as of the "utilitarian" social message; but it is not (according to Kelley) a particular concern of cartooning. Nevertheless in Kelley's appropriations of this style, drawing itself does tell a story. And Kelley has a particular story to tell: it is about adolescence as a style and as a special area of art production — of youth culture and the origins of art. It is about adolescence as the threshold of adult creative involvement in society. Adolescent behavior translated into the language of art, particularly in Dada and Surrealist collage, was a trope for a critique of adulthood and its failures—a strategy for remaining outside that is bound to fail, since adolescence is neither the inno-

cence of childhood nor a transfer of primitivism onto society. Adolescents are biological adults; they are *inside* the culture — often dysfunctional but nevertheless inside seeking to become functional. They are pictured as powerful by Kelley because, standing at the threshold of adult socialization, they are at a moment of maximum power, full of hope for change by sheer force of will. In art the dysfunction becomes idealized; idealized, the dysfunctional becomes heroic as the artist gets trapped into looking for perfection. But the "avant-garde" artist now has permission to be antisocial, he is socially sanctioned and expected to be an outsider, a kind of radical-chic pet, so that as a result the whole notion of not conforming becomes problematic. Thus the art of the adolescent is looked at with nostalgia. In this fashion, Kelley looks back at his own roots and addresses the problem of idealizing the radical. What he is trying to address with these drawings is his idea of adolescent style and its relation to the origin of the artistic impulse. As Kelley explained when asked how he could return to an adolescent style, that is, make a socialized drawing in a cartoon style that looked like a thirteen-year-old had made it, he replied that if the artist is sufficiently skilled, he can draw anything that he looks at, even imitate the untrained. Everything is a style — even adolescence can be created as a style. "I can draw like a cartoonist, or like an advertisement, or I can draw like Pollock, if I want to. It's just another style. . . . It's just a lexicon . . . a visual language. I tend to keep to certain lexicons more for social or political reasons than I do for any other reason; I can shift lexicons, based on what I want to say. . . . If I let my hand show, I tend to like to keep it to something that is about the 'personal.' . . . So I don't have to get caught up into an aesthetic argument about whether my hand is good or bad, because . . . those kinds of aesthetic arguments are moot points. . . . I'm not going to get down to saying that the hand is a good or a bad hand."[71]

In Richard Prince's hands (page 100) the cartoon drawing becomes another aspect of the pastoral, as the unlikely machine invades the Garden, the low meets the high, and the snake enters paradise: in a suburban kitchen, a mother helps her child "shoot up." Prince, perversely, works both in and against the new technical language; burrowing from within, he copies from magazine cartoons and restores them to the hand. He also borrows, not only from cartoon conventions but, as an ex-collagist working with photographs, from a photographic convention in which picture and caption oscillate around one another, meeting only in a disjunctive fashion. Their meanings however do not coincide so neatly as the convention suggests; Prince's jokes form a wild text parallel to his pictures, elaborating on the central caption as a kind of free-form personal rap. Written jokes and pictures developed apart at first, coming together in his *New Yorker*-cartoon appropriations. There is the interplay between the "abstract sublime" and the anecdotal detail — a meeting at the center in an exaggeration of extremes — in Prince's juxtaposition of written and printed text, jokes, and images against the spacious white monochrome support with its layers of broad paint strokes, which refers back to heroic abstraction at its best. Formerly Prince withheld his hand as beside the point, a side issue to the graphic

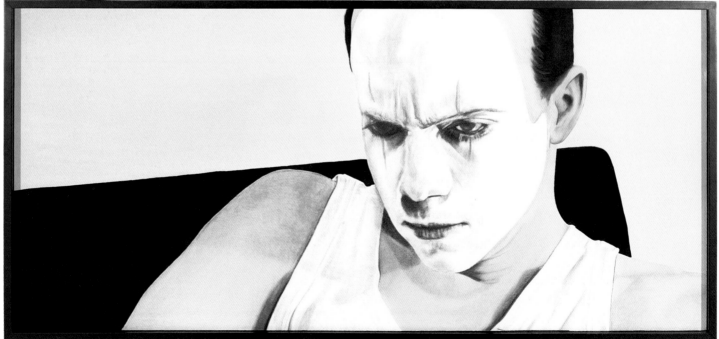

image with its neutral message and to the message of manipulation that the mechanical (in the form of photo-collages) delivered to his Gangs collages and that silkscreens delivered to his "*New Yorker* cartoons." Recently he has begun to show his drawing appropriations, juxtaposing drawing, silkscreen, and paint on both paper and canvas so that the hand and the mechanical, the "natural" and the cultivated, are read through one another. The accessible language of hip cartoon drawing is copied with a seriousness that recalls Oldenburg's theory that drawing is only possible as a parody of high style. However, Prince's parody is not of the baroque but a takeoff on conventions of intellectual cartoon drawing of a certain era — itself a parody of the truly skillful drawing that is used as a paradigm of "real art" in popular parlance. Prince is working, like Kelley (and Oldenburg), with the notion of skill (he, too, can copy any style or hand) so that as reproduced drawing is turned back into hand drawing yet another inversion of modernism's idea of originality is produced. But the inversion is more cynical; the stakes have been raised. If Oldenburg's imitation was of a high baroque drawing style, and Lichtenstein's was a version of modernist art and style seen through the conventions of the cartoon, Prince, like Kelley, is now imitating the stylistic conventions of popular drawing itself, re-creating a new stylistic vocabulary. This strategy is not unlike that of Braque and Picasso as they approached popular imagery and techniques in creating Cubism.

For Mike and Doug Starn (page 92) the creative process resides in two modes of production: behind the camera as a critical function and afterward as the critical process is prolonged, in a nonmechanical (sentiment-laden) function — the process of the retrieval of history. They work within photography, painting, collage, and drawing conventions. In a reversal of photography, they "return" it to cut-and-paste collage, in which the photographs, usually of "pre-modern" art, resemble old photographs. They work in front of paintings in museums, but they do not paint or draw their subjects; they photograph them, cut the images apart, and reassemble them, using the drawing grid as a structural control onto which they project their compositions. The sense of paper as a material and its cut edge as a drawing device are fundamental to their aesthetic. However, memory is the real grid in which they work; enmeshed in its net is a felt loss of art's former authority, and a re-collection of it through the use of a pseudomechanical, technical language to generate nostalgia.

If for Kelley the illustration and the cartoon are classical conventions, that is also true for Tim Rollins + K.O.S. In works such as *X-Men 1967* (pages 88–89), where a year's comic books are pasted up, the drawing of the cartoon itself is appropriated. For the Kids, a changing group of adolescents and young adults from the South Bronx whom Rollins teaches and with whom he collaborates, the drawing in these cartoons is real drawing — a real style and their first contact with art.[72] They see no reason to redraw it; they just use it. In the gridlike cartoon adolescent fantasy is subordinated to a kind of formal marching order, what might be called a clear ideological manipulation. Here fantasy is again sublimated to the grid of high style. The comic book is gridded and gets re-gridded in the pasteup, in another imitation

ROBERT LONGO

Pressure. (1982–83)

Two parts: painted wood with lacquer finish, and charcoal, graphite, and ink on paper
Overall 9' 4 ⅜" x 7' 6" x 36 ½"
(260 x 228.5 x 92.7 cm)
The Museum of Modern Art, New York
Gift of the Louis and Bessie Adler Foundation, Seymour M. Klein, President

Robert Longo was born in Brooklyn in 1953. From 1969 to 1972 he studied at North Texas State University, Denton, and Nassau Community College, New York. In 1972 he received a B.F.A. from the State University of New York, Buffalo. In 1974, with the painter Charles Clough, he founded Hallwalls, a not-for-profit artists' cooperative gallery. *Artful Dodger,* presented at Hallwalls in 1976, was the first of Longo's performances or special installations; others have included *Temptation to Exit/Things I Will Regret* at Artists Space, New York (1976), *Sound Distance of a Good Man* at Franklin Furnace, New York (1978), *Boys Slow Dance* at The Kitchen, New York (1979), and *Empire,* at The Corcoran Gallery of Art, Washington, D.C. (1981). From 1979 to 1982 Longo produced Men in the Cities, a series of drawings and reliefs of figures, often in violent motion. In 1983 his exhibition at Metro Pictures and Leo Castelli Gallery featured a large selection of works combining painting, drawing, and relief. Since 1986 his work has concentrated less on the full-length human figure and more on combinations of mechanical, architectural, or technological images. Longo has collaborated extensively with other performing artists, including Eric Bogosian, composer Rhys Chatham, and Richard Prince, with whom he performed in the rock band Menthol Wars. He has directed more than ten films and videos for music groups, including Golden Palominos, New Order, Megadeth, R.E.M., and Rubén Blades, and designed a number of album covers. His film *Arena Brains* was released in 1989. Longo's work was included in the *Biennial,* Whitney Museum of American Art, New York (1983), the *Carnegie International,* Museum of Art, Carnegie Institute, Pittsburgh (1985), *An International Survey of Recent Painting and Sculpture,* The Museum of Modern Art (1984), and *Documenta 7* and *8,* Kassel (1982 and 1987). A large traveling retrospective was organized by the Los Angeles County Museum of Art in 1989. Longo lives and works in Paris and New York.

MIKE KELLEY

Defamation: Soft and Hard. 1984

Synthetic polymer paint on paper, pinned to canvas
Two panels: 71 ½ x 60 ¼" (181.6 x 159.2 cm)
and 60" x 7' 11 ¼" (152.5 x 242 cm)
The Museum of Modern Art, New York
Gift of Charles B. Benenson

Mike Kelley was born in Detroit, Michigan, in 1954.
The painter, sculptor, and performance artist
received his B.F.A. in 1976 from the University of
Michigan, Ann Arbor, and his M.F.A. in 1978 from the
California Institute of the Arts, Valencia. *Poetry in
Motion*, presented at Los Angeles Contemporary
Exhibitions (L.A.C.E.) in 1978, was the first of his
performances. Among the others are *The Monitor
and the Merrimac* (1979), *The Sublime* (1984), and
Plato's Cave, Rothko's Chapel and Lincoln's Profile,
and *The Peristaltic Airwaves* (both 1986), which
were given at various institutions in Los Angeles and
New York in 1986. Many of his works have taken the
form of glued felt banners, quilts, and sculptures
combining stuffed cloth dolls or animals and knit
blankets. Among his cycles of drawings are Incorrect
Sexual Models (1987) and Garbage Drawings
(1988). He has taught at a variety of institutions
including U.C.L.A. (1983–85), the Otis Art Institute,
Los Angeles (1984–87), and the Art Center College
of Design, Pasadena (since 1987). His first one-man
exhibition, at the Mizuno Gallery, Los Angeles, in
1981, was followed the next year by a show at
Metro Pictures, New York. His work was exhibited in
the *Biennial*, Whitney Museum of American Art, New
York (1985 and 1991), the Venice Biennale (1988),
The BiNATIONAL: American Art of the Late 80's, in
Germany and the United States (1988), and in a
one-man exhibition at The Renaissance Society,
University of Chicago (1988). Most recently, he has
had an exhibition at the Hirshhorn Museum and
Sculpture Garden, Washington, D.C. Kelley lives and
works in Los Angeles.

of an imitation. Basic to the group's work is that the individual hand is not at issue (although the Kids do have individual "hands"); what is paramount is the collective project. Rollins, artist and teacher, uses art to bring potential victims of the street culture inside, bringing them into conversation with the dominant culture. With the texts of such books as Franz Kafka's *Amerika*, or *Alice in Wonderland*, the Kids translate and learn to read through collective visual interpretations that are drawn right over the texts. As the Kids draw their interpretations of the texts, they filter them through their own experience by way of a conventionalized, permissible adult account: Alice swallows a "substance" and takes a "trip" through some hallucinatory experiences. This comes out as the monochrome surface of high art, as the space of possibility, or as the space of "wipe-out"; but Alice emerges wiser, closer to an adult for her fantasy voyage.

X-Men 1967, the work of Angel Abreu, Christopher Hernandez, Victor Llanos, Nelson Montes, Carlos Rivera, Nelson Savinon, and Tim Rollins, establishes a meeting of different cultures and raises the issue of the nature of collaboration. The comic book is our culture's childhood common ground, it is also "ready-made" drawing, a meeting between high and low art. At issue again is the politicization of adolescence as a style. But as the adolescent is on the threshold of entering society responsibly, these young people must find appropriate structures to manipulate. The whole grid-like arrangement of comic books is a metaphor for the control of fantasy. In *X-Men 1967* a scientist leads a group of adolescent mutants he has created into a series of threatening situations in which they are heroic saviors; it is a popular interpretation, complete with dress-ups, of the fiction of the Knights of the Round Table. It is also unambiguously read as the real-life story of Rollins and the Kids as they transform and save themselves: art becomes an arena for heroes.

Collaboration has been an issue in recent drawing since LeWitt's first wall drawings, as each party — artist and executor — surrenders some control while at the same time gains some discretionary freedom within formal limits. Collaboration, which serves as the primary impetus in the work of Rollins + K.O.S., here raises further aspects of control and social equalization as the relationship is unequal in a different manner. Although Rollins, the adult, is in control of the workshop situation, nevertheless he and the Kids come together on a number of levels; for Rollins, too, sees the comic book as part of his "poor white" adolescence, and the kids as a route back to that primary creative moment.

Rollins's contribution is the savvy to know the high-art end, not just of adolescence as a style but of the special codes in high-art language. He has the scientific knowledge, they have the street smarts: as he sublimates his fantasies to theirs and shows them how to work with materials, heroically, he and they turn the tables on their own manipulation, using the "right" language.

I noted earlier that in the 1960s the radicalization of drawing grew out of the revival of its traditional use as a tool for the study and fabrication of three-dimensional

"I eat politics and I sleep politics, but I never drink politics."

work. For Reinhard Mucha (see page 122) sculpture and drawing come together in *Kopfdiktate,* 1990, an autobiographical work constructed of felt, steel, and glass; in it photographs of the artist during his childhood are mounted beside a school copy-book in which he has repeatedly written "I must not be quiet." Robert Gober (page 103), Martin Puryear (page 105), and Richard Deacon (page 104) all make traditional study drawings as first thoughts. Yet the drawings go beyond the factual to evoke the particular and idiosyncratic poetry of each of their pieces, a power that "first-thought" drawings generally have. Deacon, for instance, goes beyond the first-thought drawing, developing his ideas at larger scale to produce plans, traditionally called "cutlery" drawings, for the actual fabrication of his pieces.

Jenny Holzer's drawings (page 106) fall into the category of cutlery drawings, as they are plans given to the stonecutter for transferring her texts to her marble sarcophagus lids. Reused (later, mounted in steel frames), they become yet another class of object — "signs" in a quite literal sense. They play a subtle game between drawing and language placement, as they become a form of concrete poetry enlarged to the size of a sign. Translated into sculpture in her stone pieces, the concrete is made literal, to the point of entombment; thus her allegory is not simply linguistic, it is also formal.

Like Spero and Holzer, Glenn Ligon (page 107) uses art as a language giving a voiceless tongue to helplessness and rage, although in this case, male Black rage, as he "talks" (via other voices, for example, that of Langston Hughes) about how it feels to be African-American. His studies for paintings are small-scale exact rehearsals of his paintings. Ligon works with a language grid as if it were a regulator for intense emotion. Making painting as a form of sign he works to create parity between the visual and the verbal. Writing stereotype over stereotype, he exposes it as an endless prejudicial history inscribed in the ground of art.

Ashley Bickerton's pencil drawings (page 108) are depictions of his sculpture, and just that, drawn in a quite literal manner, at times using orthogonal perspective, which distorts them slightly. In his drawings Bickerton also often studies the motifs/topics painted on his objects. His rendering refers to Duchamp's rendering in the *Chocolate Grinder* (1912–14); it is a parallel language consistent with his sculpture, and both develop the Duchampian mechanistic theme.

Robert Longo (page 96) has other people make the drawings for his large sculptural reliefs, collage ensembles composed of drawing, silkscreened canvases, and cast and molded reliefs. These ensembles, often site-specific, are theatrical, and perversely heroic. The images come straight out of cartoons, illustrations, stop-action video frames, and photographs made by the artist himself. Longo was originally a performance artist; like Kounellis he conceives of the gallery installation as a form of theater. But Longo also makes a variety of study drawings, from the first thought of motifs to fully developed small-scale studies of his large narrative ensembles. His is a drawing system that moves the work toward monumental scale and reduced means, and that relinquishes his hand. It then takes its place as a "sculptural" fragment in

RICHARD PRINCE

Untitled. 1991

Synthetic polymer paint, silkscreen, and pencil on canvas
8' 3 ½" x 9' 8" (252.7 x 294.6 cm)
Philadelphia Museum of Art
Purchased with a grant from the National Endowment for the Arts with matching funds contributed by various donors, and funds from the Adele Haas Turner and Beatrice Pastorius Turner Memorial Fund

Richard Prince was born in 1949 in the Panama Canal Zone. His education in art came through various apprenticeships to artists in Boston and Paris, with whom he studied painting, printmaking, and sculpture. In 1977 Prince made his first photographs of advertising images of pens, watches, and cigarettes from magazines. These were first shown at the Galerie Jollenbeck, Cologne, in 1978. Prince's first one-man exhibitions were held in 1980 at Artists Space, New York, and the Center for Experimental and Perceptual Photography (CEPA) in Buffalo, New York. For the latter he published a book, *Menthol Pictures* (the title echoes the name of the rock band in which he participated with Robert Longo, Menthol Wars). Among Prince's works of the early 1980s are the Sunsets, Cowboys, and Entertainers, selections of which were included in the *Biennial*, Whitney Museum of American Art, New York (1985 and 1987). In 1984 Prince first worked in what he termed the "Gang" format of grouped multiple images, including cartoons, advertisements, and photographs from magazines. His work was the subject of a large exhibition, *Spiritual America*, at IVAM [The Valencian Institute of Modern Art] Col.lecció Centre del Carme, Valencia, Spain (1988). Prince has published a number of artist's books including *Why I Go To The Movies Alone* (1983) and *Inside World* (1989). More recently Prince has worked extensively with silkscreen on canvas. His works were exhibited in *The BiNATIONAL: American Art of the Late 80's*, in Germany and the United States (1988), and *A Forest of Signs: Art in the Crisis of Representation,* Museum of Contemporary Art, Los Angeles (1989). Prince lives and works in New York.

the ensemble. His drawings often evoke the alienated, gray-toned emotional atmosphere and the compact, economical, plots of the B-grade movies of the 1940s and what Marshall McLuhan called the coolness of television when it was a black-and-white medium. His style, like Salle's, is directed to evoking the chiaroscuro of the filmic medium and to a more reduced narrative than that of his models. Cutting into the narrative with stop-frame technology produces a disjunctive collage narrative.

Tom Otterness (page 109) uses drawing as a system for cataloguing and reducing selected art-historical sources to one homogeneous figure: the producer of art. The production of art is Otterness's subject (just as it is Allan McCollum's). This figure (and only very occasionally his female counterpart) works on or produces the other characters of his artwork narratives. Using such disparate sources as Cézanne, Indian art, Renaissance masters, and even the anthropomorphized cartoon characters who have now become part of art history, he creates the "common" workman on the production line as both a sculptor and a sculpture, bringing the latter to life as a projection of himself and as the idea of work as a self-reproductive corpus. The figure is his primary interest, and he sketches prolifically, working in museums before works of art and from reproductions of figure drawings and paintings. Unlike Cézanne, from whose drawings of sculpture he works, he does not draw in front of sculpture. As a sculptor, Otterness works from two dimensions into three. His drawing is a parody of the old-fashioned academic system. Like all copyists, and particularly those involved with imitating illustration, he uses outline drawing; but as a sophisticated draftsman in the academic mode, he deploys so-called bracelet shading, horizontal linear hatching marks across contours, much in the Albrecht Dürer tradition, as a shadow system, using it to give the illusion of roundness and plasticity to his cartoonlike little round workmen. In a comment on art-production one of his figures is hard at work with chisel and hammer on stone producing another version of himself. Art produces art, as both a parody of the core notion of modernist art, and a confirmation of its truth despite changes in language.

For Allan McCollum (page 111) drawing is both mass-produced and unique as he also breaks out of orthodox conceptions of originality, skill, and authorship, using others to make his drawings. These issues of originality and themes of repetition and redundancy which run through his work are related to the issue of the art object as a token of exchange in a fluctuating marketplace, which cyclically redistributes it, changing its meaning as it changes its value — making meaning reside in value. The central issue of McCollum's work is the exposure of the "unique" object and its operation as an "exclusionary device" that solidifies class distinctions, as people discriminate on the basis of identification with the class of objects they buy. McCollum's drawings are, as everything else in his work, conceived as objects, mediating between two-dimensional and three-dimensional concerns and between the concrete and the abstract, as they seem to allude to identifiable yet generalized forms.

McCollum has worked in museums, and his drawings are framed in conformity

ROBERT GOBER

Untitled. 1985

Pencil on paper
14 x 17" (35.6 x 43.2 cm)
Collection Leslie Alexander and Lawrence Luhring

Untitled. 1984

Pencil on paper
11 x 14" (27.9 x 35.6 cm)
Private collection, New York

Robert Gober was born in Wallingford, Connecticut, in 1954. He studied art and criticism at Middlebury College, Vermont, spent a year in Rome with the Tyler School of Art (Philadelphia) in 1973–74, and received a B.A. in 1976. His first one-man show was held at Paula Cooper Gallery, New York, in 1984, where he first showed his sculptures of domestic objects such as sinks, cribs, and beds. More recently, Gober has printed some of his images onto wallpaper and begun to produce sculptural objects on subjects outside his early domestic subject matter using more elaborate means. In addition to regular one-man exhibitions at Paula Cooper Gallery he has participated in numerous group exhibitions: with Jeff Koons and Haim Steinbach at the Renaissance Society, University of Chicago (1986), in *Art and Its Double: A New York Perspective*, Fundació Caixa de Pensions, Barcelona (1986), at The Institute of Contemporary Art, Boston, where he executed an installation for *Utopia Post Utopia*, and at the Venice Biennale (both 1988), with Sherrie Levine in *The BiNATIONAL: American Art of the Late 80's*, in Germany and the United States (1988), with Peter Halley and Jon Kessler at the Kunstverein, Munich (1989), in *Horn of Plenty*, Stedelijk Museum, Amsterdam (1989), in the Sydney Biennial (1990), in the *Biennial*, Whitney Museum of American Art, New York (1989 and 1991), and in *Metropolis,* Martin-Gropius-Bau, Berlin (1991). Recent one-man shows were held at The Art Institute of Chicago (1988) and the Museum Boymans–van Beuningen, Rotterdam (1990). Gober lives and works in New York.

RICHARD DEACON

Untitled. 1990

Pencil on paper
30 x 44" (76.2 x 101.6 cm)
Marian Goodman Gallery, New York

Richard Deacon was born in Bangor, Wales, in 1949.
A student of mathematics and physics in prepara-
tory school, the British sculptor and printmaker first
studied art in 1968–69 at Somerset College of Art,
Taunton. In 1972 he received a B.A. from St.
Martin's School of Art, London. In 1973 he traveled
to Chicago, where he briefly studied acting. He
returned to London to study environmental media at
the Royal College of Art, and received an M.A. in
1977. Deacon lived in New York in 1978–79. Shortly
after his return to England, he made the first of the
large-scale open structures of wood and metal that
occupied him throughout the 1980s. Among these
are works in an extensive series of sculptures, Art
for Other People, begun in 1982. He had his first
exhibition at the Lisson Gallery, London, in 1983. In
1987 he received the Turner Prize, awarded by The
Tate Gallery, London. Deacon collaborated with John
Tchalenk on a film, *Wall of Light*, in 1985, and two
years later designed sets for *Replacing*, a dance
choreographed by Lucy Bethune for the Rambert
Dance Company. Deacon has taught at various insti-
tutions including Winchester College of Art, Bath
Academy of Art, and Chelsea School of Art, where
he is still on the faculty. His work was included in *An
International Survey of Recent Painting and
Sculpture*, The Museum of Modern Art, New York
(1984), and has been the subject of a number of
retrospective exhibitions, most recently at the
Whitechapel Art Gallery, London (1988–89), and
the Fundacion Caja de Pensiones, Madrid (1988).
Deacon lives and works in London.

with museum custom, making them objects to be manipulated and re-arranged.
Multiplied in the thousands, they are shown as occupying all available wall space, as
well as standing on tables and on the gallery floors, highlighting the gallery's func-
tion as a show place in which, as part of its function, the installation itself is subject
to sale in sections. Despite their seemingly uninflected rendering, all McCollum's
objects are hand drawn by assistants and are composed of two components, top and
bottom, each bilaterally symmetrical and composed of straight, convex, and concave
contours, combined and recombined in complex arrangements. The forms are com-
posed of two to four curves and/or angles; the size of the drawing varies with the
number used. These form a centralized motif which is unique to each drawing, as
McCollum condenses the substance of modernism into pictorial archetypes.[73] Their
funerary black and reliquary shapes suggest the death of the object and the museum
(or gallery) as mausoleum.

Part of McCollum's strategy is "a sort of campaign to put across both that the
single individual can mass-produce and that other mass-produced items are made by
people. For exalting the handiwork of the 'artist' is surely a method by which to
devalue the handiwork of those 'workers' who produce ninety-nine per cent of the
rest of our made environment."[74] McCollum's drawings are substitutes for substi-
tutes; they are substitutes for the fine-art objects they represent in an endless mirror-
ing of art's self-representing function, made socially transparent, as they make us
aware that all objects have power through the allure expressed in their surfaces. And

MARTIN PURYEAR

Untitled. c. 1987

Graphite on paper
23 x 29" (58.4 x 73.7 cm)
David McKee Gallery, New York

Martin Puryear was born in Washington, D.C., in
1941. He received a B.A. from Catholic University of
America, where he studied biology, and then art with
Nell B. Sonneman. From 1964 to 1966 Puryear
served in the Peace Corps in Sierra Leone, where he
taught secondary school and learned traditional
African techniques of wood craftsmanship from local
carpenters. As a guest student at the Royal Academy
of Art in Stockholm between 1966 and 1968 he
learned Scandinavian woodworking and furniture
design. Puryear then attended Yale University, New
Haven, receiving an M.F.A. in 1971. From 1971 to
1973 Puryear taught at Fisk University, Nashville.
His first one-man exhibitions were held there and at
the Henri Gallery, Washington, D.C., in 1972.
Puryear set up a studio in Brooklyn in 1973. From
1974 to 1977 he taught at the University of
Maryland, College Park. In 1977 The Corcoran
Gallery of Art, Washington, D.C., presented an exhi-
bition of his sculpture. The following year Puryear
moved to Chicago to teach at the University of
Illinois. Puryear's sculpture was included in the
Biennial, Whitney Museum of American Art, New
York (1979, 1981, and 1989), and *An International
Survey of Recent Painting and Sculpture,* The
Museum of Modern Art, New York (1984). In 1980
he installed a large work, *Equation for Jim
Beckwourth,* for a one-man show at the Museum of
Contemporary Art, Chicago. A John S. Guggenheim
Memorial Foundation Grant in 1983 allowed Puryear
to travel to Japan, where he studied traditional and
contemporary architecture and gardens. A year later
the University Gallery, University of Massachusetts,
Amherst, organized a traveling ten-year survey of his
work. Puryear was a visiting artist at the American
Academy in Rome in 1986. In 1989 he received a
John D. and Catherine T. MacArthur Foundation
Fellowship, and was the U.S. representative to the
São Paulo Bienal. In 1991 The Art Institute of
Chicago organized a large retrospective exhibition of
his sculpture. Puryear lives and works in New York
State.

McCollum's drawings are all surface, all "skin"; they are made, in his terms, to "sell," to be objects of desire. He notes, "Objects sell best when they add life, and when they accommodate our magical thinking."[75] The constant recombination of the same forms and their multiplication both facilitate and frustrate the attempt to make something new as a hook for desire. For McCollum, "Constant attempts at making something new are symptomatic of a world in which nothing is shared and nothing is right, thus condemning us always to try to make it right."[76]

Ghosts and imitations, the body, or corpus, of modern art as a corpse to be rebuilt from the original — like an "exquisite corpse,"[77] — is the substance of con-temporary art. In Stephen Prina's work, the original body of modernist painting serves as a supertext throughout, with individual oeuvres or "bodies" as its collect-ed works. The anthropomorphized metaphor refers to collective cultural memory, to its power as an institution. The reference to supertext is ideological, as a reading of institutional power.

His best-known work, *Exquisite Corpse: The Complete Paintings of Manet,* begun in 1988, reproduces or produces "a serial reenactment" (preceded by a print-ed index, or frontispiece) of all the paintings of Manet, numbered and to scale,

JENNY HOLZER

Selection from *Laments*
(*"No Record of Joy . . . "*). 1988–89

Oil transfer on rubbing paper
6' 10" x 30" (208.3 x 76.2 cm)
Barbara Gladstone Gallery, New York

Jenny Holzer was born in Gallipolis, Ohio, in 1950
and grew up in the town of Lancaster. After studying
at Duke University, in Durham, North Carolina, and
The University of Chicago, she received a B.F.A. in
painting and printmaking from Ohio University,
Athens, in 1973. In 1977 she received an M.F.A.
from the Rhode Island School of Design, Providence,
and moved to New York, where she participated in
the Independent Study Program of the Whitney
Museum of American Art, New York. In the same
year she made the first works known as Truisms,
which were made into posters mounted surrepti-
tiously in public spaces throughout Manhattan. In
1979 she became an apprentice typesetter, began
to work with the artists' group Colab (Collaborative
Projects), and produced a new set of posters,
Inflammatory Essays. She continued to work as a
typesetter and produced, in collaboration with Peter
Nadin, a number of books and metal plaques of
Truisms. In 1982, at the invitation of The Public Art
Fund, she displayed an electronic version of *Truisms*
in Times Square, and shortly thereafter began to
make extensive use of electronic display boards. In
the same year, her work was shown at *Documenta
7,* Kassel, where with Stefan Eins she opened
Fashion Moda, a "store" (and artists' group in the
Bronx) which sold inexpensive artworks for the dura-
tion of the exhibition. *Laments*, an installation of
engraved granite sarcophagi accompanied by run-
ning texts on tall electronic signs, was first shown at
Documenta 8, Kassel (1987). Holzer's work was
included in the *Biennial*, Whitney Museum of
American Art (1985 and 1991). Among her one-
woman exhibitions are those organized by The
Solomon R. Guggenheim Museum, New York (1989),
and DIA Center for the Arts, New York (1990). She
was selected to represent the United States in the
1990 Venice Biennale. Holzer lives and works in
Hoosick Falls, New York.

GLENN LIGON

**Untitled ("I Do Not Always Feel Colored").
1991**

Oilstick on paper
30 x 16" (76.2 x 40.6 cm)
Jack Tilton Gallery, New York

Glenn Ligon was born in 1960 in the Bronx, New York. He attended the Rhode Island School of Design, Providence, and Wesleyan University, Middletown, Connecticut, where he received a B.A. in 1982. He served as a curatorial intern at The Studio Museum in Harlem, and three years later participated in the Independent Study Program of the Whitney Museum of American Art, New York. Ligon received a National Endowment for the Arts Fellowship for drawing in 1989 when he was also a resident of the MacDowell Colony, Peterborough, New Hampshire. In 1989–90 he had a studio at P.S. 1, The Clocktower, New York. His work was shown in several one-man exhibitions including the Winter Exhibition series at the P.S. 1 Museum, Long Island City, New York (1990), *How It Feels To Be Colored Me* at BACA Downtown, Brooklyn (1990), an exhibition at White Columns, New York (1991), and *Knowledge: Aspects of Conceptual Art*, University Art Museum, Santa Barbara (1992). Ligon's work was included in the *Biennial*, Whitney Museum of American Art (1991). In 1991 he received a National Endowment for the Arts Fellowship for painting. He lives and works in New York.

ASHLEY BICKERTON

Plan for Atmosphere. 1988

Pencil on paper
22 ½ x 28 ½" (57.2 x 72.4 cm)
Collection Chase Manhattan Bank, N.A.

Ashley Bickerton was born in 1959 in Barbados, and grew up in Africa, South America, Europe, the West Indies, and Hawaii. In 1982 he received a B.F.A. from the California Institute of the Arts, Valencia, an institution central in the development of the debate over postmodernism. Three years later he participated in the Independent Study Program of the Whitney Museum of American Art, New York. Bickerton's earliest works were word paintings executed on masonite sheets; later, around 1988, he began the carefully crafted, painted wall constructions for which he is widely known. His first one-man exhibition was held at Artists Space, New York (1984); this was followed the next year by an exhibition at the Cable Gallery, New York. Since 1988 he has exhibited at Sonnabend Gallery, New York. Bickerton's work has been included in a number of large group exhibitions such as *Art and Its Double: A New York Perspective*, Fundació Caixa de Pensions, Barcelona (1987), *Horn of Plenty*, Stedelijk Museum, Amsterdam (1989), the *Biennial*, Whitney Museum of American Art (1989), and the Venice Biennale (1990). Bickerton divides his time between New York and Indonesia.

rendered in wash. *Monochrome Painting*, 1988–89, is another series of his paintings that comprises fourteen "life-size" black monochrome paintings by Prina after monochrome paintings by a number of classical modernist artists from Kasimir Malevich to Blinky Palermo, and which includes as part of the work the catalogue, poster, and invitation (pages 112 and 113). Prina's current project, a new work of 1991, is a commentary on his *Monochrome Painting* consisting of a drawing variant in sepia ink to exact size and is titled *"The history of modern painting, to label it with a phrase, has been the struggle against the catalog, . . ." — Barnett Newman/(Monochrome Painting, 1988–89).*[78] In this project Prina uses Newman's witticism to provide a verbal cross-axis to the piece, seizing as his subject not only whole bodies of modernist art but also his own appropriation of the institutional devices that have created them as monuments and myths.

Like other current installation work, this drawing series refers to the institutional framework. Framed, the work is a reference both to the painting series and to their own insertion into exhibition spaces; their format as objects is especially conditioned by the museum model. Prina sees every space as "systematized" so that in installation his objects follow a strict order, and the conformation of the work as a whole changes from place to place, in order to maintain the sequence. The work forms a *cabinet des dessins* of its own, or at least a simulation of a traditional

T O M O T T E R N E S S

Tables (Working Drawing). 1986–87

Graphite and ink on paper
19 x 24¾" (48.3 x 62.9)
Private collection, New York

Tom Otterness was born in Wichita, Kansas, in 1952. He studied at the Art Students League, New York, in 1970, and in 1973 participated in the Independent Study Program of the Whitney Museum of American Art, New York. Otterness's early sculptures in plaster were first seen in odd nooks and crannies of SoHo where the artist surreptitiously deposited them in the late 1970s. Otterness was also one of the most active members of Colab (Collaborative Projects), founded in 1977 as an alternative to commercial galleries. He was one of the prime movers of *The Times Square Show*, a large exhibition organized in an abandoned massage parlor by Colab and the artists' group Fashion Moda in 1980. His first gallery exhibitions of sculpture and drawings were held at Brooke Alexander Gallery, New York, in 1983. Otterness's work was included in *An International Survey of Recent Painting and Sculpture*, The Museum of Modern Art, New York (1984), the *Biennial*, Whitney Museum of American Art (1985), and the Aperto section of the Venice Biennale (1988). His bronze fountain sculpture *The Tables* was exhibited in a Projects exhibition at The Museum of Modern Art (1987), and later toured to Germany and Spain in 1991. Otterness has received a number of public commissions, among them a small plaza with sculpture to be permanently installed in Battery Park, New York, and a frieze for the Federal Courthouse, Los Angeles. Otterness lives and works in New York.

ALLAN McCOLLUM

Drawings. 1991

Pencil on mat board
More than 2,000 framed sheets,
various dimensions
Installation view, Lisson Gallery, London

Allan McCollum was born in Los Angeles in 1944. His works of the late 1960s were paintings on canvas and handkerchiefs in which dye and bleach were used in an ironical reversal of the "stain-painting" technique initiated by Helen Frankenthaler and much discussed in the early 1960s. His first one-man exhibition was held at the Jack Glenn Gallery, Corona del Mar, California, in 1971. In the mid-1970s McCollum's works included paper constructions made from a repertoire of cut-out stenciled shapes. In 1975 he moved to New York, and two years later made the first of the Surrogate Paintings, a series of small, framed monochromes on wood of different sizes, normally hung in large clusters or "collections"; in 1982 these developed into the Plaster Surrogates, which he continues to make today. McCollum turned to freestanding sculpture in 1985, producing the often large, urnlike Perfect Vehicles. Two years later he began to make the Individual Works, hand-sized symmetrical sculptures usually massed in groups of over 10,000 and arranged on tables. McCollum has also worked extensively in photography, and collaborated with photographers Louise Lawler and Laurie Simmons. McCollum's work has been included in numerous group exhibitions, including the *Biennial*, Whitney Museum of American Art, New York (1975 and 1989), the Venice Biennale (1988), *Bilderstreit* [*Iconoclasm*] at the Museum Ludwig, Cologne (1989), and *A Forest of Signs: Art in the Crisis of Representation*, Museum of Contemporary Art, Los Angeles (1989). Among his one-man exhibitions are one in the series Investigations, at the Institute of Contemporary Art, University of Pennsylvania, Philadelphia, and a large exhibition of work from the 1980s organized by the Stedelijk Van Abbemuseum, Eindhoven. McCollum lives and works in New York.

connoisseur's cabinet, as its "units" are hung in the traditional floor-to-ceiling manner. Each is both whole, in referring to one painting, and a fragment, as part of the suite to be manipulated by Prina as he collaborates with himself as his own curator. As objects, they negotiate among the concerns of several modes (painting, sculpture, drawing, and reproduction) and between the attributes of copies and originals — although not, as in Levine's case, as ghosts, or as simulacra, but as new creations made by reprocessing information deduced from the old. As nonfigurative representations Prina's drawings are another inversion of the process of personification in which the "body" represented is rendered as a concrete material generalization, restricted by the rules of one discipline, as the artist conceives it.

For Prina, drawing is essentially "the process of setting limits."[79] Although his drawings are not studies as such they are consistent with that aspect of study drawing which establishes the limits of what will be explored in painting. His drawings are about the dividing line between what is acceptable material for exploration and what is not, and the wish to insert that limit ideologically into the graphic, both literally and as a metaphor. Thus Prina's drawings, as catalogues or taxonomies of paintings already twice in existence are inversions of what it is acceptable to study as proper to drawing, in that they are posterior rather than prior to painting. They represent a catalogue of the painting through information appropriate to drawing, which returns the paintings to the realm of possibility. He envisions the graphic as a convergence of desires, some practical, some not. One of the aspects of the practical, which unites it with the impractical, is that the drawings are made on "barrier" paper, used in frames as an atmospheric block between mat and backing. In this configuration the material itself — the "barrier" paper — becomes a metaphor for the metaphysical gap between the sacred and the profane, a crossed axis between artistic and unartisitic material.

Prina uses sepia for these drawings because of its traditional registry as a preparatory procedure. He sees the tonal field as a potentially figurative graphic ground. For Prina the figuration is hidden in the material, to be brought forth by the artist; it exists in the particular facture of the ground. The identical format and color of the drawings brings the facture to the forefront of attention; in current artistic parlance, it "foregrounds" it as the subject of the work. The aura of the original is maintained throughout on the rigorous thread of structure, as different marking systems are used with different projects. As a parallel to his idea of each space imposing its own system, he sees each gesture as the prefiguration of the next gesture. With the Manet project, he made drawings that used one "characteristic common to all of Manet's paintings [as a] generative material . . . and [took that] characteristic as their limitation. . . . These different marking systems weave in and out of history, expanding and contracting and form a model of how time and reference have come to structure the experience of history."[80] Thus the fragment stands for history, allowing Prina to ally himself to a revolutionary history for which the aesthetic offers itself as a model.

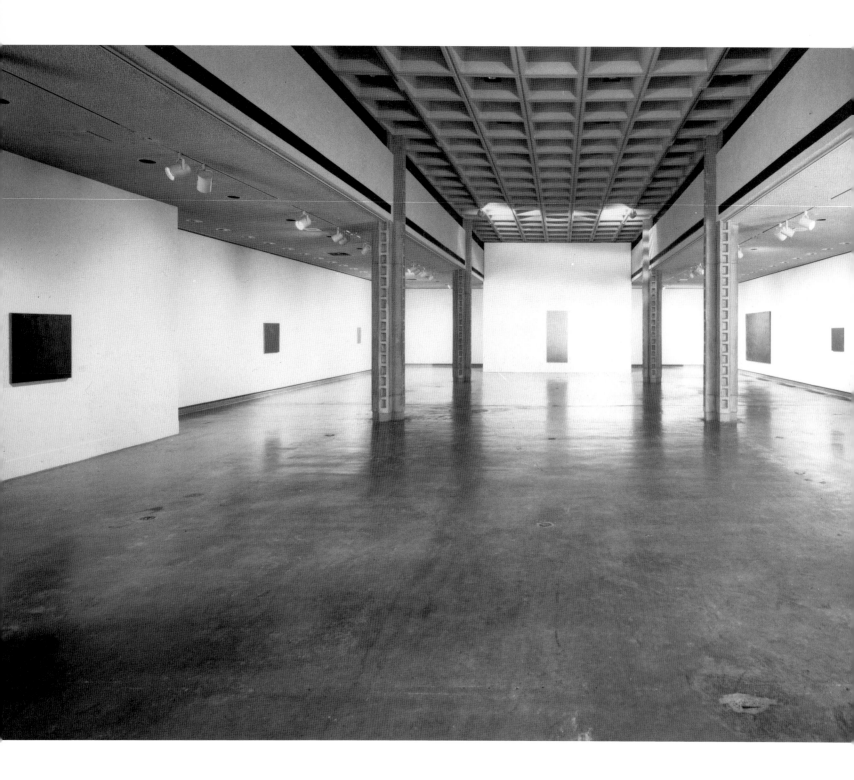

STEPHEN PRINA

Monochrome Painting. 1988–89

Fifty units: fourteen painted panels, enamel on linen on mahogany; fourteen labels, screenprinted on plastic; catalogue, poster, invitation, and envelope, all offset lithography on paper; wall graphics (eighteen units)
Dimensions variable
Luhring Augustine, New York

Opposite:
Installation view, Los Angeles Municipal Art Gallery, 1989

Left:
Poster, catalogue, and invitation

Stephen Prina was born in Galesburg, Illinois, in 1954. After receiving a B.F.A. from Northern Illinois University, DeKalb, in 1977, he moved to Los Angeles. In 1980 he received an M.F.A. from the California Institute of the Arts, Valencia, where he studied with John Baldessari, Doug Huebler, and Michael Asher. Prina's *Evening of 19th and 20th Century Piano Music* was performed at Symphony Space, New York, in 1985, the same year a performance of his was included in *The Art of Memory/ The Loss of History*, The New Museum of Contemporary Art, New York. The series *Monochrome Painting* was exhibited at The Renaissance Society, University of Chicago, in 1988. Prina's project *Exquisite Corpse: The Complete Paintings of Manet* was begun in 1988; a "drawing" index of this exhibition was shown at the *Carnegie International*, Museum of Art, Carnegie Institute, Pittsburgh (1991). Prina has taught art history and critical theory at the Otis Art Institute, Los Angeles (1981–87), at the California Institute of the Arts, Valencia (1987), and at the Art Center College of Design, Pasadena (since 1980). His work was included in *The BiNATIONAL: American Art of the Late 80's*, in Germany and the United States (1988), *A Forest of Signs: Art in the Crisis of Representation*, Museum of Contemporary Art, Los Angeles (1989), the Venice Biennale (1990), and the Sydney Biennial (1990). Prina lives and works in Los Angeles.

Prina has said he believes in negativity "in the Adorno sense," for as Terry Eagleton has written of Theodor Adorno: "Just as artistic modernism figures the impossibility of art, so Adorno's modernist aesthetic marks the point at which the high aesthetic tradition is pressed to an extreme limit and begins to self-destruct, leaving among its ruins a few cryptic clues as to what might lie beyond it. Yet this undermining of classical aesthetics is achieved from *within* the aesthetic, and owes much to the lineages it throws into crisis."[81]

So as the body of high modernism and its heroic totalizing myth lies shattered at the end of the twentieth century, it provides the fragments from which to build a new vision of the real. And Adorno shall have the last word, for out of his negativity comes affirmation: "The only philosophy which can be responsibly practised in the face of despair is the attempt to contemplate all things as they would present themselves from the standpoint of redemption. Knowledge has no light but that shed on the world by redemption; all else is reconstruction, mere technique. Perspectives must be fashioned that displace and estrange the world, reveal it to be, with its rifts and crevices, as indigent and distorted as it will appear one day in the messianic light."[82]

NOTES

1. See Leo Marx, *The Machine in the Garden: Technology and the Pastoral Ideal In America* (London and New York: Oxford University Press, 1968).

2. Andy Grundberg, *Mike and Doug Starn* (New York: Harry N. Abrams, Inc., 1990), p. 19.

3. See Benjamin H. D. Buchloh, "Andy Warhol's One-Dimensional Art: 1956–1966," in Kynaston McShine, ed., *Andy Warhol: A Retrospective* (New York: The Museum of Modern Art, 1989), p. 45.

4. See Bernice Rose, *Drawing Now* (New York: The Museum of Modern Art, 1976), p. 91.

5. Rosalind Krauss, "The Originality of the Avant-Garde: A Postmodern Repetition," in Brian Wallis, ed., *Art after Modernism: Rethinking Representation* (New York: The New Museum of Contemporary Art/Boston: David Godine Publisher, 1984), p. 21 [essay originally published in *October*, No. 18 (Fall 1981), pp. 47–66].

6. Craig Owens, "The Allegorical Impulse: Toward a Theory of Postmodernism," in Wallis, *Art after Modernism,* p. 209 [essay originally published in *October*, No. 12 (Spring 1980), pp. 67–86, and No. 13 (Summer 1980), pp. 59–83].

7. Ibid., p. 205.

8. Ibid., pp. 204–05.

9. Ibid., p. 215.

10. Ibid., pp. 203, 205.

11. Ibid., p. 206.

12. Ibid., p. 209.

13. See Buchloh, "Andy Warhol's One-Dimensional Art," pp. 48–50.

14. Owens, "The Allegorical Impulse," p. 223.

15. "The avant-garde poet or artist tries in effect to imitate God by creating something valid solely on its own terms, in the way nature itself is valid . . . something *given*, increate, independent of meanings, similars or originals. Content is to be dissolved so completely into form that the work of art or literature cannot be reduced in whole or in part to anything not itself. . . . The poet or artist, being what he is, cherishes certain relative values more than others. . . . And so he turns out to be imitating, not God — and here I use 'imitate' in its Aristotelian sense — but the disciplines and processes of art and literature themselves. This is the genesis of the 'abstract.' In turning his attention away from subject matter of common experience, the poet or artist turns it in upon the medium of his own craft. The nonrepresentational or 'abstract,' if it is to have aesthetic validity, cannot be arbitrary and accidental, but must stem from obedience to some

worthy constraint or original." — Clement Greenberg, *Art and Culture: Critical Essays* (Boston: Beacon Press, 1961), pp. 6–7.

16. Owens, "The Allegorical Impulse," p. 203.

17. Prudence Carlson, *Sigmar Polke: Drawings from the 1960's* (New York: David Nolan Gallery, 1987), p. 7.

18. Ibid., p. 5.

19. Benjamin H. D. Buchloh, "Polke und das Grosse Triviale," in *Sigmar Polke: Bilder, Tücher, Objekte: Werkauswahl 1962–1971* (Tübingen: Kunsthalle, 1976), p. 13 [catalogue for exhibition at Kunsthalle, Tübingen; Kunsthalle, Düsseldorf; and Stedelijk Van Abbemuseum, Eindhoven].

20. Jacques Derrida, quoted in David Harvey, *The Condition of Postmodernity: An Enquiry into the Origins of Cultural Change* (Oxford and Cambridge, Mass.: Basil Blackwell, 1989), p. 51.

21. Harvey, ibid., p. 54.

22. Sigmar Polke, quoted in Carlson, *Sigmar Polke: Drawings*, p. 9 [originally published in Sigmar Polke, " — frühe Einflüsse, späte Folgen. . . ," in *Sigmar Polke: Bilder, Tücher, Objekte*].

23. For further discussion see Benjamin H. D. Buchloh, "Figures of Authority, Ciphers of Regression," in Wallis, *Art after Modernism*, pp. 107–35 [essay originally published in *October*, No. 16 (Spring 1981), pp. 39–68]. See also Donald B. Kuspit, "Flak from the 'Radicals': The American Case against German Painting," in Wallis, *Art after Modernism,* pp. 136–51 [essay originally published in Jack Cowart, ed., *Expressions: New Art from Germany* (St. Louis: The St. Louis Art Museum/Munich: Prestel-Verlag, 1983), pp. 43–55].

24. R. H. Fuchs, "Chicago Lecture," *Tema Celeste: Contemporary Art Review*, No. 19 (January–March 1989), p. 56.

25. Paul Crowther, "Nietzsche to Neo-Expressionism — A Context for Baselitz," in *German Art Now* (London: Academy Editions/New York: St. Martin's Press, 1989), p. 77.

26. Kuspit, "Flak from the 'Radicals,'" p. 141.

27. Ibid., p. 143.

28. Nature is imitative; culture is not. The "natural" entails imitation; culture does not. It arises independent of nature, although it may employ nature in its operations. This is exemplified by the following passage from Claude Lévi-Strauss, *The Raw and the Cooked: Introduction to a Science of Mythology*, Vol. 1, translated from the French by John and Doreen Weightman (Chicago: University of Chicago Press, 1969), p. 20: "We must not forget, however, that painting and music stand in opposite

relations to nature, though nature speaks to them both. Nature spontaneously offers man models of all colors and sometimes even their substance in a pure state. In order to paint he has only to make use of them. But, as I have emphasized, nature produces noises, not musical sounds; the latter are solely a consequence of culture, which has invented musical instruments and singing."

29. Buchloh, "Figures of Authority," p. 133.

30. Ibid.

31. Ibid.

32. Thomas McEvilley, "Mute Prophecies: The Art of Jannis Kounellis," in Mary Jane Jacob and Thomas McEvilley, *Kounellis* (Chicago: Museum of Contemporary Art, 1986), p. 119.

33. Ibid., p. 52.

34. Walter Benjamin, quoted in Owens, "The Allegorical Impulse," p. 206.

35. Pat Steir, "Brice Marden: An Interview," in *Brice Marden: Recent Drawings and Etchings* (New York: Matthew Marks, 1991), n.p.

36. Ibid.

37. Ibid.

38. Gerhard Richter, quoted by Anne Rorimer, "Gerhard Richter," in Rosemarie Schwarzwälder, ed., *Abstract Painting of America and Europe* (Klagenfurt: Ritter Verlag, 1988), p. 101 [catalogue of exhibition at Galerie Nächst St. Stephan, Vienna].

39. Susan Sontag, *On Photography* (New York: Farrar, Straus and Giroux, 1977), p. 154.

40. Ibid., pp. 159–60.

41. Ibid., p. 159.

42. Bruce Nauman, quoted in interview with Bob Smith, *Journal: A Contemporary Art Magazine* (Los Angeles Institute of Contemporary Art), No. 32 (Spring 1982), pp. 35–38.

43. See Bernice Rose, *New Work on Paper 3* (New York: The Museum of Modern Art, 1985), p. 10.

44. Ibid., p. 14.

45. Ibid.

46. Pat Steir, conversation with the author, July 1991.

47. Ibid.

48. See Rose, *Drawing Now*, passim.

49. Robert Storr, "Realm of the Senses," *Art in America* (November 1987), p. 134.

50. Ibid., p. 144.

51. Donald B. Kuspit, "From Existence to Essence: Nancy Spero," *Art in America* (January 1984), p. 88.

52. Donald B. Kuspit, "Spero's Apocalypse," *Artforum* (April 1980) p. 34.

53. Thomas Crow, "Versions of Pastoral in Some Recent American Art," in *The BiNATIONAL: American Art of the Late 80's* (Boston: The Institute of Contemporary Art and Museum of Fine Arts/Cologne: DuMont Buchverlag, 1988), p. 33.

54. Ibid., pp. 33–34.

55. David Salle, quoted in "Expressionism Today: An Artists' Symposium," *Art in America* (December 1982), p. 58.

56. Harvey, *The Condition of Postmodernity*, p. 50.

57. David Salle, quoted in Eleanor Heartney, "David Salle: Impersonal Effects," *Art in America* (June 1988), p. 122.

58. Ibid.

59. David Salle, "Jack Goldstein: Distance Equals Control," in *Jack Goldstein* (Buffalo: Hallwalls, 1978), p. 1.

60. Thomas Lawson, quoted in Heartney, "David Salle," p. 121.

61. Robert Storr, "Two Hundred Beats per Min.," in *Jean Michel Basquiat: Drawings* (New York: Robert Miller Gallery, 1990).

62. Mike Kelley, "Foul Perfection: Thoughts on Caricature," *Artforum* (January 1989), p. 93.

63. Douglas Crimp, "Appropriating Appropriation," in *Image Scavengers: Photography* (Philadelphia: Institute of Contemporary Art, University of Pennsylvania, 1982), p. 30.

64. Owens, "The Allegorical Impulse," p. 205.

65. Jeanne Siegel, "After Sherrie Levine," *Arts Magazine* (Summer 1985), p. 141.

66. Ibid.

67. Thomas Crow, "The Return of Hank Herron," in *Endgame: Reference and Simulation in Recent Painting and Sculpture* (Cambridge: M.I.T. Press, 1986), p. 16.

68. Veit Loers, "You Might Think There Was Nothing to See," in *Günther Förg* (Stuttgart: Edition Cantz, 1990), p. 30 [exhibition catalogue].

69. Mike Kelley, conversations with the author, June and July 1991.

70. Ibid.

71. Ibid.

72. Tim Rollins and Nelson Savinon, conversation with the author, July 1991.

73. Daniela Salvioni, "Interview with McCollum and Koons," *Flash Art* (December 1986/January 1987), p. 66.

74. Ibid.

75. Ibid., p. 68.

76. Ibid.

77. "Exquisite Corpse: Among Surrealist techniques exploiting the mystique of accident was a kind of collective collage of words or images called *cadavre exquis* (exquisite corpse). Based on an old parlor game, it was played by several people, each of whom would write a phrase on a sheet of paper, fold the paper to conceal part of it, and pass it on to the next player for his contribution. The technique got its name from results obtained in an initial playing, 'Le cadavre exquis boira le vin nouveau' (The exquisite corpse will drink the young wine). The game was adapted to the possibilities of drawing and even collage by assigning a section of a body to each player, though the Surrealist principle of metaphoric displacement led to images that only vaguely resembled the human form." — William S. Rubin, *Dada, Surrealism, and Their Heritage* (New York: The Museum of Modern Art, 1968), p. 83.

78. For the context of this quotation see Thomas B. Hess, *Barnett Newman* (New York: The Museum of Modern Art, 1971), p. 15.

79. Stephen Prina, conversations with the author, May and July 1991.

80. Stephen Prina, interview with Elisabeth Sussman and David Joselit, *The BiNATIONAL*, pp. 157–58.

81. Terry Eagleton, *The Ideology of the Aesthetic* (Oxford and Cambridge, Mass.: Basil Blackwell, 1990), p. 361.

82. Theodor Adorno, quoted in ibid., p. 359.

SELECTED BIBLIOGRAPHY

Compiled by Robert Evren

The following bibliographic documentation is arranged in two sections: General Works and Individual Artists. The first section includes books on contemporary drawing, painting, and sculpture; works cited in the text; and group exhibition catalogues. The second section, arranged alphabetically by artist, contains a selection of monographs and articles. An asterisk indicates that the publication is not an exhibition catalogue. Biographical data appear in this listing only for artists whose work is not illustrated in this volume.

GENERAL WORKS

Ammann, Jean-Christophe, and R. Hollenstein. *From Twombly to Clemente: Selected Works from a Private Collection.* Basel: Kunsthalle Basel, 1985 [in German and English].

The BiNATIONAL: American Art of the Late 80's. Texts by Thomas Crow and Lynne Tillman. Interviews by Trevor Fairbrother, David Joselit, and Elisabeth Sussman. Boston: The Institute of Contemporary Art and Museum of Fine Arts/Cologne: DuMont Buchverlag, 1988 [in German and English].

BiNATIONALE: Deutsche Kunst der späten 80er Jahre. Texts by Jürgen Harten, Jürg Altwegg, and Dietmar Kamper. Interviews by Rainer Crone, Marie Luise Syring, and Christiane Vielhaber. Boston: The Institute of Contemporary Art and Museum of Fine Arts/Cologne: DuMont Buchverlag, 1988 [in German and English].

Cameron, Dan, and Gosse Oosterhof. *Horn of Plenty: Sixteen Artists from NYC.* Amsterdam: Stedelijk Museum, 1989 [in Dutch and English].

Cooke, Lynne, and Mark Francis, eds. *Carnegie International 1991.* Pittsburgh: Museum of Art, The Carnegie Institute/New York: Rizzoli International, 1991.

Cowart, Jack, ed. *Expressions: New Art from Germany.* Texts by Jack Cowart, Siegfried Gohr, and Donald Kuspit. St. Louis: The St. Louis Art Museum/Munich: Prestel-Verlag, 1983.

Culture and Commentary: An Eighties Perspective. Texts by Kathy Halbreich, Maurice Culot, Vijak Mahdavi and Bernardo Nadal-Ginard, Michael M. Thomas, Sherry Turkle, and Simon Watney. Washington, D.C.: Hirshhorn Museum and Sculpture Garden, Smithsonian Institution, 1990.

Davenport, Guy. *Artists' Sketchbooks*. New York: Matthew Marks, 1991.

Drawing Distinctions: American Drawings of the Seventies. Texts by Richard Armstrong, Alfred Kren, Carter Ratcliff, and Peter Schjeldahl. Humlebaek: Louisiana Museum of Modern Art/Munich: Prestel-Verlag, 1981.

Drawings: The Pluralist Decade. Introduction by Janet Kardon. Texts by John Hallmark Neff, Rosalind Krauss, Richard Lorber, Edit deAk, John Perrault, and Howard N. Fox. Philadelphia: Institute of Contemporary Art, University of Pennsylvania, 1980.

Eagleton, Terry. *The Ideology of the Aesthetic*. Oxford and Cambridge, Mass.: Basil Blackwell, 1990.*

Endgame: Reference and Simulation in Recent Painting and Sculpture. Texts by Yve-Alain Bois, Thomas Crow, et al. Cambridge: M.I.T. Press, 1986.*

Die Enthauptete Hand — 100 Zeichnungen aus Italien: Chia, Clemente, Cucchi, Paladino. Texts by Wolfgang M. Faust, Margarethe Jochimsen, and Achille Bonito Oliva. Bonn: Bonner Kunstverein, 1980.

Gercken, Gunther, and Uwe M. Schneede. *Zeichen setzen durch Zeichnen*. Hamburg: Kunstverein, 1979.

German Art Now. London: Academy Editions/New York: St. Martin's Press, 1989.*

Goldstein, Ann, and Mary Jane Jacob. *A Forest of Signs: Art in the Crisis of Representation*. Los Angeles: The Museum of Contemporary Art, 1989.

Harvey, David. *The Condition of Postmodernity: An Enquiry into the Origins of Cultural Change*. Oxford and Cambridge, Mass.: Basil Blackwell, 1989.*

Emanuel Hoffmann-Stiftung. Texts by Christian Geelhar, Katharina Steib, Jean-Christophe Ammann, et al. Basel: Wiese Verlag, 1991.*

Image Scavengers: Photography. Texts by Douglas Crimp and Paula Marincola. Philadelphia: Institute of Contemporary Art, University of Pennsylvania, 1982.

Jacobowitz, Ellen, and Ann Percy. *New Art on Paper*. Philadelphia: Philadelphia Museum of Art, 1988.

Jameson, Fredric, et al. *Utopia Post Utopia: Configurations of Nature and Culture in Recent Sculpture and Photography*. Boston: The Institute of Contemporary Art and M.I.T. Press, 1988.

Joachimides, Christos. *A New Spirit in Painting*. London: Royal Academy of Arts, 1981.

Joachimides, Christos M., and Norman Rosenthal, eds. *Zeitgeist*. Berlin: Martin-Gropius-Bau, 1983.

Joachimides, Christos M., and Norman Rosenthal, eds. *Metropolis*. Berlin: Martin-Gropius-Bau, 1991.

Koepplin, Dieter. *Raume heutiger Zeichnungen, Werke aus dem Baseler Kupferstichkabinett*. Baden-Baden: Staatliche Kunsthalle, 1985.

Koepplin, Dieter. *Zeichnungen aus dem Kupferstichkabinett Basel*. Nuremburg: Kunsthalle, 1990.

Krauss, Rosalind. *Line as Language: Six Artists Draw*. Princeton: The Art Museum, Princeton University, 1974.

Little Arena: Drawings and Sculptures from the Collection of Adri, Martin, and Geertjan Visser. Introduction by Toos van Kooten. Interview with Caroline Visser by Rudi Oxenaar. Otterlö: Rijksmuseum Kröller-Müller, 1984.

McShine, Kynaston, ed. *An International Survey of Recent Painting and Sculpture*. New York: The Museum of Modern Art, 1984.

Marx, Leo. *The Machine in the Garden: Technology and the Pastoral Ideal in America*. London and New York: Oxford University Press, 1968.*

Meyer, Franz, and Zdenek Felix. *Zeichnen/Bezeichnen*. Basel: Kunstmuseum, 1976.

Olander, William, and Andy Grundberg. *Drawings: After Photography*. New York: Independant Curators Inc., 1984.

Oxenaar, R., and Carter Ratcliff. *Diagrams and Drawings*. Otterlö: Rijksmuseum Kröller-Müller, n.d.

Plous, Phyllis. *Contemporary Drawings: In Search of an Image*. Santa Barbara: University Art Museum, University of California, 1981.

Rose, Bernice. *Drawing Now*. New York: The Museum of Modern Art, 1976.

Rose, Bernice. *New Work on Paper 2: Jonathan Borofsky, Francesco Clemente, Mario Merz, A. R. Penck, Giuseppe Penone*. New York: The Museum of Modern Art, 1982.

Rose, Bernice. *New Work on Paper 3*. New York: The Museum of Modern Art, 1985.

Schwarzwälder, Rosemarie, ed. *Abstract Painting of America and Europe*. Klagenfurt: Ritter Verlag, 1988 [in German and English].

Sontag, Susan. *On Photography*. New York: Farrar, Straus and Giroux, 1977.*

Wallis, Brian, ed. *Art after Modernism: Rethinking Representation*. New York: The New Museum of Contemporary Art/Boston: David Godine Publisher, 1984.*

Zeichenkunst der Gegenwart: Sammlung Prinz Franz von Bayern. Introduction by Wolfgang Holler. Munich: Staatliche Graphische Sammlung, 1988.

INDIVIDUAL ARTISTS

GEORG BASELITZ

Franzke, Andreas. *Georg Baselitz*. Munich: Prestel-Verlag, 1989.*

Gachnang, Johannes, and Theo Kneubuhler. *Georg Baselitz: Malerei, Handzeichnungen, Druckgraphik*. Bern: Kunsthalle, 1976.

Haenlein, Carl, ed. *Georg Baselitz: Skulpturen und Zeichnungen 1979–1987*. Texts by Stephanie Barron, Eric Darrago, Andreas Franzke, Carl Haenlein, and A. M. Hammacher. With abstract of a conversation with Jean-Louis Froment and Jean-Marc Poinsot. Hannover: Kestner-Gesellschaft, 1987.

Haks, F. *Georg Baselitz: Tekeningen/Zeichnungen*. Interview by Johannes Gachnang. Groningen: Groninger Museum, 1979.

Koepplin, Dieter. *Georg Baselitz: Zeichnungen und druckgraphische Werke aus dem Kupferstichkabinett Basel*. Basel: Kunsthalle, 1989.

Koepplin, Dieter, and Rudi Fuchs. *Georg Baselitz: Zeichnungen 1958–1983*. Basel: Kunstmuseum, 1984.

JEAN MICHEL BASQUIAT

Jean Michel Basquiat: Drawings. Introduction by Robert Storr. New York: Robert Miller Gallery, 1990.

Davvetas, Demosthenes. *Jean Michel Basquiat: Paintings, Sculptures, Works on Paper and Drawings*. Paris: Galerie Enrico Navarra, 1989 [in French and English].

Enrici, Michel. *J. M. Basquiat*. Paris: Editions de la Différence, 1989.*

Haenlein, Carl, ed. *Jean Michel Basquiat*. Text by Robert Farris Thompson. Hannover: Kestner-Gesellschaft, 1986.

Haenlein, Carl, ed. *Jean Michel Basquiat: Das zeichnerische Werk*. Texts by Carsten Ahrens, Demosthenes Davvetas, Carl Haenlein, and Keith Haring. Hannover: Kestner-Gesellschaft, 1989.

Pellizzi, Francesco, and Glenn O'Brien. *Jean Michel Basquiat*. New York: Vrej Baghoomian, Inc., 1989.

ASHLEY BICKERTON

Foster, Hal. "Signs Taken for Wonders." *Art in America* (June 1986), pp. 80–91, 139.*

Ghez, Suzanne. *California Arts: Skeptical Beliefs*. Newport Beach, Calif.: Newport Harbor Art Museum/Chicago: The Renaissance Society, University of Chicago, 1988.

Leigh, Christian. "It's the End of the World and I Feel Fine." *Artforum* (Summer 1988), pp. 116–19.*

Mind Over Matter: Concept and Object. Interview by Richard Armstrong. New York: Whitney Museum of American Art, 1990. Pp. 35–37.

The Silent Baroque. Interview by Mark Dion. Salzburg: Edition Thaddaeus Ropac, 1989. P. 277.

JONATHAN BOROFSKY

Jonathan Borofsky. Texts by Olle Granath, Joan Simon, Dieter Koepplin, and Richard Armstrong. Stockholm: Moderna Museet, 1984 [in Swedish and English].

Jonathan Borofsky: An Installation. Interview by Kathy Halbreich. Boston: Hayden Gallery, M.I.T., 1980.

Geelhaar, Christian, and Dieter Koepplin. *Jonathan Borofsky: Zeichnungen 1960–1983*. Basel: Kunstmuseum, 1983.

Rosenthal, Mark, and Richard Marshall. *Jonathan Borofsky*. Philadelphia: Philadelphia Museum of Art/New York: Whitney Museum of American Art, 1984.

Simon, Joan. "An Interview with Jonathan Borofsky." *Art in America* (November 1981), pp. 156–67.*

Simon, Joan. *Jonathan Borofsky: Dreams 1973–1981*. London: Institute of Contemporary Arts/Basel: Kunsthalle, 1981.

FRANCESCO CLEMENTE

Francesco Clemente. Texts by Michael Auping and Francesco Pellizzi in collaboration with Jean-Christophe Amman. Sarasota: The John and Mable Ringling Museum of Art/New York: Harry N. Abrams, Inc., 1985.

Francesco Clemente CVIII: Watercolours Adayar 1985. Introduction by Dieter Koepplin. Basel: Museum für Gegenwartskunst, 1987.

Francesco Clemente: Pastelle 1973–1983. Texts by Rainer Crone, Zdenek Felix, Lucius Grisebach, and Joseph Leo Koerner. Munich: Prestel-Verlag 1984.

Francesco Clemente: Testa Coda. Introduction by Dieter Koepplin. Essay and interview by Michael McClure. New York: Gagosian Gallery and Rizzoli International, 1991.

Francesco Clemente: Three Worlds. Texts by Ann Percy, Raymond Foye, Stella Kramrisch, and Ettore Sottsass. Philadelphia: Philadelphia Museum of Art, 1990.

Crone, Rainer, and Georgia Marsh. *An Interview with Francesco Clemente*. New York: Vintage Books, 1987.*

GEORGE CONDO

Casey, Michael. *George Condo: Drawings, Watercolors*. Helsinki: Galerie Kajforsblom, 1990.

George Condo. Introduction and interview by Felix Guattari. Paris: Galerie Daniel Templon, 1990 [in French and English].

George Condo: Paintings and Drawings. Introduction by Henry Geldzahler. New York: The Pace Gallery, 1988.

George Condo: Paintings and Drawings 1985–87. Introduction by Wilfried Dickhoff. Zürich: Gallery Bruno Bischofberger, 1985 [in German and English].

Davvetas, Demosthenes. *The American Painter of the 20th Century in Germany: George Condo, Paintings 1984–1987*. Introduction by Zdenek Felix. With fragments from Davvetas's novel *OREST*. Munich: Kunstverein, 1987 [in German and English].

Dickhoff, Wilfried. *George Condo*. New York: Barbara Gladstone Gallery, 1986.

RICHARD DEACON

Cooke, Lynne, and Marjorie Allthorpe-Guyton. *Richard Deacon*. London: Whitechapel Art Gallery, 1988.

Richard Deacon. Texts by Richard Deacon, Lynne Cooke, Michael Newman, Peter Schjeldahl, John Caldwell, and Claudia James. Pittsburgh: Museum of Art, The Carnegie Institute, 1988.

Richard Deacon Talking About For Those Who Have Ears No. 2 and Other Works. Interview by Richard Francis. London: The Tate Gallery, Patrons of New Art, 1985.

Harrison, Charles, and Peter Schjeldahl. *Richard Deacon: Sculptures and Drawings*. Madrid: Fundacion Caja de Pensiones, 1988 [in Spanish and English].

Newman, Michael. *Richard Deacon: Sculpture 1980–1984*. Edinburgh: The Fruitmarket /Lyon: Nouveau Musée, 1984.

GÜNTHER FÖRG

Bool, Flip, and Rudi Fuchs. *Günther Förg*. The Hague: Haags Gemeentemuseum, 1988 [in English].

Günther Förg. Texts by Veit Loers, Jan Hoet, Dieter Gleisberg, Götz Adriani, and Michael Tacke. Stuttgart: Edition Cantz, 1990 [in German and English].

Günther Förg: The Large Drawings. Text by Werner Lippert. Cologne: Galerie Gisela Capitain, 1990 [in German and English].

Günther Förg: Painting/Sculpture/Installation. Texts by Bonnie Clearwater, Stephen Ellis, Christoph Schenker, Paul Schimmel, and Max Wechsler. Newport Beach, Calif.: Newport Harbor Art Museum/Chicago: The Renaissance Society, University of Chicago, 1989.

Groot, Paul, and Max Hetzler. *Günther Förg*. Munster: Westfälischer Kunstverein Munster, 1986.

ROBERT GOBER

Gholson, Craig. "Robert Gober" [interview]. *Bomb* (Fall 1989), pp. 32–36.*

Robert Gober. Texts by Ulrich Loock, Karel Schampers, and Trevor Fairbrother. Rotterdam: Museum Boymans–van Beuningen, 1990 [in Dutch and English].

Robert Gober/Louise Bourgeois. Texts by Josef Helfenstein, Nancy Spector, and Hans-Ulrich Obrist, and a conversation between Teresia Bush, Robert Gober, and Ned Rifkin. *Parkett,* Special Issue: No. 27 (1991) [in German and English].*

Joselit, David. "Investigating the Ordinary." *Art in America* (May 1988), pp. 149–54.*

Sherlock, Maureen P. "Arcadian Elegy: The Art of Robert Gober." *Arts Magazine* (September 1989), pp. 45–49.*

KEITH HARING

Deitch, Jeffrey. *Keith Haring: Paintings, Drawings and a Velum.* Introduction by Wim Beeren. Interview by Paul Donker Duyvis. Amsterdam: Stedelijk Museum, 1986 [in Dutch and English].

Keith Haring. Texts by Robert Pincus-Witten, Jeffrey Deitch, and David Shapiro. New York: Tony Shafrazi Gallery, 1982.

Keith Haring: Future Primeval. Introduction by William S. Burroughs. Texts by Barry Blinderman, Timothy Leary, Maarten van de Guchte, and Vince Aletti. Normal: University Galleries, Illinios State University, 1990.

Keith Haring: Peintures, Sculptures, et Dessins. Text by Jean-Louis Froment, Brion Gysin, and Sylvie Couderc. Bordeaux: Musée d'Art Contemporain, 1985 [in French and English].

Ricard, Rene. "The Radiant Child." *Artforum* (December 1981), pp. 35–43.*

JENNY HOLZER

Auping, Michael. *Jenny Holzer: The Venice Installation.* Buffalo: Albright-Knox Art Gallery, 1991.

Holzer, Jenny. *Truisms and Essays,* Halifax: Press of the Nova Scotia College of Art and Design, 1983.*

Siegel, Jeanne. "Jenny Holzer's Language Games" [interview]. *Arts Magazine* (December 1985), pp. 64–68. Reprinted in *Artwords 2: Discourse on the Early 80s.* Ann Arbor and London: UMI Press, 1988. Pp. 285–97.*

Simon, Joan. *Jenny Holzer: Signs.* Des Moines: Des Moines Art Center, 1986.

Waldman, Diane. *Jenny Holzer.* New York: Solomon R. Guggenheim Foundation and Harry N. Abrams, Inc., 1989.

JÖRG IMMENDORFF

Boetzkes, Manfred, and Diana Nguy. *Immendorff — zeichne: Zeichnungen 1959–1989.* Hildesheim: Roemer-Museum, 1989.

Gachnang, Johannes, and Max Wechsler. *Jörg Immendorff: Malermut rundum.* Bern: Kunsthalle , 1980.

Immendorff's Handbuch der Akademie für Adler. Cologne: Verlag der Buchhandlung Walther Konig, 1990.*

Jörg Immendorff: Brandenburger Tor Weltfrage. With a poem by A. R. Penck. New York: The Museum of Modern Art, 1982.

Jörg Immendorff: LIDL 1966–1970. Eindhoven: Stedelijk Van Abbemuseum, 1981.

Koepplin, Dieter. *Jörg Immendorff: Cafe Deutschland.* Basel: Kunstmuseum, 1979.

MIKE KELLEY

Cameron, Dan. "Mike Kelley's Act of Violation." *Arts Magazine* (June 1986), pp. 4–17.*

Kelley, Mike. "Foul Perfection: Thoughts on Caricature," *Artforum* (January 1989), pp. 92–99.*

Kelley, Mike. "Mike Talks about Mike." Interview with M. Smith. *High Performance* 33 (1986), pp. 28–34.*

Kelley, Mike. *Plato's Cave, Rothko's Chapel, Lincoln's Profile.* New York: Artists Space, 1986.

Knight, Christopher. *Mike Kelley.* Cologne: Jablonka Galerie, 1989 [in German and English].

Singerman, Howard, and John Miller. *Mike Kelley. Three Projects: Half a Man, From My Institution to Yours, Pay for Your Pleasure.* Chicago: The Renaissance Society, University of Chicago, 1988.

MARTIN KIPPENBERGER

Werner Büttner, Martin Kippenberger, Albert Oehlen: Wahrheit ist Arbeit. Texts by the artists, Anette Grotkasten, Nicola Reidenbach, Diedrich Diedrichsen, Reinald Goetz, and Dr. Helmut R. Leppien. Essen: Folkwang Museum, 1984.

Caldwell, John. *Martin Kippenberger: I Had A Vision.* Interview by Jutta Koether. San Francisco: San Francisco Museum of Modern Art, 1991.

Martin Kippenberger. Texts by Diedrich Diedrichsen, Patrick Frey, and Martin Prinzhorn with Bice Curiger. *Parkett,* Special Issue: No. 19 (1989) [in German and English].*

Martin Kippenberger: Miete Strom Gas. Texts by Johann-Karl Schmidt, Martin Prinzhorn, Bazon Brock, and Diedrich Diedrichsen. Darmstadt: Hessisches Landesmuseum , 1986 [in German and English].

Muthesius, Angelika, and Burkhard Riemschneider. *Martin Kippenberger: Ten Years After.* Cologne: Taschen, 1991 [in English, French, and German].*

See also OEHLEN

JANNIS KOUNELLIS

Briganti, Giuliano. *Kounellis — Via del Mare.* Interview by Wim Beeren. Amsterdam: Stedelijk Museum, 1990 [in English, Dutch, and French].

Fuchs, Rudi H., and Jannis Kounellis. *Jannis Kounellis.* Eindhoven: Stedelijk Van Abbemuseum, 1981 [in Dutch and English].

Jacob, Mary Jane, and Thomas McEvilley. *Kounellis.* Chicago: Museum of Contemporary Art, 1986

Jannis Kounellis. Texts by Jean-Christophe Ammann, Alberto Boatto, Germano Celant, Bruno Cora, Mario Diacono, Zdenek Felix, Rudi H. Fuchs, Jannis Kounellis, Filiberto Menna, Tommaso Trini, Cesare Vivaldi, and Maria Volpi. Rimini: Musei Comunali, 1983.

Jannis Kounellis: Arbeiten von 1958–1985. Texts by Helmut Friedel, Bernd Growe, Marianne Stockebrand, and Jannis Kounellis. Munich: Städtische Galerie im Lenbachhaus, 1985.

Moure, Gloria. *Kounellis.* New York: Rizzoli, 1990.*

SHERRIE LEVINE

Buchloh, Benjamin. "Allegorical Procedures: Appropriation and Montage in Contemporary Art." *Artforum* (September 1982), pp. 43–56.*

Cameron, Dan. "Absence and Allure: Sherrie Levine's Recent Work." *Arts Magazine* (December 1983), pp. 84–87.*

Marzorati, Gerald. "Art in the (re)Making." *Art News* (May 1986), pp. 90–99.*

Morgan, Robert C. "Sherrie Levine: Language Games." *Arts Magazine* (December 1987), pp. 86–88.*

Rosenzweig, Phyllis, and Susan Krane. *Sherrie Levine.* Atlanta: High Museum of Art, 1988.

Siegel, Jeanne. "After Sherrie Levine." *Arts Magazine* (Summer 1985), pp. 141–44.*

SOL LeWITT

Alloway, Lawrence. "Sol LeWitt: Modules, Walls, Books," *Artforum* (April 1975), pp. 38–45.*

Grevenstein, Alexander van, and Jan Debbaut. *Sol LeWitt: Wall Drawings 1968–1984.* Amsterdam: Stedelijk Museum/Eindhoven: Stedelijk Van Abbemuseum/Hartford: Wadsworth Atheneum, 1984.

Legg, Alicia, ed. *Sol LeWitt.* Texts by Robert Rosenblum, Lucy R. Lippard, and Bernice Rose. New York: The Museum of Modern Art, 1978.

LeWitt, Sol. "Paragraphs on Conceptual Art," *Artforum* (June 1967), pp. 79–80.*

Sol LeWitt. Texts by John N. Chandler, Enno Develing, Dan Graham, Hans Strelow, Lawrence Wiener, Barbara M. Reise, Dick van der Net, Lucy Lippard, Ira Licht, Rosalind Krauss, Michael Kirby, Eva Hesse, Coosje van Bruggen, Dan Flavin, Mel Bochner, Terry Atkinson, and Carl Andre; statements by the artist. The Hague: Haags Gemeentemuseum, 1970.

Loock, Ulrich. *Sol LeWitt: Wall Drawings 1984–1988.* Hartford: Wadsworth Atheneum/Bern: Kunsthalle, 1989.

GLENN LIGON

Double Take: Collective Memory and Current Art. Texts by Lynne Cooke, Bice Curiger, and Greg Hilty. London: Hayward Gallery, 1991.

Faust, Gretchen. "BACA Downtown, Brooklyn." *Arts Magazine* (December 1990), p. 104.*

Larson, Kay. "A Sock to the System." *New York Magazine* (April 29, 1991).*

Plous, Phyllis, and Frances Colpitt. *Knowledge: Aspects of Conceptual Art.* Santa Barbara: University Art Museum, 1992.

Smith, Roberta. "Lack of Location is My Location." *New York Times,* June 16, 1991. Section C, p. 1.*

ROBERT LONGO

Foster, Hal. "The Art of Spectacle." *Art in America* (April 1983), pp. 144–49.*

Foster, Hal. *Robert Longo: Drawings & Reliefs.* Akron: Akron Art Museum, 1984.

Hobbs, Robert. *Robert Longo: Dis-Illusions.* Iowa City: The University of Iowa Museum of Art, 1985.

Robert Longo. Texts by Howard N. Fox, Hal Foster, Katherine Dieckmann, and Brian Wallis. Los Angeles: Los Angeles County Museum of Art, 1989.

Robert Longo: Men in the Cities, 1979–1982. Introduction and interview by Richard Price. New York: Harry N. Abrams, Inc., 1986.*

Ratcliff, Carter. *Robert Longo.* New York: Rizzoli International/ Munich: Schirmer/Mosel, 1985.*

BRICE MARDEN

Bann, Stephan. *Brice Marden: Paintings, Drawings, Etchings 1975–1980.* Amsterdam: Stedelijk Museum, 1981 [in Dutch and English].

Kern, Hermann, and Klaus Kertess. *Brice Marden: Drawings 1964–1978.* Munich: Kunstraum, 1979 [in German and English].

Lebensztejn, Jean-Claude, and Klaus Kertess. *Brice Marden.* Paris: Galerie Montenay, 1987 [in French and English].

Brice Marden. Texts by Carter Ratcliff, Lisa Liebmann, Franz Meyer, and Francesco Pellizzi. *Parkett,* Special Issue: No. 7 (1986) [in German and English].*

Brice Marden: Paintings, Drawings and Prints 1975–80. Texts by Nicholas Serota, Stephen Bann, and Roberta Smith. London: Whitechapel Art Gallery, 1981.

Brice Marden: Recent Drawings and Etchings. Interview by Pat Steir. New York: Matthew Marks, 1991.

Yau, John. *Brice Marden: Recent Paintings & Drawings.* London: Anthony d'Offay Gallery, 1988.

ALLAN McCOLLUM

"An Interview with Allan McCollum." *Arts Magazine* (October 1985), pp. 40–44.*

Fraser, Andrea. *Allan McCollum: Investigations.* Philadelphia: Institute of Contemporary Art, University of Pennsylvania, 1986.

Fraser, Andrea, and Ulrich Wilmes. *Allan McCollum: Individual Works.* New York: John Weber Gallery, 1988.

Jacobs, Joseph. *Allan McCollum: Perfect Vehicles.* Sarasota: The John and Mable Ringling Museum of Art, 1988.

Allan McCollum. Texts by Anne Rorimer, Lynne Cooke, and Selma Klein Essink. Eindhoven: Stedelijk Van Abbemuseum, 1989.

Owens, Craig. *Allan McCollum: Surrogates.* London: Lisson Gallery, 1985.

REINHARD MUCHA

Reinhard Mucha was born in 1950 in Düsseldorf, where he still lives. His work has combined sculptural constructions in metal, felt, and other materials with quasi-documentary photography and drawing. His first one-man exhibition, *. . . sondern staatdessen einen Dreck wie mich [. . . but instead rubbish like me],* was held at the Verwaltungs- und Wirtschaftsakademie, Düsseldorf, in 1977. His work has been included in group exhibitions at the Kunsthalle, Baden-Baden, in *Kunst Wird Material,* Nationalgalerie, Berlin (1982), *The BiNATIONAL: German Art of the Late 80's,* in Germany and the United States (1988), and *Metropolis,* Martin-Gropius-Bau, Berlin (1991). Since 1982 he has been associated with the Max Hetzler Gallery, Cologne, where he has had three exhibitions; other exhibitions of his work have been *Nordausgang,* Kunsthalle, Basel, *Kasse beim Fahrer,* Kunsthalle, Bern (both 1987), and *Kopfdiktate,* Museum Haus Esters, Krefeld (1989). He represented Germany, with photographers Bernd and Hilla Becher, at the 1991 Venice Biennale.

Amman, Jean-Christophe, and Ulrich Loock. *Reinhard Mucha, Kasse beim Fahrer/Nordausgang.* Bern: Kunsthalle/Basel: Kunsthalle, 1987.

Cooke, Lynne. "Reinhard Mucha." *Artscribe* (March–April 1987), pp. 56–58.*

Frey, P. "Reinhard Mucha: Verbindungen/Connections." *Parkett* 12 (March 1987), pp. 104–19 [in German and English].*

Reinhard Mucha, Gladbeck. Paris: Centre Georges Pompidou, 1986.

BRUCE NAUMAN

Bruggen, Coosje van. *Bruce Nauman.* New York: Rizzoli International, 1988.*

Livingston, Jane, and Marcia Tucker. *Bruce Nauman: Works from 1965–1972.* Los Angeles: Los Angeles County Museum of Art/New York: Praeger Publishers, 1972.

Bruce Nauman. Texts by Jeanne Silverthorne, Patrick Frey, Rein Wolfs, Chris Dercon, and Robert Storr. *Parkett,* Special Issue: No. 10 (1986) [in German and English].*

Bruce Nauman: Drawings 1965–1986. Texts by Coosje van Bruggen, Dieter Koepplin, and Franz Meyer. Basel: Museum für Gegenwartskunst, 1986 [in German and English].

Richardson, Brenda. *Bruce Nauman: Neons.* Baltimore: The Baltimore Museum of Art, 1983.

Simon, Joan, and Jean-Christophe Amman. *Bruce Nauman.* Foreword by Nicholas Serota. London: Whitechapel Art Gallery, 1986.

Zütter, Jörg, ed. *Bruce Nauman: Skulpturen und Installationen 1985–1990.* Texts by Franz Meyer and Jörg Zütter. Cologne: Dumont Buchverlag, 1990.*

ALBERT OEHLEN

Abräumung-Prokrustische Malerei 1982–84. Zürich: Kunsthalle, 1987.

Oehlen, Albert. *Ewige Feile.* Poems by Wolfgang Bauer. Cologne: Walther Koenig, 1983.

Oehlen, Albert, and Martin Kippenberger. *The Cologne Manifesto.* Graz-Cologne-Hamburg: Edition Lord Jim Lodge, 1985.*

Albert Oehlen: Zeichnungen. Vienna: Galerie Peter Pakesch, 1985.

Le Radius Kronenbourg: Werner Büttner, Martin Kippenberger, Albert Oehlen, Markus Oehlen. Nice: Centre National d'Art Contemporain, Villa Arson, 1987.

See also KIPPENBERGER

TOM OTTERNESS

Herrera, Hayden. *Tom Otterness.* New York: Brooke Alexander Gallery, 1990.

Kirshner, Judith Russi. *The Tables: Tom Otterness.* Valencia: IVAM Centre Julio González/Frankfurt am Main: Portikus/Senckenbergmuseum/The Hague: Haags Gemeentemuseum, 1991 [in English, German, and Spanish].

Russell, John, "Tom Otterness's 'Tables' at the Modern." *New York Times,* August 7, 1987. Section C.

Shearer, Linda. *Projects: Tom Otterness.* New York: The Museum of Modern Art, 1987 [brochure].

A. R. PENCK

Gachnang, Johannes, ed. *A. R. Penck. Zeichnungen 1958–1985.* Text by A. R. Penck. Bern and Berlin: Verlag Gachnang & Springer, 1986.*

Koepplin, Dieter. *A. R. Penck: Penck Mal TM.* Bern: Kunsthalle, 1975.

Koepplin, Dieter. *A. R. Penck: Zeichnungen bis 1975.* Introduction by Johannes Gachnang. Basel: Kunstmuseum, 1978.

A. R. Penck. Texts by A. R. Penck, Sascha Anderson, Johannes Gachnang, Lucius Grisebach, Thomas Kirchner, and Jürgen Schweinebraden Freiherr von Wichmann-Eichhorn. Berlin: Nationalgalerie /Munich: Prestel-Verlag, 1988.

A. R. Penck: Tekeningen. Texts by R. H. Fuchs, Mariette Josephus Jitta, and A. R. Penck. The Hague: Haags Gemeentemuseum, 1988 [in Dutch, English, and German].

Schmied, Wieland. *A. R. Penck: Penck — West in Berlin: Zeichnungen aus den Jahren 1980–82.* Berlin: Deutscher Akademischer Austauschdienst and Rainer Verlag, 1986.

ELLEN PHELAN

Albee, Edward. *Ellen Phelan: Matrix 48.* Hartford: The Wadsworth Atheneum, 1979 [brochure].*

Armstrong, Richard. "Un Tour d'Horizon: Mary Heilmann and Ellen Phelan." *Bomb,* No. 4 (1982), pp. 14–15.*

Loughery, John. "Landscape Painting in the Eighties: April Gornik, Ellen Phelan and Joan Nelson." *Arts Magazine* (May 1983), pp. 44–48.*

Spector, Buzz, "Ellen Phelan." *Artforum* (February 1987), p. 113.*

Westfall, Stephen, "Ellen Phelan: Barbara Toll Gallery." *Flash Art* (March–April 1988), pp. 114–15.*

SIGMAR POLKE

Buchloh, Benjamin. "Parody and Appropriation in Francis Picabia and Sigmar Polke." *Artforum* (March 1982), pp. 28–34.*

Carlson, Prudence. *Sigmar Polke: Drawings from the 1960's.* New York: David Nolan Gallery, 1987.

Sigmar Polke. Texts by Harald Szeeman, Dietrich Helms, Siegfried Gohr, Reiner Speck, Jürgen Hohmeyer, Sigmar Polke, and Gerhard Richter. Cologne: Josef-Haubrich-Kunsthalle, 1984.

Sigmar Polke. Texts by Susanne Pagé, Bernard Lamarche-Vadel, Demosthenes Davvetas, Bernard Marcadé, Bice Curiger, Michael Oppitz, Hagen Lieberknect, Feelman & Dietman. Paris: Musée d'Art Moderne/ARC, 1988.

Sigmar Polke. Texts by John Caldwell, Peter Schjeldahl, John Baldessari, Reiner Speck, Michael Oppitz, and Katharina Schmidt. San Francisco: San Francisco Museum of Modern Art, 1991.

Sigmar Polke: Bilder, Tücher, Objeckte: Werkauswahl 1962–1971. Texts by Joseph Beuys, Sigmar Polke, Gerhard Richter, Friedrich Wolfram Heubach, and Benjamin Buchloh. Tübingen: Kunsthalle, 1976.

Schmidt, Katharina, and Gunter Schweikhart. *Sigmar Polke: Zeichnungen, Aquarelle, Skizzenbucher 1962–1988.* Bonn: Kunstmuseum, 1988.

STEPHEN PRINA

Martin, Timothy. "Steve Prina." *Visions* (Winter 1988), pp. 6–10.*

Martin, Timothy. *Stephen Prina: Exquisite Corpse, The Complete Paintings of Manet, 57 through 66 of 556.* London: Karsten Schubert Ltd., 1989.

Prina, Stephen. *Monochrome Painting.* Chicago: The Renaissance Society, University of Chicago, 1989.

Prina, Stephen, and Christopher Williams. "A Conversation with Sheila McLaughlin and Lynn Tillman." *Journal of the Los Angeles Institute of Contemporary Art* (Spring 1985), pp. 40–45.*

RICHARD PRINCE

Linker, Kate. *Richard Prince.* Villeurbanne, France: Nouveau Musée, 1983 [in French and English].

Rian, Jeffrey. [Interview with Richard Prince]. *Art in America* (March 1987), pp. 86–95.*

Richard Prince: Jokes, Gangs, Hoods. Cologne: Galerie Rafael Jablonka and Galerie Gisela Capitain, 1990 [artist's book].*

Spiritual America — Richard Prince. Valencia: IVAM Centre del Carme, 1989 [artist's book].*

MARTIN PURYEAR

Benezra, Neal, and Robert Storr. *Martin Puryear.* Chicago: The Art Institute of Chicago/New York: Thames and Hudson, 1991.

Davies, Hugh M., and Helaine Posner. *Martin Puryear.* Amherst: University Gallery, University of Massachusetts, 1984.

Day, Holliday T. *I-80 Series: Martin Puryear.* Omaha: Joslyn Art Museum, 1980.

Fuller, Patricia, and Judith Russi Kirshner. *Martin Puryear: Public and Personal.* Chicago: Chicago Public Library Cultural Center, 1987.

King, Elaine. *Martin Puryear: Beyond Style, The Power of the Simple.* Pittsburgh: Carnegie Mellon University Art Gallery, 1987.

Lewallen, Constance. *Martin Puryear: Matrix 1986.* Berkeley: University Art Museum, University of California at Berkeley, 1985 [brochure].

GERHARD RICHTER

Buchloh, Benjamin H. D. *Gerhard Richter: Abstract Paintings.* Introduction by R. H. Fuchs. Eindhoven: Stedelijk Van Abbemuseum/London: Whitechapel Art Gallery, 1978.

Harten, Jürgen, and Dietmar Elger. *Gerhard Richter: Bilder/Paintings 1962–1985.* Cologne: DuMont Buchverlag, 1986 [in German and English].*

Loock, Ulrich. *Gerhard Richter: Aquarelle.* Stuttgart: Staatsgalerie, Graphische Sammlung/Munich: Verlag Fred Jahn, 1985.

Nasgaard, Roald, and I. Michael Danoff. *Gerhard Richter: Paintings.* Interview by Benjamin H. D. Buchloh. London and New York: Thames and Hudson, 1988.*

Gerhard Richter. Texts by Sean Rainbird, Stefan Germer, and Neal Ascherson. Notes by the artist. London: The Tate Gallery, 1991.

Gerhard Richter: Werken op papier 1983–1986. Notes by Gerhard Richter. Amsterdam: Museum Overholland/Munich: Verlag Fred Jahn, 1987.

TIM ROLLINS + K.O.S.

Daniel, Marko, and Jean Fisher. *Tim Rollins + K.O.S.* London: Riverside Studios, 1988.

Koepplin, Dieter, and Tim Rollins. *Tim Rollins + K.O.S.: Temptation of Saint Anthony 1987–1990*. Dialogue between Tim Rollins and the Kids of Survival. Interview by Constance Lewallen. Basel: Museum für Gegenwartskunst, 1990. Published in English in *View* (San Francisco) (Winter 1990).

Tim Rollins + K.O.S. Texts by Tim Rollins + K.O.S., Marshall Berman, and Trevor Fairbrother. *Parkett,* Special Issue, No. 20 (1989) [in German and English].*

Tim Rollins + K.O.S.: Amerika. Introduction by Gary Garrels. Texts by Michele Wallace, Arthur C. Danto, and Tim Rollins. New York: DIA Art Foundation, 1989.

SUSAN ROTHENBERG

Auping, Michael, and Dave Hickey. *Susan Rothenberg: Paintings and Drawings.* Buffalo: Albright-Knox Art Gallery, 1992.

Blum, Peter. *Susan Rothenberg.* Introduction by Jean-Christophe Ammann. Basel: Kunsthalle, 1981.

Grevenstein, Alexander van. *Susan Rothenberg: Recent Paintings.* Amsterdam: Stedelijk Museum, 1982 [in Dutch and English].

Simon, Joan. *Susan Rothenberg.* New York: Harry N. Abrams, Inc., 1991.*

Storr, Robert. *Susan Rothenberg.* Malmö, Sweden: Rooseum Center for Contemporary Art, 1990 [in Swedish and English].

Tuchman, Maurice. *Susan Rothenberg.* Los Angeles: Los Angeles County Museum of Art, 1983.

DAVID SALLE

Beeren, W. A. L., and Carter Ratcliff. *David Salle: Paintings.* Rotterdam: Museum Boymans–van Beuningen, 1983 [in Dutch and English].

Busche, Ernst A. *David Salle: Works on Paper.* Dortmund: Museum am Ostwall, 1986 [in German and English].

Kardon, Janet, and Lisa Phillips. *David Salle.* Philadelphia: Institute of Contemporary Art, University of Pennsylvania, 1986.

Power, Kevin, and Carla Schulz-Hoffmann. *David Salle.* Madrid: Fundacion Caja de Pensiones, 1988 [in Spanish and English].

Rosenblum, Robert, and Richard Thompson. *David Salle.* Edinburgh: The Fruitmarket, 1987.

Schjeldahl, Peter. *David Salle.* New York: Vintage Books, 1987.*

JULIAN SCHNABEL

Barzel, Amnon, and Thomas McEvilley. *Julian Schnabel.* With excerpts from "The Recognitions" by William Gaddis. Prato, Italy: Museo d'Arte Contemporanea Luigi Pecci, 1989 [in Italian and English].

Geelhaar, Christian. "Julian Schnabel's 'Head for Albert.'" *Arts Magazine* (October 1982), pp. 74–75.*

Schiff, Gert. *Julian Schnabel.* New York: The Pace Gallery, 1984.

Julian Schnabel: Oeuvres 1975–86. Texts by B. Ceysson, B. Blistène, A. Cueff, W. Dickhoff, and T. McEvilley. Paris: Centre Georges Pompidou, 1987.

Julian Schnabel: Paintings 1975–1987. Texts by Thomas McEvilley, Lisa Phillips, and Julian Schnabel. London: Whitechapel Art Gallery, 1987.

Zütter, Jörg, ed. *Julian Schnabel: Works on Paper 1975–1988.* Texts by Brooke Adams, Donald Kuspit, and Jörg Zütter. Munich: Prestel-Verlag, 1989.

JOEL SHAPIRO

Bloem, Marja, and Karel Schampers. *Joel Shapiro.* Commentaries by Joel Shapiro. Amsterdam: Stedelijk Museum, 1985 [in Dutch, English, and German].

"Interview: Joel Shapiro Talks with Paul Cummings." *Drawing* (July–August 1990), pp. 31–35.*

Ormond, Mark. *Joel Shapiro, Selected Drawings 1968–1990.* Miami: Center for the Fine Arts, 1991.

Ratcliff, Carter. "Joel Shapiro's Drawings." *The Print Collector's Newsletter* (March–April 1978), pp. 1–4.*

Smith, Roberta. *Joel Shapiro.* Commentaries by Joel Shapiro. New York: Whitney Museum of American Art, 1982.

Smith, Roberta. *Joel Shapiro: Sculpture and Drawing.* London: Whitechapel Art Gallery, 1980.

NANCY SPERO

Kuspit, Donald B. "From Existence to Essence: Nancy Spero." *Art in America* (January 1984), pp. 88–96.*

Tickner, Lisa, and Jon Bird. *Nancy Spero*. London: Institute of Contemporary Arts/Edinburgh: The Fruitmarket/Derry: Orchard Gallery/Foyle Arts Project, 1987.

Nancy Spero: Bilder 1958–1990. Texts by Jon Bird, Thomas Kempas, and Annelie Pohlen. Berlin: Haus am Waldsee/Bonn: Bonner Kunstverein, 1990.

Nancy Spero: 43 Works on Paper, Excerpts from the Writings of Antonin Artaud. Interview by Barbara Flynn. Cologne: Galerie Rudolf Zwirner, 1987.

Nancy Spero: Works since 1950. Texts by Jo-Anna Isaak, Robert Storr, and Leon Golub. Syracuse: Everson Museum of Art, 1987.

Weskott, Hanne. *Nancy Spero: Arbeiten auf Papier 1981–1991*. Munich: Glyptothek am Königsplatz, 1991.

DOUG AND MIKE STARN

Grundberg, Andy. *Mike and Doug Starn*. Introduction by Robert Rosenblum. New York: Harry N. Abrams, Inc., 1990.*

Indiana, Gary. "Imitation of Life." *Village Voice*. April 29, 1986, p. 71.*

Jacobs, Joseph. *Doug and Mike Starn: The Christ Series*. Sarasota: The John and Mable Ringling Museum of Art, 1987.

Masheck, Joseph. "Of One Mind: Photos by the Starn Twins of Boston." *Arts Magazine* (March 1986), pp. 69–71.*

Ottmann, Klaus. "Interview with Doug and Mike Starn." *Journal of Contemporary Art* (Spring/Summer 1990), pp. 66–79.*

Pincus-Witten, Robert. "Being Twins — The Art of Doug and Mike Starn." *Arts Magazine* (October 1988), pp. 72–77.*

PAT STEIR

Broun, Elizabeth. *Form, Illusion, Myth. Prints and Drawings of Pat Steir*. Lawrence: Spencer Art Museum, University of Kansas, 1983.

Cohen, Nancy. *Pat Steir: Ways of Seeing*. Summit: New Jersey Center for the Visual Arts, 1990.

Mayo, Marti. *Arbitrary Order: Paintings by Pat Steir*. Interview by Ted Castle. Houston: Contemporary Arts Museum, 1983.

Ratcliff, Carter. *Pat Steir: Paintings*. New York: Harry N. Abrams, Inc., 1986.*

White, Robin. [Interview with Pat Steir]. *View* (San Francisco), Vol. 1 (1978).*

ROSEMARIE TROCKEL

Drateln, Doris von. "Rosemarie Trockel: Endlich ahnen, nicht nur wissen" [interview]. *Kunstforum* (March 1988), pp. 210–17.*

Koepplin, Dieter. *Rosemarie Trockel: Papierarbeiten*. Basel: Kunstmuseum, Öffentliche Kunstsammlung, 1991.

Penck, A. R., and Reiner Speck. *Rosemarie Trockel: Skulpturen und Bilder*. Hamburg: Galerie Ascan Crone, 1984.

Stich, Sidra, and Elisabeth Sussman. *Rosemarie Trockel*. Munich: Prestel-Verlag, 1991.*

Rosemarie Trockel. Texts by Jean-Christophe Ammann, Peter Weibel, and Wilfried Dickhoff. Basel: Kunsthalle/London: Institute of Contemporary Arts, 1988 [in German and English].

Rosemarie Trockel: Neue Arbeiten. Cologne: Galerie Michael Werner, 1990.

TERRY WINTERS

Carlson, Prudence. "Terry Winters' Earthly Anecdotes." *Artforum* (November 1984), pp. 65–68.*

Kertess, Klaus, and Martin Kunz. *Terry Winters*. Lucerne: Kunstmuseum, 1985 [in German and English].

Phillips, Lisa, and Klaus Kertess. *Terry Winters*. New York: Whitney Museum of American Art, 1991.

Plous, Phyllis, and Christopher Knight. *Terry Winters: Painting and Drawing*. Santa Barbara: University Art Museum, 1987.

Shapiro, David. *Terry Winters: Fourteen Drawings, Fourteen Etchings*. Munich: Verlag Fred Jahn, 1990 [in German and English].*

Winters, Terry. *Schema*. Introduction by Roberta Smith. West Islip, New York: Universal Limited Art Editions, 1988.*

CHRISTOPHER WOOL

Caldwell, John. *Christopher Wool: New Work*. San Francisco: San Francisco Museum of Modern Art, 1989.

Cooke, Lynne. *Michael Craig-Martin, Gary Hume, Christopher Wool*. London: Karsten Schubert Ltd., 1990.

Indiana, Gary. "Chronicle in Black and White." *Village Voice*. May 31, 1987, p. 89.*

Saltz, Jerry. "This Is the End: Christopher Wool's Apocalypse Now." *Arts Magazine* (September 1988), pp. 19–20.*

Wool, Christopher. *Cats in Bag/Bags in River*. Outline by Glenn O'Brien. Rotterdam: Museum Boymans–van Beuningen, 1991. Two volumes [artist's book].

PHOTOGRAPH CREDITS

The photographers and sources for the works reproduced in this volume are listed alphabetically below, followed by the page on which the image appears.

Brian Albert, New York: 70–71
Courtesy Thomas Amman, Zürich: 21
Courtesy Vrej Baghoomian, Inc., New York: 76
© The Estate of Jean Michel Basquiat. All rights reserved. Photo, Beth Page: 75
Geoffrey Clements: 55
Ken Cohen: 66
Ralf Cohen, Karlsbad: 25
Courtesy Crex Collection, Zürich: 22
Prudence Cuming Associates, Ltd., London: 62, 65
D. James Dee: 39, 72, 72–73, 103 bottom
Dorothée Fischer, Düsseldorf: 46
Courtesy Gagosian Gallery, New York: 69
Michael Goodman, New York: 104
Bill Jacobson, New York: 37
Steven Kasher, 56–57
Kate Keller, The Museum of Modern Art, New York: 48, 52, 82, 83, 96, 105
Larry Lame, New York: 100, 106
Peter Muscato: 103 top
Noble/Pelka: 40
Courtesy Anthony d'Offay Gallery, London: 36
Courtesy Öffentliche Kunstsammlung, Kunstmuseum, Basel: 32
Mali Olatunji, The Museum of Modern Art, New York: 30, 45, 51, 79
Courtesy The Pace Gallery, New York: 68, 85
Douglas M. Parker Studio, Los Angeles: 99
David Regen: 91
Sandak/GK Hall: 17
Harry Shunk, New York: 35
Courtesy Sonnabend Gallery, New York: 108
Glenn Steigelman: 41
Courtesy Stux Gallery, New York, and Leo Castelli Gallery, New York: 92
Ivan dalla Tana: 109
Courtesy Jack Tilton Gallery, New York: 107
Courtesy Galerie Michael Werner, Cologne: 18, 26, 29
Gareth Winters, London: 111
Zindeman/Fremont: 80, 84, 86, 88–89 (*The X-Men*: Trademark and copyright by Marvel Entertainment Group, Inc. All rights reserved.)

TRUSTEES OF THE MUSEUM OF MODERN ART

Mrs. Henry Ives Cobb
Vice Chairman Emeritus

Mrs. John D. Rockefeller 3rd
President Emeritus

David Rockefeller
Chairman of the Board

Mrs. Frank Y. Larkin
Donald B. Marron
Gifford Phillips
Vice Chairmen

Agnes Gund
President

Ronald S. Lauder
Vice President

John Parkinson III
Vice President and Treasurer

Frederick M. Alger III
Lily Auchincloss
Edward Larrabee Barnes
Celeste G. Bartos
Sid R. Bass
H.R.H. Prinz Franz von Bayern**
Hilary P. Califano
Thomas S. Carroll*
Marshall S. Cogan
Robert R. Douglass
Gianluigi Gabetti
Lillian Gish**
Paul Gottlieb

Mrs. Melville Wakeman Hall
George Heard Hamilton*
Barbara Jakobson
Philip Johnson
John L. Loeb*
Mrs. John L. Marion
Robert B. Menschel
Dorothy C. Miller**
J. Irwin Miller*
S. I. Newhouse, Jr.
Philip S. Niarchos
James G. Niven
Richard E. Oldenburg
Michael S. Ovitz
Peter G. Peterson
John Rewald**
David Rockefeller, Jr.
Rodman C. Rockefeller
Richard E. Salomon
Mrs. Wolfgang Schoenborn*
Mrs. Robert F. Shapiro
Mrs. Bertram Smith
Jerry I. Speyer
Mrs. Alfred R. Stern
Mrs. Donald B. Straus
Robert L. B. Tobin
E. Thomas Williams, Jr.
Richard S. Zeisler

*Trustee Emeritus
**Honorary Trustee

Ex Officio

David N. Dinkins
Mayor of the City of New York

Elizabeth Holtzman
Comptroller of the City of New York

Jeanne C. Thayer
President of The International Council

COMMITTEE ON DRAWINGS

Mrs. Frank Y. Larkin
Robert L. B. Tobin
Co-chairmen

Lily Auchincloss
Walter Bareiss
Charles B. Benenson
Mrs. Roger S. Berlind
Edward R. Broida
Mrs. Carroll L. Cartwright
Marshall S. Cogan
Agnes Gund
Mrs. Melville Wakeman Hall
Philip H. Isles
Steingrim Laursen
Ronald S. Lauder
Raymond Learsy
Donald B. Marron
Hans Mautner
Francois de Menil
Gifford Phillips
Mrs. Max Pine
Richard E. Salomon
Sheldon H. Solow
Mrs. Bertram Smith
Mrs. Alfred R. Stern
Mrs. Donald B. Straus

Ex Officio

David Rockefeller
Richard E. Oldenburg